Jobs In Arts And Media Management

What They Are <u>And</u> How To Get One!

Complete With Career Kit

Stephen Langley

&

James Abruzzo

DRAMA BOOK PUBLISHERS

New York

JOBS IN ARTS & MEDIA MANAGEMENT
Copyright© 1986 |by Stephen Langley and James Abruzzo
Printed in the United States of America.

For information address:
Drama Book Publishers, 821 Broadway, New York, NY 10003

First Edition

Library of Congress Cataloging-in-Publication Data
Langley, Stephen.
 Jobs in arts and media management.
 Bibliography: p.
 1. Arts—Management—Vocational guidance—United
States. 2. Mass media—Management—Vocational guidance
—United States. I. Abruzzo, James. II. Title.
NX765.L36 1985 700'.68 85-16099
ISBN 0-89676-090-1
ISBN 0-89676-073-1 (pbk.)

10 9 8 7 6 5 4 3 2 1

This volume is dedicated
to the full employment of
arts and media professionals
everywhere.

Contents

Chapter 7 **JOBS IN MARKETING, PUBLIC RELATIONS, AND SALES** p. 130

Chapter 8 **JOBS IN FUNDRAISING, FUND GIVING, AND IN SERVICE ORGANIZATIONS** p. 144

THE ARTS AND MEDIA MANAGEMENT CAREER KIT p. 179

List of Charts

Acknowledgements

While it is not possible to mention everyone consulted in preparing this book, we would like to express our gratitude to the following individuals:

For their research assistance while they were students in the Brooklyn College M.F.A. Performing Arts Management Program, we would like to acknowledge Alice Bernstein, Barbara Ann Brown, Kim Konikow, John Moore, Grace Rubin, and Gary Tydings.

For their information input and their editorial commentary we are especially indebted to the following: Ron Aja of Actors' Equity Association, Bruce Birkenhead of the Emanuel Azenberg producing office and professor emeritus of Brooklyn College, Janet S. Blake of Mary Tyler Moore Productions, Abe Cohen of International Creative Management, Inc., Jeffrey Fuerst of the Museum of Broadcasting, Kathryn Haapala of the Society for Stage Directors and Choreographers, Jana Jevnikar of the Center for Arts Information, Gregory Kandel of Management Consultants for the Arts, Inc., Ellen Lampert of the Brooklyn Academy of Music, Professor Edward O. Lutz of Brooklyn College, James McCallum and Robert Hudoba of Musical America, Inc., Patricia MacKay of *Theatre Crafts Magazine,* Thomas Murphy, Esq., Jack Nulsen of the Brooklyn Academy of Music, Mark Rosenthal of CBS Cable, Tobie S. Stein of the Brooklyn Center at Brooklyn College, Andrew Suser of ABC, Maureen Walsh, Lloyd W. Weintraub of MGM/UA Entertainment Co., and Amy Wynn of the Dance Theatre of Harlem. We are also indebted to the editor of this manuscript, Bob Perry, and to our publisher, Ralph Pine of Drama Book Publishers.

For their moral support and encouragement the authors wish to thank Lorraine Abruzzo and Edelmiro Olavarria.

Finally, this book could not have been written without the authors' many, many professional acquaintances—most notably the clients and their associates with whom Mr. Abruzzo has worked at Tarnow International, Inc., and at Opportunity Resources; and the students and their internship sponsors with whom Dr. Langley has worked at Brooklyn College of the City University of New York. The contents of this book reflect—as honestly and as accurately as we could manage—the accumulated experience of two very happy, rewarding, and ongoing careers in the arts.

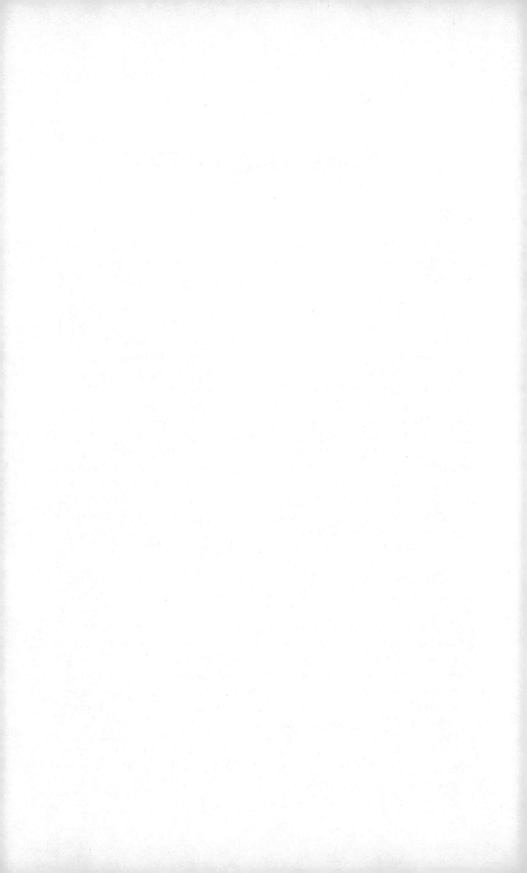

Introduction

Jobs in Arts and Media Management is the only "careers" book to embrace the performing, visual, and media arts as a single industry. It is the first comprehensive guide to the job market and to career development that embraces theatre, music, dance, opera, museums, galleries, film, telecommunications, and the many types of managers and support personnel who earn a living by working at a desk behind the scenes.

This book is for managers and aspiring managers of all ages who hope to develop a career, get a better job, or switch from one discipline of the arts and media industry to another. It does not, however, consider the disciplines of publishing, graphic arts, popular music, or music recording, and it avoids discussion of jobs that are primarily creative, even though some of these may require some degree of managerial responsibility. Positions covered range from executive jobs at the top to jobs in finance, marketing, public relations, sales, fundraising, fund giving, production, operations, and others you may never have known existed—you'll also find out about opportunities for becoming an independent entrepreneur. Career counselors, students, and teachers in the field will also find this a valuable resource, as will board members and managers concerned with personnel organization, staff structure, job descriptions, and job responsibilities. Any job market, after all, concerns both employers and employees.

A broad spectrum of the contemporary arts world is covered here, showing similarities between jobs in companies presenting "live" art and those in companies presenting the arts through the electronic media—as well as similarities between the commercial and the not-for-profit sectors of the industry. As artists discover that it is increasingly possible and lucrative to work in art forms that are presented live or electronically, arts managers must also understand how each operates in order to facilitate and enhance the growing relationship between art and technology. Leadership in the arts management field requires, more than ever, a broad knowledge of its diverse parts, combined with an entrepreneurial imagination that can bring those parts together.

The business of managing the arts, of course, requires a special love and dedication that goes beyond mere competence in various job skills. If art is the record of civilization and artists our true historians, then the mission of arts management must include a far-reaching sense of obligation. It must also include a sense of joy and fascination with the arts—this is an important aspect

of the compensation you will receive for working in this field.

The first chapter of this book defines arts management as a profession by placing it in the context of recent history and showing how the role of the arts manager has evolved distinctive characteristics. In subsequent chapters you will learn how to plan your career, determine what kind of training you need, discover how to apply for and gain the position you want—and you'll learn how to move up. Then, after reading how the industry is organized, you can examine the myriad job possibilities. These are described generically, illustrating how easily skills may be transferred from one branch of the industry to another. Because most people work as employees before forming their own businesses, the options for becoming self-employed in the arts management field are saved for the final chapter. Finally, we have created a Career Kit that gives you easy access to valuable job information—a resource you will want to consult whenever you're considering a job or career change.

It is not expected that all readers will peruse this book from the first page to the last. Anxieties about job hunting run high: You may want to check out the table of contents first; then flip to the job sections that most interest you; and then proceed through the book guided by your immediate information needs. Finding a job, making a career change, or relocating is not easy. This book tries to make such options both friendly and comprehensible. The Career Kit may be all you need to get started on the road to success. But keep this book as a reference to use when you get an offer to fill a challenging new position or, more likely, when you would like to get someone to make you such an offer. Also, use the appropriate chapters whenever you rewrite your resume, begin a job search, or prepare for an interview. If you follow our advice, you may be engaged in those activities sooner than you think!

☆ 1 ☆

Birth of a Profession

Perhaps your experience as a board member for an arts organization, or as a frustrated actor earning a few welcome dollars working for a theatrical press agent, or as someone trying to establish your own arts group because no one would hire you has opened your eyes to the world of arts management. Or perhaps you would like to move into arts management from a different field altogether. You have glimpsed the complex and fascinating infrastructure, invisible to the general public, that functions beyond and behind what is seen on the stage, on the film or television screen, or on the canvas: an industrious network of management leaders and employees who are facilitating the production and distribution of artistic products by, to put it as simply as possible, putting the money where the talent is.

The three basic elements that serve the creative product are talent, capital, and management. The artist evolves or expresses the basic idea—or product, if you will—and the money sustains the artist and supports the product. Management brings together these two elements.

If you have given up any artistic career goals you might have had; if you have an informed appreciation of the arts, together with a desire to serve artistic accomplishment; and if, at least for the foreseeable future, you are willing to take career risks, train or retrain, earn less than you might in another career, and work longer hours than you might in another job—*keep reading!*

What Is an Arts Manager?

Because this book is meant for future arts and media administrators, managers, and producers, perhaps a quick definition of those work titles is in order.

While the words *administrate* and *manage* are often used as synonyms, it is our view that a manager is a person of somewhat greater position, responsibility, and authority than an administrator. To quote an article about the Pentagon in the February 6, 1983, *New York Times Magazine*: "Administration must make events march on time, have the right people in the right places, get maximum results at minimum cost. Management is different. It must choose directions, decide on policies, set the targets, not for the day

1

but for the decade." There are similar differences between executive and clerical positions. Presumably, managers and executives are paid more because they *think* rather than *do*. Their primary function is to oversee the work of others by determining what those others will do, why they will do it, when they will do it, how they will do it, and for how much they will do it. Successful managers accomplish all this in a manner that increases rather than stifles employee incentives. In the broadest sense a manager is any person responsible for one or more of the following activities: planning, organizing, supervising, controlling and/or staffing.

You're right if you say that this definition makes just about anybody a manager in some capacity, even the parent raising a child or the host of a party. The critical difference is that some people manage well and some don't. As you consider a career in arts management, you would be wise to assess honestly your aptitude in regard to the four basic management functions. Are you a person with a good reputation as a manager? You probably are if you can answer yes to these three simple questions:

1. Do others call upon you when there is an important job or assignment to be done?
2. Are you able to get others to comply with your wishes and requests easily?
3. Do events usually turn out as you planned them?

Yes? Then you almost certainly have an aptitude for management. However, it is important that you genuinely enjoy being involved in the management process, whether the goal is a successful dinner party or a successful opening night. If you wish to become a professional, you must also possess self-discipline. Humphrey Bogart once defined a professional as "someone who does his job well, even when he doesn't feel like it!"

Obviously, the more money, people, and resources a person is charged with managing, the greater that person's responsibility and, usually, his title and salary. However, one's ability to move from clerical work to supervisory work and finally to an important leadership position depends not only on basic management skills and acquired knowledge, but also on such God-given qualities as vision, insight, intelligence, and energy. It also doesn't hurt to have a high degree of motivation, intellectual curiosity, taste, and a desire to contribute to the betterment of humankind.

Seeking to define the ideal qualities of an arts manager—at least in the not-for-profit sector—the landmark Rockefeller panel report *The Performing Arts: Problems and Prospects* (New York: McGraw-Hill, 1965) describes

> a person who is knowledgeable in the art with which he is concerned, an impresario, labor negotiator, diplomat, educator, publicity and public relations expert, politician, skilled businessman, a social sophisticate, a servant of the community, a tireless leader—becomingly humble before authority—a teacher, a tyrant, and a continuing student of the arts.

Not an easy job vacancy to fill! But it's smart to keep in mind the highest position you would like to achieve while you're picking up valuable skills and experience along the way.

Before discussing training programs and graduate degrees, job placement services and interview techniques, job descriptions and career advancement, it seems appropriate to take a brief look at the evolution of the arts and the media in this country. What is the tradition that you are about to inherit?

The Growth of the Lively Arts in America

The story of how the arts have been managed in America can, for the sake of simplicity, be divided into two one-hundred-year periods—roughly, from 1750 to 1850 and from 1850 to 1950. The third hundred years, what we will call the era of the third-century manager, is, of course, presently underway.

Prior to the middle of the nineteenth century—while the number and variety of performances grew steadily and the level of professionalism continued to improve—there was little, if any, institutionalization of the arts. There were a number of established troupes of touring actors, as well as stock theatres, music groups, and independent visual artists, but nothing like, for example, the Chicago Lyric Opera or the National Gallery of Art. Theatre business was conducted by an actor-manager, usually the leading player of the company; opera and musical events were organized by a leading singer or musician; and the visual artist sold his work out of his own studio or gallery. In other words, the business of the arts was controlled by the artists themselves. And in most cases it was a small business operated along the lines of a mom-and-pop grocery store. Real estate was cheap—you could earn back the cost of a modest theatre building with the receipts from a single week's performance. You could perform whatever you wished, however you wished, without giving a thought to royalties, fees, commissions, copyright infringements, or agents. No one received pay for rehearsal time, and performers had to provide their own costumes, wigs, and makeup. But America's industrial growth quickened by mid-century, and as the American way of doing business changed, the arts business changed along with it.

Following the gold rush in 1849, the railway industry began its incredible expansion by laying thousands of miles of tracks, linking every major city in the country by the year 1870. This growth in modern transportation, perhaps more than any other factor, drastically altered the entertainment business. Now, rather than touring alone and playing with members of the local stock company, a star could travel complete with a full cast and all the costumes and scenery that were needed. The result was a rapid, almost total decline in the number of resident or stock theatre companies. New York City was the heart of the nation's railroad network; because of that it became the city in which actors, vaudevillians, members of minstrel companies, and other performers congregated, and where a new breed of theatre managers conducted business.

Starting out as booking agents who arranged tours and supplied shows for the nation's theatres, these managers were businessmen out to make a fast buck. They were neither performers nor were they socialite millionaires interested in supporting the arts. They extracted a booking fee from the theatre owners, a casting fee from the actors, and, often, a percentage of the actors' salaries. In 1896 three sets of partners joined forces to create what became the infamous Theatrical Syndicate, which by the turn of the century held a virtual monopoly on the country's five thousand theatres. By the early twentieth century the Shubert brothers replaced the Syndicate and soon exercised an even greater monopoly over the American theatre by virtue of the fact that they owned a large number of theatres and also had exclusive booking authority with those they didn't own. Their power was, however, eventually lessened by the growth of the Actors' Equity Association and other unions, the emergence of the motion picture industry, the crash of the stock market, the loss of a federal antitrust suit, and other events.

Commercial theatre had become completely centralized in New York City, and during much of this second hundred-year period, there was little else being produced. Consequently, when the Great Depression forced the closing of many theatres—or forced their conversion into movie houses—theatre circuits went down like rows of dominoes. By the year 1932 there were, at one point, only thirty-two legitimate theatres operating in the whole country!

Until the 1929 stock market crash, virtually all theatrical productions were bankrolled from the pockets of a single producer: men like Lee and J. J. Shubert, Florenz Ziegfeld, Billy Rose, Daniel Frohman, and others. After the crash, with rising costs and fewer millionaires, it was usually necessary for producers to seek out investors, or "angels," to help in financing a show. To facilitate this process an attorney named John Wharton adopted the Limited Partnership Agreement to define the rights of both the producers, or general partners, and the investors, or limited partners, and to simplify the producer's legal obligations with such agencies as the Securities and Exchange Commission. This method of producing a Broadway show is still the most common, although other schemes have been tried, such as offering over-the-counter shares through the stock market. Today some shows are completely financed by a mere handful of corporate producing organizations, though the Limited Partnership Agreement is still used in these cases.

While the American theatre was becoming centralized and controlled by showmen with considerable business acumen, serious music and visual arts projects were being institutionalized by wealthy industrialists and socialites. The building of the Academy of Music in Manhattan—which opened in 1854, replacing the Astor Place Opera House—was financed by a collection of socially prominent people who bought subscriptions, or shares, in the company. This entitled them to "own" boxes for the performances—not to earn profits on their investments, but just to gain admission. Such was the typical method of financing large operatic and symphonic organizations until

the early twentieth century. The Metropolitan Opera was founded in 1883 mainly to satisfy a demand for boxes that the Academy of Music could not fulfill. The original organizers subscribed $10,000 each—buying one hundred shares at $100 per share—this being the cost of a single box. Those early patrons included among their numbers the Vanderbilts, Belmonts, Morgans, Rhinelanders, Goulds, and other prominent families of the day. In 1891 the philanthropist Andrew Carnegie built and endowed Carnegie Hall; others followed his example, attempting to memorialize themselves in bricks and mortar by funding arts facilities.

Just as the Depression had affected the commercial theatre, it also influenced other types of arts institutions, causing many to reorganize their business structures in order to become less reliant upon the largess of a small number of patrons. The Metropolitan Opera, for example, was purchased from its stockholders in 1940 to become a national trust. Any private or corporate contribution to a not-for-profit organization had become tax deductible—a powerful incentive for giving ever since the insidious growth of taxation following World War I. Arts institutions to this day still benefit from large gifts given by a few wealthy individuals, but they are increasingly reliant upon many small contributions as well as corporate and tax-levied support.

A key point to remember is that American museums, opera and dance companies, and serious music ensembles have tended to be institutionalized from their inception and have been supported by admission revenues together with, when necessary, financial contributions. Of the live arts, only the theatre and popular music started out and continued, until recently, to be financed primarily by entrepreneurs and investors hoping to make profits on their ventures.

Enter: The Media Monster

In 1914 Cecil B. DeMille together with Samuel Goldwyn produced the first feature length film in Hollywood. *The Square Man.* DeMille made his first "spectacle film," *Carmen,* in 1915. That same year saw the premier of D. W. Griffith's *The Birth of a Nation,* by which time there were already over ten thousand movie theatres nationwide, though many of them were nickelodeons or makeshift viewing areas set up in the back rooms of stores or saloons. By 1920 there were over twenty thousand movie theatres, many of them of permanent and elaborate design. Network radio began to function in 1925, and within several years few American households were without radios. Talking pictures, beginning in 1927, redoubled movie audiences; and a generation later, starting in 1948, the advent of network television ushered in yet another media craze.

Functioning unseen during this ongoing media boom were producers, managers, and other executives whose visions, tastes, insights, and thinking—or lack of same—have probably done more to shape the world in which we

live than all the presidents, generals, and diplomats of the same period! The leading movie studios were owned by men who founded them, making their power all the more absolute. Eventually, partners were taken in and after the founding moguls retired or died, the studios did go public and offered shares.

Nobody was really certain at first whether film, and then television, should be used primarily for entertainment or for educational and informational purposes. Nonetheless, a prodigious amount of work that qualifies as artistic was eventually produced. And a major reason for this—a reason that should not be lost amid all the hardware, big budgets, and corporate mergers—is the heavy dependence that the film industry and the broadcast media have always had upon artistic talent working in the live arts. Sooner or later, most leading artists in the performing arts tried their luck in the media industry. Actors, opera singers, dancers, choreographers, writers, composers, conductors—all were in demand. The NBC Symphony, for example, was formed for Arturo Toscanini in 1937; CBS sponsored live radio broadcasts of the New York Philharmonic; Leopold Stokowski went to Hollywood; Enrico Caruso and Geraldine Ferrar starred—voiceless—in DeMille's *Carmen;* actors deserted Broadway in hordes; and other talents followed during this twentieth-century update of the gold rush.

From the time that Thomas Edison began his experimentation with motion pictures in the 1870s until the creation of the private, nonprofit though government-funded Corporation for Public Broadcasting—formed in 1968 to assist noncommercial radio and television programming—the media industry was comprised primarily of commercial, profit-making enterprises, as was the theatre. But now a new type of financing was being introduced.

For Sale But Not For Profit: The Advent of Subsidy

The professional American theatre remained in a precarious state until 1958 when in a momentous decision the Ford Foundation, inspired by W. MacNeil Lowry, committed $58 million dollars to assist the arts over several years and, especially, to assist theatre and dance companies. Mindful of the comparatively successful models provided by American museum, symphony, and opera institutions, the Ford Foundation gambled on its belief that the American theatre could also become institutionalized, and, as it were, legitimized. In supporting and nurturing a number of nonprofit regional theatre and dance companies, the Ford Foundation served as the impetus of a substantially increased amount of professional activity outside New York.

A few years later, in 1965, the Rockefeller Brothers Fund published its panel report *The Performing Arts: Problems and Prospects,* which was an eloquent call for government support for the arts. In that same year Nelson Rockefeller, as governor of New York, established the first state arts council in the nation,

modeled along the lines of the British Arts Council. Then-President Lyndon Johnson—still riding a wave of legislation passed in posthumous tribute to John F. Kennedy—created the twin agencies of the National Endowment for the Arts and the National Endowment for the Humanities. Although it is true that the original allocations to these agencies were small, they mandated matching allocations to any state that would equal federal money with state money. The result, predictably, was that within a single year every state in the union established a state arts council. Then in 1968, as mentioned, came the Corporation for Public Broadcasting, which also received federal support.

So the snowball began to roll: federal arts agencies, state arts agencies, city arts agencies, community arts agencies, and all the new jobs and expertise required to support this sprawling new system of subsidizing the arts. And, while tax-levied support increased each year—until the 1981 Reagan cutbacks—so did contributions from the corporate and private sectors. Not only were federal dollars generating more dollars through the "matching," or "challenge," grants system—an unusually productive expenditure of tax money—arts organizations were also hustling to raise money from other sources.

Paralleling the growth of public arts agencies was the growth of private, nonprofit arts service organizations. Theatre Communications Group (TCG), the American Symphony Orchestra League (ASOL), the Association of College, University, and Community Arts Administrators (ACUCAA), and others not only brought arts people of similar interests together but also assisted in the process of defining the structure of the nonprofit arts world and its management needs. They helped, too, in various lobbying efforts to put pressure on legislators for increased tax support. Other organizations, most notably the Business Committee for the Arts, lobbied corporations to contribute to the arts.

The State of the Arts and Media Industry Today

With the construction of an estimated 3,000 new theatres and performing arts centers—many on college campuses—during the sixties and seventies; with the growth of the resident theatre movement from a mere handful of companies to nearly 200; and with the even more phenomenal growth of dance companies—the 1982 *Dance Magazine Annual* lists 322 ballet companies and 380 modern dance companies in the United States and Canada, plus hundreds of other specialized dance groups—thousands of new arts administration positions have been created. Impressive growth has also been seen in the number of symphony orchestras, chamber and choral music groups, opera companies, museums, and art galleries. It was during this same twenty-year period that New York City replaced Paris as the unquestioned international hub of visual arts activity, prompting France to build the striking

Centre Pompidou in an attempt to regain its former reputation. New York City is also the world's dance capital. And the rest of America—no longer the cultural wasteland that critics used to decry—has grown richer in and because of the arts. With the creation and artistic development of such institutions as the National Gallery, the National Symphony, the Arena Stage Company, and the Washington Opera Society, and with the opening of the Kennedy Center for the Performing Arts, the nation's capital is now both a major exhibitor and a major producer of the arts. So are, if to lesser degrees, Los Angeles, San Francisco, Chicago, Toronto, Sante Fe, Minneapolis, Dallas, Seattle, Charleston, and other cities. As the arts in America have become more established, they have also become more diversified, and, importantly, more popular, even surpassing the gate admissions for sports events.

But the greatest explosion of growth in the arts industry is reflected not, perhaps, by what has happened in the past—as impressive as that has been—but by what is happening right now. The newest theatres, concert halls, and exhibition spaces in America are not being built on Main Street but, rather, in our very own living rooms. These new stages may *look* like television screens, but they are much more than that. They are no longer owned exclusively by NBC, CBS, and ABC. They are no longer dominated by the Hollywood of yesteryear or, for that matter, the Hollywood of this year. A television screen now brings the entire range of entertainment and information into our homes.

Many people considering a career in the performing arts professions today—either as artists or as administrators—are skeptical about its future: "Won't the media kill live theatre?" "How can you make a living unless you go into TV and films?" "Why go out when you can watch it on TV?" These are shortsighted questions.

To gain perspective, take a look at the contemporary American kitchen. With a food processor and a microwave oven one can quickly and easily produce a succession of fabulous gourmet meals right at home. Yet, is anybody predicting the demise of the restaurant industry? Has the enrollment in culinary schools dropped off? Similarly, have the superb color reproductions in art books kept people away from museums that exhibit the originals? Has "living stereo" kept people away from the concert halls? On the contrary. People are not going to lock themselves up in their media rooms, never again to seek the thrill of experiencing the live arts or the satisfaction of seeing a film on a wide screen.

While the film industry was hard hit economically in the years following the advent of television, this was largely because it chose to compete with television rather than to invest in it. Back lots and sound stages were sold off or rented for television production; the Desilu Studio quickly became one of the busiest in Hollywood; mergers and sellouts became commonplace. The most valuable assets retained by the studios were their libraries of films, which most had the foresight to rent rather than to sell outright for showing on television. Film production became secondary to film rental and, eventually, few new

films were made without an eye to their value in the television and video-cassette markets.

It is significant that most major films are now produced by independent companies, even though financing is often provided by a major studio in return for distribution rights. Many such companies were formed by stars-turned-producers, such as Peter Fonda, Robert Redford, Jane Fonda, and Warren Beatty. This has been a healthy way to get the creative process back under the control of the artists. Metro-Goldwyn-Mayer, Warner Brothers and other former big studios are now subsidiaries of large conglomerates—such as Coca-Cola and Warner Communications—and are mainly in the business of film distribution and rental. They are also nervously testing various ways to become more involved in the rapidly expanding telecommunications industry. Few board presidents or chief executive officers of these companies have much background in film production. Nor are they film producers in the traditional sense of that term; they do not select and develop the basic properties or scripts. Similarly, the leading Broadway theatre landlords—namely the Shubert Organization and the Nederlander Organization—are now financing numerous Broadway productions, but virtually all of their shows are first developed and staged by other producing companies.

Just as the major studios failed to invest in the growth of television, they were also largely closed out of the video-cassette market. While they continue to supply films to movie theatres on a rental basis, video cassettes are generally distributed to retailers by companies such as Sound Video Unlimited and Commtrom, which acquire the cassettes directly from film manufacturers like Bell & Howell of Chicago. The studios do not share in the profits generated by this market unless they distribute cassettes themselves, which to date has rarely been done. So the way in which the film business is structured is again going through drastic change—this time because of home video.

The growing impact of telecommunications on artists was well illustrated by the lengthy 1981 strike by the Screen Actors Guild. Its goal was to secure for its members a share of the potentially enormous profits of film sales to cable television and video-cassette companies. Much negotiation will be required before the economics of such matters can be hammered out, and new laws will be required to insure that profits are distributed in an equitable fashion. Considerable effort will also have to be made before live arts events can be more successfully translated into television and video programming. But the introduction of such programming has begun and has already made an impression upon both the media moguls and the media audiences. Arts programming may never have the same number of viewers as the current prime-time fare, but the demand is sufficiently widespread to give the lively arts a fighting chance of cashing in on the technological revolution.

Paradoxically, rapidly expanding video cassette recorder (VCR) sales have helped rather than harmed movie-theatre attendance—just as telecasts of live theatre, opera, symphony, and dance performances have stimulated box-office

sales for live events. The Japanese have introduced "video theatres"—multiple screening rooms under one roof that seat about fifty people each and show video cassettes. The entire operation—ticket sales, concession sales, and projection—is handled by one person. In America it appears that satellite disc sales will soon outstrip VCR sales and this is bound to bring further changes. The fact is that the arts and media industry today is replete with opportunity for the introduction and development of new products, companies, and markets. And such opportunity exists not only in the areas of hardware and software but also, importantly, for art wares. In every sense of the term this is a growth industry if ever there was one!

The Third-Century Arts Manager

With the sizable increase in arts activity caused by the media explosion, and with the advent of corporate and government subsidies, a new managerial support structure for the arts, together with a new entrepreneurial philosophy, has been put in place, thereby ushering in the era of the third-century arts manager—a distinctly American term in a century distinct for American achievement in the arts and media field.

Both artists and arts managers have a great deal of learning and catching up to do if they are to benefit from the opportunities at hand. While the media must learn how to allot more time to artistic considerations as well as to the processes of communication, arts people must acquire a new vocabulary, if not a new pedagogy, if the two are to become equal partners. To illustrate this point with a brief job story: Dr. Frank Stanton, who was for many years president of CBS, was recently asked to serve on the search committee for a new director of Harvard's prestigious Fogg Art Museum. Asked to list the qualifications that he thought necessary for this position, he recommended that the person be able to demonstrate scholarship, curatorial experience, and a knowledge of technology and telecommunications. The last qualification, of course, is increasingly necessary as the process of museum research becomes computerized and as the ability to order instant pictures of documents and art works via satellite becomes a reality.

Tomorrow's arts manager will be an expert in his or her own art form, will possess the managerial qualities mentioned earlier in this chapter, and will demonstrate an eagerness to move into the future. A few people will have the qualifications to transcend the function and role of the arts management job and will rise to positions of leadership. They will be both humanists and generalists—people who can grasp the essence of whole disciplines, who can perceive conceptual relationships, and who can relate general principles to specific problems or projects.

The management of the arts in America is no longer neatly divided between Broadway and Hollywood, or, for that matter, between what is called "commercial" and "serious" art. No longer can one expect to specialize in

either live or electronic ventures, nor can one expect to settle down on one coast or the other, ignoring everything in between. Similarly, textbooks, grade school and college courses, and training programs that deal with communication and with the arts can no longer ignore the interrelationships and the growing interdependencies among the various disciplines within the arts and media industry. *The arts industry today is one integrated whole.* A marriage has been made, perhaps not in heaven, but in the temple of technology—where viewers have already given it a high rating!

Arts management is a profession that is still in the process of being defined and is just now beginning to be understood and accepted as a necessary and legitimate field. Producers, impresarios, curators, and patrons—their functions dating back at least to the ancient Egyptians—have contributed to the evolution of the concept of arts management. Yet, only now have needs and resources combined to mandate the emergence of a professional arts manager. Many people within the arts and media industry itself still do not understand what this profession is all about, much less that a new breed of manager is in our midst. Gradually it will become clear that arts management is a viable, certifiable profession—even though it has taken several millennia of practice, experience, and accomplishment to define it.

Wherever you wish to fit into this sprawling industry, don't be overwhelmed by its size or complexity, just fuel yourself with the wonderment. Embrace the essentially facilitative role of arts management—its special responsibility to arts production and preservation, its underlying generosity of spirit—and with a little luck and a lot of hard work, the odds are that the profession will also be generous to you!

Chart 1

A Statistical Profile of the Arts and Media Industry*

THEATRE

Broadway Theatres	38
Off-Broadway Theatres	42
Off-Off-Broadway Showcase Theatres and Companies	175
Los Angeles Theatre Alliance Companies	60
San Francisco Bay Area Theatres and Production Companies	85
Chicago Alliance Theatres	25
Chicago Non-Equity Theatres	84
Boston League of Theatres	12
Canadian Theatres Equity	126
Non-Equity	64
Union Des Artistes	34
Equity Stock Theatres	82
Non-Equity Stock Theatres	168
Equity Regional LORT Theatres	92
Equity Dinner Theatres	35
Equity Children's Theatre Companies	80

Chart 1—Continued

Road Theatres for Professional Productions 126
College Theatre Programs U.S. 1503
Canada 26

Total 2,701

OPERA AND/OR MUSICAL THEATRE
Opera Companies (U.S. and Canada)
Budgets over $1 million 23
Budgets over $500,000 20
Budgets over $100,000 65
Budgets over $25,000 60
Lyric Theatre Companies 40
Miscellaneous (or budgets n/a) 134
College Programs and/or Workshops (U.S. and Canada) 480

Total 822

MUSIC
Symphony Orchestras

Budgets over $2.5 million U.S. 34
Canada 6
Budgets over $500,000 U.S. 61
Canada 13
Budgets over $100,000 U.S. 167
Canada 8
Budgets over $50,000 U.S. 78
Canada 3
Budgets under $50,000 U.S. 1101
Canada 124
Choral Groups (U.S. only) .. 528
Music Festivals U.S. 222
Canada 10
Chamber Music Ensembles (U.S. and Canada) 1000
College Music Programs (U.S. and Canada) 1010

Total 4,335

DANCE (U.S. and Canada)

Ballet Companies .. 322
Modern Dance Companies .. 380
College Programs .. 256
Miscellaneous Groups ... 1500

Total 2,458

PERFORMING ARTS PRESENTING ORGANIZATIONS (U.S. only)

Independent Presenting Organizations 821
College and University Centers .. 460
Community and Civic Organizations 361

Total 2,045

TAX-SUPPORTED ARTS COUNCILS

U.S. Federal .. 6
U.S. State .. 56
U.S. Community .. 1500
U.S. Regional Arts Associations 19
Canadian Arts Councils ... 18

Total 1,599

Chart 1—Continued

BROADCASTING AND CABLECASTING

Broadcasting Companies	U.S.	46
	Canada	6
Operating Cable Systems	U.S.	4800
	Canada	400
Cable Franchises Not Yet Built (U.S. only)		3400
Operating Radio Stations (U.S.)		9092
Operating Television Stations (295 are Public) (U.S.)		1042
College Radio/Television/Film Programs (U.S.)		307

Total 19,093

FILM

Motion Picture Theatres (U.S.)		19000
Motion Picture Organizations	U.S.	25
	Canada	44
Independent Film Companies (U.S.)		8000
Major Film Studios (U.S.)		17
Film Distribution Companies (U.S.)		40

Total 27,126

VISUAL ARTS

Museums (U.S.)	History	2500
	Science	900
	Art	700
	Other	900
Art Galleries	New York City	310
	Other U.S.	997
	Canada	157
College Visual Arts Programs (U.S.)		1729

Total 7,693

UNIONS, GUILDS, AND EMPLOYEE ORGANIZATIONS (U.S.)

SERVICE AND MEMBERSHIP ORGANIZATIONS (U.S.) Total 65

The Performing Arts	535
Broadcasting and Cablecasting	63
Film	72
The Visual Arts	186

Total 856

RECORDING COMPANIES

	U.S.	213
	Canada	15

Total 228

Grand Total 69,020

*Statistics are based on a variety of 1983 and 1984 surveys and sources and, of course, are ever-changing. Where exact figures were not available, close approximations have been given. Not included here are artists' representatives and agents, who number in the thousands, and arts-related publishing companies—there are 24,505 music publishers alone.

☆ 2 ☆

Planning Your Career

Whether you are just starting a career or assessing your future in a job market you've already entered, the sooner you come up with the answers to the following questions—answers that you will stick with—the better:

How far do I wish to go in this field? (Position)
How long am I willing to give it? (Time)
How much do I wish to earn? (Money)
What do I wish to achieve? (Goal)

Setting Goals and Priorities

If your goals are modest—a difficult but by no means immoral confession in this age of upward mobility—recognize that you probably do not need a graduate degree. Attach yourself to a competent professional in the specialization of your choice and, without turning another page, hand this book to the person waiting behind you at the employment agency!

It's usually difficult for a person to realistically assess his or her potential. Even aptitude tests and professional career counselors can be inaccurate. Many people with seemingly mediocre potential have gone to the top of their professions, while others with seemingly limitless potential have fallen short. Perhaps the most important success factor is, quite simply, happiness. Do you enjoy what you're doing and take such delight in it that you can't wait to jump out of bed in the morning? When that's the way you feel, you've found the right line of work. When you don't feel that way, it's time to make a change.

Assuming that you have decided to begin a new career or expand your present one, you must now consider your goals more specifically. Temper your dreams with a little common sense and write down next to each of the following items a brief indication of what you would like for yourself ten years from now.

Job Title _____
Type of Institution or
Sector of the Industry _____
Location _____
Salary _____
Major Accomplishment _____

Your answers will indicate whether your goals are modest, reasonably ambitious, or very ambitious. Perhaps you would be satisfied with a middle-management staff position with a large, established arts institution or performing company. Or perhaps you aspire to become a Broadway company manager or the executive director of an arts council. Maybe your goal is more ambitious—to become a general manager for a major performing arts center or the chief executive officer for a film company or the executive director of a leading museum. Or do you eventually wish to work independently and produce a major play or film, own an art gallery on Fifty-seventh Street in New York City, or head your own casting agency? Obviously, the higher your aspirations, the longer it will take to achieve them and the more extensive your preparations must be, both academically and professionally.

The following are all valid types of preparation that can lead you to your dream job:

1. Amateur and volunteer experience
2. On-the-job training
3. Specialized schools and workshops
4. An undergraduate degree
5. A graduate degree
6. Broad professional experience

Modest career goals may require only the first two or three of these steps, while ambitious goals will require you fulfill all six. In other words, your goal will dictate what you must do in the next one to six years in order to reach that goal in three to ten years.

If you have the ability to place long-range goals ahead of immediate gratification, you'll be able to formulate a clear five-year or ten-year plan. Life being what it is, you'll have to compromise and modify your plans along the way; but without a clear set of priorities, you might easily find yourself right where you are now, except five or ten years older!

Let's say that your ten-year goal is to become the manager of an established symphony orchestra with a moderate budget in the midwestern city in which you live. You hold a B.A. in music education, give private flute lessons, and, unable to secure a full-time teaching job, work as a teller at the local bank. You've always been an enthusiastic patron of the symphony and now volunteer many hours working with its subscription committee. Even though you disagree with the marketing director, you've learned a lot from him about how a symphony is managed. But you think it can be better managed. You want to expand its season, send it on tour, introduce concerts for children, and the like. Should you continue to hang around and hope for a salaried position to open up with the symphony? Would you even be qualified if an administrative job did become available? Do you really know anything more about symphony management than what you've picked up from the very people of whom you're so critical? This is a typical career crossroads for hundreds of would-be arts managers.

It is no easy matter to quit a well-paying job, to move to another city in search of experience and training, to become a student again, or to scuttle the goal of your *original* ten-year plan and admit to yourself that you'll never be first flutist with the Cleveland Orchestra. Starting over is a tough assignment, but it's made a lot easier when you realize that you are not so much starting over as building on your earlier education, aspirations, and experiences. Even your work in that bank has probably been of value. If you hadn't taken all those earlier steps, you would never have found yourself in your present and deliciously challenging predicament.

After you've taken a firsthand glimpse at the field of arts administration—an absolutely crucial first step—continue your quest for new knowledge by joining as many management service organizations as you can afford, by reading their literature, and by attending their workshops and conferences. These activities will give you quick, inexpensive exposure to the field and will provide many opportunities to talk with people in your position as well as with experienced professionals. You may discover that it is not the right field for you, after all. But if it is still your choice, you should spend a rainy Saturday sending for brochures and applications from all the arts management, and other appropriate, training and degree programs around the country. The Career Kit includes an extensive listing of those programs.

If your determination to pursue your goal increases rather than diminishes with this process, you'll find that your priorities will arrange themselves in a logical sequence. After learning about paid internships, scholarships, tuition waivers, and student loans, quitting your job at the bank will no longer seem like the end of the world. After getting the symphony to reward your many hours of volunteer labor by paying for your trip to that arts administrators' conference, you may discover that there is a lot you don't know but that you're anxious to learn. You will have talked with people who have not only started a new career in arts management, but who have done it despite obstacles greater than your own: relocating both husband and wife, dealing with young children, having few financial resources, or going back to school at the age of fifty. If you want something badly enough, chances are you will get it—given the determination combined with a logical, long-term plan.

The School of Hard Knocks Versus Formal Education

General principles as well as trade secrets have long been handed down from one generation to another by means of the apprenticeship method of learning. For centuries artisans, as well as artists and arts managers, have learned the fundamentals of their professions in this manner—the best of them, of course, far surpassing the achievements of their own masters.

To this day membership in many unions requires a one-to-three-year apprenticeship. If you wish to be a card-carrying electrician or a Broadway

company manager, a mason or a press agent, you must usually serve an apprenticeship with one or more members of the appropriate union. Because this is the only real training many people have received, it is often touted as the only way to learn. Time and again you will hear about the importance of "hands-on experience," "working your way up through the ranks," and "learning by doing." It's an argument that is valid: Nobody becomes a manager simply by having learned some theory and been given a title. Conversely, one *may* be an effective manager without having had any formal training, and without ever having cracked a textbook.

Practical, on-the-job experience is both desirable and necessary. But the *quality* of that experience is all-important and has a direct correlation to how far you will go and how fast. Herein lies a powerful case against on-the-job training as the exclusive approach to building a career, at least if your ambitions are high.

If you are now working in the field—and in every position you hold in the future—it is imperative that you ask:

What am I learning?
Where am I learning it?
From whom am I learning it?

If you associate yourself with a person or place of employment with a poor professional reputation, you may unknowingly brand yourself with that same reputation for the rest of your career. If you are learning hackneyed, old-fashioned, and noncompetitive work habits—not to mention incorrect or unethical habits—you are obviously doing yourself great harm. Bear in mind that there are very few widely recognized masters in any field—usually only a handful, in fact. Such learning opportunities are rare.

Because the School of Hard Knocks was the only one to offer training in arts management and film and television production until the sixties, few people in the field over the age of forty, and therefore few people in leading positions today, know about recently developed alternatives. Most of them started as office boys or secretaries, and with great drive, perseverance, intelligence, and luck they have worked their way to the top. A few might have been well-educated lawyers or businessmen who came in through the side door. Most had little, if any, formal education in the arts, much less in arts management. You shouldn't be surprised, then, to find few older arts managers or media executives who would recommend formal training to you. In fact, most are proud of their "self-made" success and thereby echo the centuries-old distrust between the arts professions and the universities.

Early in the present century, however, academia began to create departments of theatre, art, and music. At first devoted entirely to history, theory, and literature, such departments eventually offered instruction in the arts and, later still, included practicing artists on their faculties. Slowly a degree of mutual respect evolved between those who were "doing it" and those who

were teaching it. And now there are departments of dance, film, and telecommunications as well as several dozen degree programs—almost exclusively on the graduate level—in the area of arts management. Virtually all include some type of management internship, or on-the-job-training, to complement classroom learning. Historically, this is an unusual nod of the mortarboard in recognition of the workaday world. Just as remarkable, the workaday world has nodded back. Many descriptions for arts management jobs now specify "a degree in arts management" as a preferred qualification, especially for positions with arts councils and service organizations.

It should be obvious that considerable expertise is required of most arts managers who are now being hired for responsible positions. A high degree of conceptual and analytical intelligence is required of anyone who assumes a top-level arts management job. It should be equally obvious that few successful careers in the field are possible without experience and specialized training, and a broad-based education as well.

Deciding Between the Commercial and Nonprofit Sectors

Whether you will function better in the commercial sector of the arts and media industry or in the nonprofit sector will likely be determined by your temperament and your world view: Are you self-oriented or altruistic? A few people have worked successfully in both sectors, but most do not. Frequently voiced complaints from people in the commercial sector include—

"It's such a cutthroat business!"
"All crass commercialism. No art!"
"It's only about getting ahead and being a star!"
"It's about ripping off the public!"

Complaints often heard from people in the nonprofit sector include—

"I'm sick of asking for handouts!"
"Why doesn't that dumb board just put up and shut up?"
"I want to do what *I* want to do, for a change!"
"To hell with art, I'm sick of starving!"

It isn't a question of which sector has greater validity—they both do. It's simply a question of which sector best suits your own particular temperament and outlook.

Compare the career choices facing you:

The Commercial Sector	*The Nonprofit Sector*
Network and/or cable broadcasting	Public broadcasting
Commercial film	Educational and/or documentary film
Broadway theatre	Resident and/or opera theatre

Popular music	Symphonic and/or serious music
Stock and/or dinner theatre	Small nonprofit companies
Galleries	Museums
Promotion	Education
Financial Speculation	Philanthropy

Do you see the differences? More important, are you more sympathetic with commercial or nonprofit choices?

Employers in the commercial sector have a monetary interest in each of their employees, each of whose salary is justified *only if that employee is helping the project or firm make money*. In the commercial sector the pressure, the pace, the demands, and the competitiveness are likely to be greater than in the nonprofit sector. In the nonprofit sector there is often more leniency and more concern for the employee as an individual and for the product as something more than a money-maker.

Are you the kind of person who would enjoy the razzmatazz of the commercial field as opposed to the comparatively tame, often more deliberate noncommercial endeavor? Which would motivate you the most: personal success and wealth or the furtherance of an artistic philosophy or ideal? Early in your career you will have to make a decision. No one can make it for you. In regard to your view of the commercial sector versus the nonprofit sector, however, don't be confused about an important economic reality that unites them: To make money, the commercial arts sector must produce high-quality artistic products—and to produce quality art, the nonprofit sector must also acquire money!

The Difference Between Union and Nonunion Positions

All labor unions involved in the arts and media industry in the United States are chartered by the American Federation of Labor and Congress of Industrial Organizations (AFL-CIO). There are also numerous professional membership organizations in the arts that serve the functions of unions but are not chartered, such as the Dramatists Guild and the Association of Theatrical Press Agents and Managers (ATPAM). Still other arts professionals, such as filmmakers and talent representatives, have to get licenses or franchises; others must earn stamps of approval from government agencies, labor unions, and the like. Understand that no union or agency recognizes a difference between profit and nonprofit employers. Union contracts, salaries, and working conditions are negotiated in the same manner for both sectors.

Contrary to popular belief, no one can be refused a job simply on the ground that he or she does not belong to a particular union having jurisdiction over a job category. This type of "closed shop" practice was outlawed by

Congress with the 1947 Taft-Hartley Law. However, gaining a job does not always mean gaining union membership. In the arts and media world it is relatively easy to get into the performers' unions and the membership associations for other creative artists because, after all, it would be too difficult and too arbitrary to devise entrance examinations that claim to measure artistic talent. So, for example, if you are hired as an actor or musician with a unionized company, you will almost certainly be asked to join the appropriate union—and, in fact, you will be obliged to do so in a timely fashion. However, this is not the case with stagehands, technicians, managers, and press agents; while you could not be denied such a position if it were offered to you, the union with jurisdiction over that job category is not required to offer you membership. This is because it is perfectly legal for unions to set annual quotas on how many new members they will accept.

According to guidelines set by the National Labor Relations Board, management cannot be unionized. This is contestable, however, and is not always followed in practice. Theatrical producers and general managers, for instance, often join ATPAM early in their careers and maintain active membership. To gain and build upon union benefits, many general managers work under ATPAM contracts—though far above minimum wage—and producers sometimes sign themselves to a company manager's contract for shows they are producing in order to earn a salary. In the role of producer exclusively, of course, they would not be entitled to a salary. Many arts and media industry executives also belong to professional peer organizations, such as Dance U.S.A.; organizations of this type are formed to combine individual forces in negotiating union contracts. Whereas groups like the League of American Theatres and Producers are formed to help members share information, maintain and improve standards in their field, and to provide a platform from which to address government, business, media, and other segments of society.

There are many people in both the artistic and managerial areas of the arts world who do not belong to an arts union or professional association but who maintain a high level of professionalism. These include many educators, people producing the arts for rehabilitation programs of various kinds, and countless others working on the community or grass-roots level. A large number earn their livings from such activities, which is the most widely accepted definition of a professional. But if one is ambitious for wide recognition, high position, and maximum income, it is unlikely that joining an arts-related union or professional association can be avoided for long. A listing of most such groups is provided in the Career Kit.

Job Titles Can Be Deceiving

As you will see from the job descriptions in later chapters, different job titles often describe the same or very similar positions. Each branch of the arts

industry has its own jargon. The differences are especially marked between the commercial and nonprofit sectors and between the public and private sectors.

Bear in mind that salary is not the only negotiable factor once you are offered a job—so is the title in many cases. Experienced employers are well aware of the fact that most people respect a title as much as, if not more than, the salary. As a consequence, a better job title may be offered in lieu of a better salary. "Office manager" sounds better than "secretary." "Director of distribution" sounds better than "salesman." "Vice-president" sounds better than "director."

Conversely, that fancy job title may really be a smoke screen created to blur the real nature of the job. This is why we strongly recommend that you speak with current employees of a prospective firm or organization—preferably with the person whom you might replace. Compare what you were promised during the interview with what responsibilities, skills, and experience the job *really* requires. Remember that, as much as you may want the job, the happiest and most optimistic moment ever shared by an employer and a hopeful employee is the moment of the job offer. This is analogous to a proposal of marriage—both parties have searched for each other for a long time, both are panting to consummate the relationship with a contract, both are convinced that they have an equal need for each other. Common sense is likely to be abandoned.

The Time Factor in Getting Ahead

People are usually impatient to get a job, then impatient to get a raise, get a promotion, get a few more of both, and ultimately to head up the whole operation. Whether you're fresh out of undergraduate school, a tax accountant looking for a mid-life career change, or a recent retiree who wants to begin a second career, chances are that your first impulse will be to try immediately for your dream job—ignoring the lesser jobs that are probably necessary as background. Things seldom happen that quickly. Nonetheless, it may not damage your ego beyond repair if you *do* submit to a few job interviews for positions presently beyond your qualifications. Use them as learning experiences to find out what the best qualifications are for these jobs. Ask the people who interview you how you might best and most quickly reach your goals. Having been warned about employers of the School of Hard Knocks variety, you should be wary of offers to begin as a "go-fer" or as a mail room attendant. It would probably take two years for you to work up to a junior office position, and without special training, you might never graduate beyond that level. If you listen carefully and hear the clues accurately, you will probably figure out that the mystery of becoming successful can best be resolved by going back to college or otherwise retraining yourself. Why take two years to graduate from the mail room and two more to discover you've come to the end of your career line, when in half the time you could have

graduated from a leading college with qualifications for a middle-management position?

In the long run at least, two years in graduate school can save you ten years on the job. And similar rules of thumb apply to other types of formal training. A one-year affiliate degree program may save you five years. Or, if you already have a graduate degree, say in economics or marketing, a few training workshops in arts management will assist you in your new specialization. So will the reading you do in the field and related areas, the performances and exhibitions you attend, the brain-picking you do among your new colleagues, and so forth. Information, technology, and the way we manage them are changing with such rapidity that the term "continuing education" is not just a marketing slogan designed to lure people back to night school—it's a necessity of life.

The best way to achieve your goals may not be the most obvious, and seldom is it the most tempting. The best way will take more time and work than you'd like. But if you return to the description of your dream job and then consider the proven ways for reaching that goal, your priorities and your course of action should become obvious.

☆ 3 ☆

College Programs and Training Opportunities

The claim will not be made in this book that college is the *only* way to become successful in arts and media management. There are too many exceptions, and genius can always find a shortcut. But are you *that* exceptional?

Options in Higher Education: A Matter of Degrees

Ordinarily, it is more prudent to increase your options in the career market with a degree or two rather than risk having doors slammed in your face later on.

If you are now an undergraduate not majoring in an arts field but are interested in an arts management career, here's what you should do:

1. Take a few arts courses that sound interesting to you.
2. Involve yourself in campus and off-campus arts or media clubs, productions, and activities.
3. Read, see, and learn about the arts as much as your free time allows.

If you are now an undergraduate who *is* majoring in the arts field and who is interested in management as a specialization—

1. Take a few courses in economics, accounting, finance, or labor relations that sound interesting.
2. Involve yourself in the administration of campus and off-campus clubs, productions, and activities.
3. Read and learn about arts management functions as much as your free time allows.

Colleges that offer graduate programs in arts management are most interested in candidates who have a good undergraduate average—usually above 3.0—and an undergraduate transcript that shows high grades in both arts courses and management-related courses, such as accounting. You might

23

have only a few courses in one area or the other, in which case the grades become even more important. Colleges also want to see a sense of commitment to the field, a sense of purpose, and a sense of your knowing where you wish to be in five or ten years.

When you go for that all-important interview or write that letter of intent as part of your application to graduate school, let your ambition show and articulate all your highest aims. This is very different from a job interview. The graduate program director wants you to be ambitious, full of purpose, and anxious to conquer the world. These same qualities may scare a potential employer by signaling that you're after his job!

If you are not an undergraduate with an arts major, you may opt to continue on to graduate school in the field of your greatest proven strength. It may be law, economics, marketing, finance, administration, or accounting. You would probably select this option because—

1. You're not yet fully convinced that the arts field is the right one for you.
2. You wish to keep your career options as open as possible.
3. You think that you will receive a better graduate education and a more valuable degree.

We wouldn't argue with you on the basis of such reasoning, providing, of course, that your search for a graduate school has been thorough, and that it has included an investigation of arts management programs, and that this decision doesn't represent a compromise that makes you feel uncomfortable. If it feels as if it's the right decision, take it. If it doesn't, don't.

Space does not allow us to list all the management-related graduate programs in the nation, but the Career Kit does list the several dozen that specialize in arts management. For information on other types of graduate programs you should consult *Peterson's Guides to Graduate Study* (Peterson's Guides, Inc., Box 2123, Princeton, NJ 08540). You will probably be interested in Book 2, which lists graduate programs in the humanities and social sciences, including the performing arts, economics, law, and mass communications. Or you may wish to consult Peterson's *American Film Institute Guide to College Courses in Film and Television.* These widely used books are updated annually with detailed and cross-referenced sources that provide ready answers to your most urgent questions regarding tuition costs, program content, financial aid, and the like. Make a list of the programs that most appeal to you, and then write off for catalogues and application forms.

Continue your research by sounding out current and former teachers whom you respect as well as current or former students of the institutions that interest you, and by reading whatever professional literature you can find. While some graduate schools will not grant interviews to potential students until after their applications have been received, most will. This technique may save you a few ten-to-fifty-dollar application fees. In any case, a personal interview with the department chairperson or program head is invaluable. It is the best way to

make a strong impression and, if you are successful, the best way to land a lucrative fellowship. It is also the best way to get a sense of the campus and the faculty and students. And, if you're on the ball, you can pick up valuable tidbits regarding housing, financial aid, whom to see for what, and various other matters that may never get printed in the official literature.

How Long Will It Take and How Much Will It Cost?

As a rule, a master of arts (M.A.) program can be completed in one year of full-time study. However, an M.A. is usually considered a mere stepping-stone to a higher degree. If research, scholarship, and further education are included in your goals, your M.A. is a good transitional experience, allowing you to expand your knowledge and search for a doctoral program that best suits your interests and needs. An M.A. will also enhance your chances of getting into such a program.

The master of fine arts (M.F.A.) and master of business administration (M.B.A.) are both considered "terminal degrees," meaning not that you will die upon completing one, but rather that you will probably not seek or necessarily need yet another degree. Hence, such programs are designed to provide a fuller education than the master's or associate degree programs. Most M.F.A. and M.B.A. degrees can be earned in two years, but it may take three. There are exceptions regarding both. Read the program descriptions closely.

The cost of earning a graduate or undergraduate degree is linked to the following major variables:

1. The time required to complete the program
2. Whether the college is a private or public institution
3. If it's a public institution, whether or not you are a resident of the state in which it is located
4. Whether or not you can earn a scholarship or fellowship
5. The availability of low-cost housing
6. Your qualifications for financial assistance—often determined in part by your parents' income level if you live at home, or by your own income level as of your last filing with the Internal Revenue Service

As everybody knows, college education is expensive these days. But it is still not out of reach for people who are bright and resourceful—even if financially destitute. Private colleges, generally considered the most prestigious, are more expensive than public colleges, meaning state-, city-, or community-supported institutions. Our advice is to examine both public and private programs. You may discover that with a fellowship or scholarship you can get a free education at an expensive Ivy League college, or you may discover that the low-tuition

public university offers a better program for you. Don't judge the catalogue by its cover! Don't judge the program by its address!

You will see that many private colleges now cost about $10,000 per academic year and that many public colleges cost less than half that amount. If you are given substantial financial aid, the cost differences are meaningless. What is most meaningful to the school is your background—your academic record, your test score results, your life experience, your articulated commitment to your field, and your character references. Lacking outstanding qualifications, you will soon learn that you must pay full dollar for your education—if you are accepted in the first place. But—and this is a big *but*— don't get discouraged or sell yourself short. Don't let a few rejections discourage you from applying elsewhere. Remember that what you put into the selection of a college program and what you get out of it are directly related. More often than not, *you* are the special ingredient that will mean success—not the teacher, the college, the program, or the address.

The best news for well-qualified students, at least through the nineties, is that they are in a buyer's market. The baby-boom generation has now passed its third decade and federal cutbacks in aid to education have discouraged many who are eligible for college from applying. Most colleges, graduate schools especially, are aggressively competing with each other for promising students. If you are accepted into several programs, you will be in a strong position to negotiate even more financial assistance than you were originally promised. Don't be afraid to dangle the acceptance letter from one college in front of the dean or chairperson from another college.

Other than scholarships, which are outright gifts of money granted by a college, a high school, or a charitable organization; or fellowships, which usually require the student to teach or conduct research, the main types of financial aid are—

1. Student loans—the number of low-interest student loans provided by the federal government has been sharply reduced, but a college or a private bank can still assist you in securing a loan;
2. Full or partial tuition waivers granted by the college—similar to scholarships;
3. College work-study assistance.

Work-study assistance is a program in which a college will pay you an hourly wage—higher for graduate students than for undergraduates—for working in a campus office or an approved off-campus agency. Sometimes coordinated by an urban corps office or a city-run cultural agency, these programs make it possible for students to be placed in jobs with nonprofit arts institutions or agencies, thereby gaining valuable experience while working through college.

Of course, there is always the possibility of taking some other job to pay for your education. One comparatively painless way of doing this, especially if you're single, is to secure a live-in position as a domestic, which would

provide room and board as well as a small salary. Or you may decide to take a full-time job and study on a part-time basis. The important thing is to begin your studies. Even if you have sufficient resources for only the first year or the first semester, begin. Make a start. If you impress the faculty favorably and learn the ins and outs of securing financial assistance or finding employment, chances are good that you will find a way to continue.

Graduate Programs in Arts Management

The list of graduate programs in the Career Kit should enable you to select at least half a dozen to contact directly for more detailed information. The points to examine most closely when making your choice include—

1. The basic thrust of the program: for example, theatre management, community arts management, public policy and the arts, museum management, management of nonprofit institutions;
2. The amount of field work or internship opportunities offered—more is usually better; and
3. The number of arts-related courses—this means courses specially designed and taught for majors, as opposed to courses picked up from other departments, smorgasbord-style, in which you would find yourself in classrooms with economics, law, hospital administration, or other majors, being taught by instructors who have little or no interest and background in the arts.

Start there. Do *not* concern yourself initially with tuition cost or the location of the college. When you receive a full catalogue, look closely at the faculty, the course descriptions, and the internship sponsors. A sizable faculty, either full-time or adjunct, with professional arts credentials is a plus, as are internship opportunities with a wide range of off-campus professional arts institutions and performance companies of high reputation. Using this criteria, you will probably narrow your choices down to two or three programs. Then arrange for interviews with the program directors and apply, negotiating for the best financial assistance.

Bear in mind that new programs are developing every year, and existing ones may be discontinued or redesigned. Tuition rates also change with inflation. You may wish to consult the latest edition of *A Survey of Arts Administration Training in the United States and Canada,* prepared by the Center for Arts Administration, Graduate School of Business, University of Wisconsin at Madison and published by the American Council for the Arts, 570 Seventh Avenue, New York, NY 10018. This listing is updated periodically.

Internships and Apprenticeships

Many individuals, companies, and organizations in the arts and media field

are willing to take on interns or apprentices, even if they are not associated with college or training programs. There is nothing to prevent your approaching someone for whom you'd like to work and asking if they would accept you on this basis. Of course, you risk being used as a go-fer, and the experience you gain may be minimal. Internships offered through formal training programs have the advantage of providing supervision, utilizing only the most reputable organizations, and setting up guidelines that the organization must follow.

The list of internships and apprenticeships given in the Career Kit includes only formal, well-established, ongoing programs. The ideal situation is one that combines classroom learning with practical, on-the-job experience under the guidance of a recognized professional. As mentioned before, virtually all graduate arts management programs offer internships as part of their required course of study. But there are alternatives. Aside from the list in the Career Kit you may also want to consult the trade papers related to your field of interest— *Variety, Back Stage, Billboard, Business Screen,* to mention a few—in which you will find apprenticeships and similar opportunities advertised by both established and incipient organizations in the arts and media industry.

Workshops, Seminars, and Information Centers

There are literally hundreds of short-term training programs, workshops, seminars, conferences, and continuing-education opportunities related to arts and media management. Many of these are conducted annually by service organizations, associations, or colleges. Others are one-time programs presented to satisfy a need or to explore a trend. For example, Theatre Communications Group has sponsored a week-long conference on "Computers and the Arts," which resulted in a publication on the subject, and New York University has sponsored a three-day seminar on "The Arts and Cable Television." All such events are open to everyone on a first-come, first-served basis.

The Career Kit lists only established training programs that are offered yearly. Each is described briefly; but keep in mind that the focus for a session may change to accommodate new trends and developments. Also included in the Kit are the leading service organizations, which may not sponsor workshops but do publish newsletters and otherwise serve as excellent sources of information for the most recently announced special training opportunities.

☆ **4** ☆

Going after the Job

Ine of the greatest feelings in life results from being offered an attractive job unexpectedly. The phone rings, you're invited to lunch, the offer is made, and suddenly your career has taken a giddy turn upward. This scenario can happen, and, in fact, if you manage your career well, it *should* happen. Success, after all, means being in demand. However, this chapter assumes that you must take the more usual approach and conduct a job search. This will entail—

1. Assessing your qualifications
2. Networking
3. Checking out job listings, services, and agencies
4. Composing your resume(s)
5. Sending out broadcast letters or information releases
6. Conducting a direct-mail campaign
7. Going to interviews
8. Following up

Experts estimate that it takes one month of searching for each $10,000 in salary you wish to receive. Conservatively, you can plan on a three-month job search for a $30,000 position. If you are seeking a significant salary increase, hoping to make a career change, or dealing with unusual circumstances, the search will probably take longer. The message should be clear: Plan well in advance.

If you are graduating in June, your job search should be in full swing by January. If you realize there is no growth potential for you in your present theatre company or symphony orchestra, start your search at the beginning of the season so you can have another position waiting at the end of it. Put time on your side and avoid being forced into taking a job for purely economic reasons. Consider it this way: For every month you are not working, you are losing the equivalent of 8 percent of your salary. If you are in the $20,000 bracket, not working for two months represents a loss of about $3,000.

Assessing Your Qualifications

Perhaps the job seeker's most common mistake is to apply for the wrong

29

position: a job for which he or she is either under- or over-qualified. If you are not being invited for interviews or are being interviewed and not getting the offers, make a comparative study of your qualifications and the job descriptions. Ask yourself—honestly and realistically—if there are not noticeable gaps between your actual skills and those required in the job descriptions. Take a look at your competition—the people who *are* getting those jobs—and find out what their qualifications are. Ask your colleagues and, perhaps, a few of your former teachers to assess your chances for getting certain positions. You may not like everything you hear, but if there is a consensus of opinion among such people, you should reassess your immediate career goals. This will be far less damaging to your ego than a continuing series of turndowns.

No matter how you construct your resume, if you have never raised funds, no one will hire you to run a fundraising campaign. Face it and, perhaps, apply for a lesser job in the development office. On the other hand, perhaps you have been a successful fund raiser for the American Heart Association, but your first love is classical theatre and you apply for a lesser-paying position with a Shakespeare festival. The size of your current salary may discourage a potential employer from even inviting you for an interview. In that case the problem is easier to solve because it's a simple task to deemphasize accomplishment, but it's impossible, without lying, to fabricate accomplishment.

As you assess your qualifications, keep in mind that virtually every potential employer is looking for a specialist: a person with a particular mix of qualities and skills to fill a particular job. It's fine to be an all-around arts administrator, except that "all-aroundness" can seldom be marketed. Ideally each broadcast letter and resume that you send out should be tailored to fit a specific job opening. When this is not possible, your resumes should be targeted for such job categories as fundraising, marketing, or press relations, in each of which you may have employable skills. Write separate resumes to illustrate separate skills. You cannot be the answer to *all* the employer's prayers—only to one of them!

Your search may take many directions, but each must be clearly defined and focused. Always, however, honestly and carefully compare your abilities and accomplishments with the demands listed in a job description. If the match is good—and includes just enough challenge to give you incentive—then go after the interview. If not, be honest with yourself and keep searching.

Networking

In every cliché there is an element of truth. Take, for example, It's not what you know, but whom you know. If this were entirely true, both education and a systematic approach to a job search would be unnecessary. Yet it is undeniably true that your professional and personal contacts can often help in building your career. It has been said that the only times you should let

everyone know your problems are when you're looking for an apartment or a job.

Using the advice in this chapter, you can transform your skills and accomplishments into a resume or a broadcast letter that invites interest. But such tools will still be only impersonal pieces of paper. They can never be as powerful as—or open as many doors as—a recommendation from a well-connected professional associate or personal friend.

Networking, in the broadest sense, is the sharing of ideas, interests, and solutions. Every profession uses networking. It is the oral tradition that complements methodology and practice. In the arts, networking is often used as the first means of job recruitment. If a museum is looking for a new public relations director, the executive director will call friends at other museums and arts organizations for suggestions. After a formal job advertising campaign, the executive director will again call contacts who may know the applicants under consideration. For these reasons networking—or the development of personal contacts—is crucial to a successful career. This is especially true in the professional arts world, which is a comparatively small and close-knit community of colleagues.

How do you get plugged into the network? Begin when you're in school. Your professors almost certainly will have contacts in the field, especially if they supervise internships or field work or serve as consultants to professional organizations. Tell them about your career plans; ask for advice and suggestions about possible job openings; give them updated copies of your resume. Teachers are always interested in the growth and development of their students. College professors receive numerous announcements about job openings and are usually delighted to make referrals. They may also offer objective advice, which can be difficult to get from other people. Because you spent a lot of time and money on your college education, it would be foolish not to continue taking advantage of that network of information, no matter how long ago you graduated.

Classmates should also become a part of your network. The so-called old-boy network, or clubism, has worked for centuries for the alumni of the Ivy League schools. It is now common practice for graduates of arts administration programs to use the academic network to enter the work force. Make it your business to obtain the names and current positions of other graduates from your college program and to contact those who may be helpful—even if you've never met. Just mentioning that you are a fellow alumnus should always get you in the door. Alumni associations, women's groups, college affiliate groups, and others are composed of working professionals. Join them!

Visit the professional arts organizations in your community and try to become acquainted with their managers. The typical arts management career includes numerous positions in different cities. The general manager of the local ballet company may be on the other side of the continent running an arts center in a few years—just when you're applying for a job there!

Start a name and address file immediately and continue to augment and update it. Make brief notes next to each name—especially for those people whom you rarely see—including spouse's name, birthdays, where you met, and other personal notes that you may use when you next meet. Such a resource is literally worth its weight in gold when you're job hunting or when *you're* in a position to hire someone yourself.

An effective professional network requires constant care and feeding. Bear in mind the following:

1. Don't make unreasonable or overly frequent demands upon your contacts, however well you may know them.
2. One good turn deserves another; reciprocate!
3. Maintain your reputation by keeping your contacts informed about your abilities and accomplishments.
4. Treat any recommendation, lead, or job offer very seriously; it represents a large professional favor.
5. Do not pursue offers that don't interest you. This infuriates people who have spent time promoting or interviewing you.
6. Thank your contacts for leads and suggestions and keep them informed about your progress.

Sad to say, the level of courtesy these days is very low. Few people bother to say thank you or to keep in touch with former friends and associates except when they need a favor. Why not increase your visibility, maintain your reputation, and demonstrate your integrity by becoming the exception to this unfortunate norm? Quick phone calls to congratulate other people on their accomplishments, short notes, or even greeting cards are sound investments in your future. Don't overdo the amenities, but don't forget them either.

The Courtesy Contact Merry-Go-Round

Now, having stressed the importance of using a personal network when looking for a job, we must add a warning about certain dangers and delusions inherent in this approach. Networking can easily become a dead end and a time-waster.

For example, your father, Aunt Tilly, or best friend knows the chairperson of the board of the local ballet company or of Warner Communications or of whatever. You let it be known that you're looking for job, and so your contact mentions your name to that chairperson, who agrees to see you as a favor. You arrange an interview and are given the royal treatment: a private meeting in a plush office, coffee, polite questions, and interesting advice. Then you're informed that there are no openings at the moment. At best, this influential chairperson may arrange for you to meet one of his or her influential colleagues, merely to avoid sending you away empty-handed. You are thereby deluded into thinking that you're making progress when, actually, you're

being treated little better than a party favor.

The next week you have another "noninterview." It is just another courtesy extended as a favor to someone else. But because you're being ushered into the most important executive offices in town, you are lulled into a false sense of hope for imminent employment; therefore, you neglect sending out resumes and broadcast letters and checking the want ads.

How can you recognize the difference between a meaningful contact and the beginning of the courtesy contact merry-go-round? Ask yourself:

> Am I even remotely qualified for a job with this organization?
> Do I want to work with this organization?
> Is this person in a position to recommend me for a job?
> Is this the best time to exploit this contact?

If your answer to any of these is no, you could be headed for disappointment. Yet meetings with celebrities and VIPs are always difficult to turn down. Go ahead, but keep your expectations very low and your questions very specific. Ask the VIP to arrange for you to meet someone lower down on the staff, someone who supervises an area or department in which you have employable skills. Ask—though the VIP may not even know—what specific openings exist within the organization. Think about the VIP's likely contacts in the profession at large and ask for a specific referral to a company or person for whom you'd like to work. Be appreciative of the VIP's time, show your seriousness by being informed and prepared, but don't grovel or appear foolishly impressed. Compliment the VIP by questioning and by listening intently as opposed to talking. If you manage to present yourself as bright and capable, the VIP may well take an interest in you and make a serious effort to promote your career. For many VIPs who can boast high salary, position, and achievement, helping others on the way up may provide a special satisfaction. Other VIPs may get their kicks from boasting and showing off—you must learn early to be a good judge of ego and character.

Consulting Job Listings, Services, and Agencies

There are over thirty thousand nonprofit arts organizations in the United States and Canada and thousands more in the commercial sector. Many of these have a constantly changing staff; new companies are formed every day; new projects that require new leadership and staff are organized. How do you find out about them? The most popular method of learning about job openings is through printed job announcements and placement listings. These may appear in the classified section of newspapers, in trade magazines, in professional association newsletters, in direct-mail announcements, or on the bulletin board in your office or dormitory.

Study the list of professional associations in the Career Kit and join the ones

that are appropriate for you. Most national associations have regional and state chapters, and membership includes a subscription to a newsletter that may list job openings. Many such associations operate a job referral or placement service. Most also run an annual conference and offer workshops and seminars. If there is a guest speaker or another member of the association whom you'd like to meet, mail a short note to that person a few weeks prior to the event. Explain that you'll be at the conference and would like a few minutes of his or her time. Don't include your resume, and don't mention that you're looking for a job. Just introduce yourself casually. When you meet in person, the other party will almost certainly remember you and feel sufficiently complimented by your note to give you some time, if not a few job tips as well.

If you're interested in a job in the commercial sector, check out the trade papers on a regular basis. Those of primary importance are listed in the Career Kit. In addition to the professional associations that offer job listings and placement services, your college or university may also operate career counseling and/or placement services, often at no charge to you or your next employer.

An employment agency, on the other hand, receives a fee based on a stipulated percentage of the first year's salary, provided that the person recommended by the agency is hired. Sometimes this fee is split, part being paid by the employer and part by the employee. There are thousands of employment agencies across the country; every city has a few. Some specialize in a particular industry, such as data processing or insurance, and some in a particular profession, such as accounting. Others are general agencies, which handle jobs in any profession or industry. But few except for the largest arts and media organizations are likely to list positions with such agencies. For one thing, the nonprofit groups can't afford—or prefer to avoid—paying the required fees, and, for another, job advertising through professional associations and direct mail is the standard practice in this industry.

Getting a job through an agency may offer certain drawbacks. Remember that an agency only makes money if it places you. Thus, it is less interested in finding a job that suits you than in simply getting you *any* job. If you receive many calls and interviews through an employment agency, be very definite about defining your job objectives to each prospective employer. You must realize that an agency may circulate your resume all over town, making it difficult or redundant for you to conduct your own job campaign and making it dangerous if your present employer doesn't know that you're looking. And be certain that you register only with reputable agencies. Each state has a chapter of the National Employment Association that will provide you with a listing of the approved employment agencies in your area.

Search firms are agencies that are retained by a company on an exclusive basis to find qualified candidates. Their fees are higher than employment agency fees, generally 25 percent to 35 percent of the first year's salary plus

expenses. Such firms are often called "recruiters" or "head hunters" because they call on successful working professionals and attempt to entice them into changing jobs. They are most often interested in senior management personnel. If you fall into that category, you may consider sending your resume to a search firm. This may not bring immediate results, but someday you may get a call.

The larger orchestras, arts centers, museums, and media companies use executive recruiters and search firms to fill upper-level positions. Try to establish relationships with the firms you have identified as being potentially helpful to you at some point in your career. If you receive an inquiry from a recruiter—either unsolicited or as a result of your own efforts—treat the contact as you would any job interview. Arrange a personal interview, even if the present job opening does not interest you, and establish a rapport with the recruiter, who should then become part of your network.

Tarnow International in Springfield, New Jersey has an arts entertainment division that fills senior level management positions for major arts and major non-profit and commercial companies. Other executive search firms also do some work with cultural institutions. Some arts management consulting firms working in the non-profit sector - such as Ampersand in Winston-Salem, North Carolina and Management Consultant for the Arts in Greenwich, Connecticut, also provide executive search for their clients. Opportunity Resources for the Arts, Inc. in New York City, a non-profit search firm represents non-profit cultural institutions exclusively. It handles openings for top positions and upper level management jobs. OR also offers seminars in career development (see the Career Kit).

Composing Your Resume(s)

When searching for a job, your first goal should be a personal interview. You must sell yourself during this interview. While a resume will almost certainly be requested at some time, the resume alone will not get you a job.

1. A resume has no intrinsic value, no magical power—you and you alone are the living document.
2. A resume is as likely to lose you an interview as to get one for you.
3. A resume can easily become an unnecessary crutch during an interview.

There are a lot of myths surrounding the importance of resumes, and there are many contrasting views about how to write one. Because a resume reflects an individual, no single model or method can be right for everyone. Your resume is about you, and, following some general guidelines, you must write it. Certain resumes serve as a curriculum vitae or vita, which presents a

straightforward statement of a person's educational and professional credits. The primary function is to provide information required for, among other things, personnel and promotion files for employees, biographical listings, or obituaries. The resume that is sent out as part of a job search, however, should be written quite differently. It must be a sales pitch.

Just for a moment compare your resume to an advertising supplement like that found in a Sunday newspaper. The purpose of the supplement is simple—to get the customer to phone the store and order the advertised merchandise, or, better still, to visit the store and buy other items as well. Because these advertising enclosures are expensive, they must be concise. Choices about the content, format, and layout must be made carefully in order to project the correct image. Also, the places in which the supplement will appear are chosen based on marketing research, with different products and copy presented in different publications—in New York City, for example, more expensive merchandise may appear in the *Times*, records and clothing in the *Daily News*.

Now consider your resume. Its purpose is to get you a personal interview. To the reader the format, style, and copy represent your image. The content should be designed with specific markets, or employers, in mind and must be based on logical criteria.

A resume will get you an interview only if it contains information about your experience and accomplishments that an employer thinks will be useful to his or her organization. It should project an image of you that fits the image of the organization. Therefore, your resume must clearly delineate experience, education, and training relevant to the job opening and to the organization. Remember that it is a sales pitch, an advertisement, for a *specific* set of your skills—one ad cannot promote everything in a department store! Be selective, and, based on your research about the job and the organization, target the content of your resume as directly as possible.

Chart 2

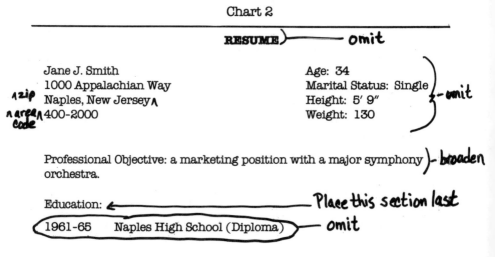

RESUME ⟩———— omit

Jane J. Smith
1000 Appalachian Way
↑zip Naples, New Jersey ∧
∧ area ∧400-2000
code

Age: 34
Marital Status: Single
Height: 5′ 9″
Weight: 130
⟩— omit

Professional Objective: a marketing position with a major symphony ⟩— broaden
orchestra.

Education: ⟵———————————— Place this section last

⟨1961-65 Naples High School (Diploma)⟩ — omit

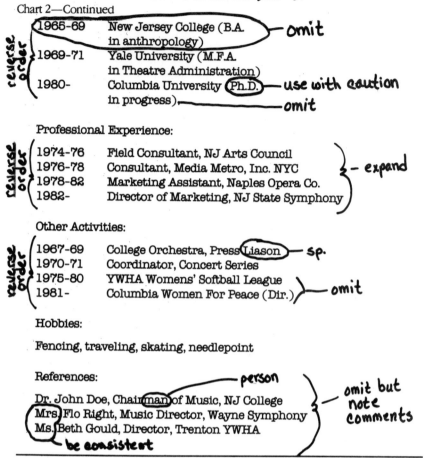

Chart 2—Continued

1965-69	New Jersey College (B.A. in anthropology)	— omit
1969-71	Yale University (M.F.A. in Theatre Administration)	reverse order
1980-	Columbia University (Ph.D. in progress)	— use with caution — omit

Professional Experience:

1974-76	Field Consultant, NJ Arts Council
1976-78	Consultant, Media Metro, Inc. NYC
1978-82	Marketing Assistant, Naples Opera Co.
1982-	Director of Marketing, NJ State Symphony

— expand (reverse order)

Other Activities:

1967-69	College Orchestra, Press Liason — sp.
1970-71	Coordinator, Concert Series
1975-80	YWHA Womens' Softball League
1981-	Columbia Women For Peace (Dir.) — omit

(reverse order)

Hobbies:

Fencing, traveling, skating, needlepoint

References: — person

Dr. John Doe, Chairman of Music, NJ College
Mrs. Flo Right, Music Director, Wayne Symphony
Ms. Beth Gould, Director, Trenton YWHA

— be consistent

— omit but note comments

Look at the fictitious resume for Jane J. Smith (Chart 2) and notice the corrections. She has apparently made every mistake possible; yet, ask yourself how many similar mistakes appear on your current resume. Now let's reconstruct Ms. Smith's resume.

From the Top
Why bother to head your resume with the word "resume"? Your covering letter has already mentioned what's enclosed, and if the person reading the resume can't tell by the format what it is, we recommend that you don't apply for the job!

Personal Information
List your full name, home address—mailing address, if different—and telephone number: Don't forget your zip code and telephone area code. If you

are not easily reached at your home telephone number, give a number where a message can be left or consider using an answering service during your job search and list that number. If you are employed and your present employer doesn't know you're looking for another position, do not include your business address or telephone number.

Do not include your age, height, weight, sex, marital status, number of dependents, or ethnic origin. It is illegal for an employer to make any hiring decisions based on these factors, and they may very well be used to your disadvantage. For example, if you are married and have three children, a prospective employer may assume that you can't afford to take a particular job because it won't pay enough to support your family. But that is for you to decide after the interview, the offer, and salary negotiations. You are usually in competition with many other qualified applicants, and a beleaguered employer may grasp at any criteria for limiting the number of applicants.

Do not include a photograph with your resume or have one superimposed upon it.

Job Category, Objective, Career Goal

Some resumes show a job category directly below the person's name, such as "general manager" or "press agent." Others give a brief description, in capsule form, of the person's employment or career goal. Both invite the quick disposal of the resume into the wastebasket. Unless, that is, the career goal has been written as a carbon copy of the job description. This may be fine for individually prepared resumes, but it is not advised for a general resume. It is simply too easy to unwittingly disqualify yourself from a potential job. For example, Ms. Smith states that her objective is "a marketing position with a major symphony orchestra." By doing this she disqualifies herself from work with presenting organizations, theatres, arts councils, recording companies, and television stations; and she may be soft-pedaling her skills in public relations and promotion. Employers are usually swamped with resumes and look for any reason to reject as many as possible. If, however, you feel compelled to give a career objective, keep it broad, avoid flowery language and hyperbole, and write something like this:

> To apply and build on my ten years of experience in the not-for-profit arts field through a challenging leadership position with a major arts organization.

Yet, why fall into the trap that ensnares so many actors by "typecasting" yourself?

Education

For job openings in which your education may be of paramount importance—academic and arts council positions, for instance—place these credits next. Otherwise, lead off with your professional experience. If your major areas of study make sense in relation to the job you're seeking, mention them. If they don't, simply name the degrees you received.

When listing your educational credits—and any others—always arrange the items in reverse chronological order, beginning with the most recent. If you don't wish your age known, omit graduation dates. Do not include your grade-point-average or class standing, although you may indicate "cum laude" or "summa cum laude." Then follow your college degrees with relevant seminars and workshops. Leave out the names of your high school, grammar school, summer camp, and flying school.

A word about Ph.D. degrees. They are very valuable and often necessary for college, arts council, and museum positions. But sometimes there is a backlash against a doctoral degree. Even though you worked very hard for that Ph.D., consider omitting it from your resume if it is not required within the job market of your choice. Also, avoid placing the words "in progress" after a degree. This may cause the employer to wonder, How can Ms. Smith work for me and complete her degree at the same time?

Professional Experience and Employment History

This is by far the most important section of your resume and requires the greatest attention. It will tell the employer how suitable you are for the job opening—providing, that is, that you *sell* it as well as tell it. Think again about that newspaper ad. Simply to state "Field consultant, New Jersey Arts Council" is comparable to simply stating the name of a product. It may be fine if the ingredients and qualities of the product are so well known that their praises need not be sung. But are your qualities that well known? If not, you must list not only your current and former positions, you must also define them and praise them. Define them by stating the responsibilities. Praise them by stating your accomplishments.

You may select from a variety of formats for this section of your resume. The most common is a chronological listing, in reverse order, of paid positions, titles, organizations worked for, and dates of employment. Remember to underscore, italicize, or otherwise set off the job titles so that they are easily seen and understood. For organizations not commonly known, include a short description. Two examples in different formats:

9/82– present VICE-PRESIDENT, Ampersand, Inc.
 (A commercial consulting firm for
 the performing arts)

EXECUTIVE DIRECTOR, Grand Opera House, 9/82–present
 (A multi-arts presenting
 organization in Wilmington, DE)

The second format is preferable because it emphasizes the job rather than the dates.

After each of your most recent positions or after those you wish to highlight as most appropriate for a particular job, state your responsibilities and accomplishments. Herein lies your sales pitch. Keep in mind that an employer

wants to see success and results and wants to believe that you will earn your salary many times over!

After listing your title in a former job, briefly describe your responsibilites. Be honest and to the point. Then sell yourself with a powerfully worded description of your accomplishments in that job.

Instead of

> designed a subscription campaign for seven mainstage productions

aim for something like

> designed a subscription campaign that increased sales by 60% and the number of subscribers from 250 to 500

What if your campaign was a failure? Don't mention it! If you can't answer the question So what? after each accomplishment you list, leave it out. Perhaps you bought and set up a computer system for your film distribution company. Did it increase record-keeping accountability, save money, or increase rentals? Or was it a white elephant that eventually sat idle in the corner? Never mention a pet project that turned out to be a dud. If you're asked to talk about it at an interview, it will be painfully clear—at least to the employer—that you're a dud!

Refer to the jobs chapter in this book that best describes your specialization; read it to understand the skills and qualifications that are most sought after by employers. This will stimulate your memory and help in writing the descriptions of your own positions, responsibilities, and *accomplishments* in your resume. Again, we stress the importance of describing your accomplishments.

It is not enough to say that you were a program director for a community arts council, for example. You must be specific. Did you increase the number of performances? How many were there when you began, and how many when you left? Did you work within budget and, perhaps, even save your organization some money? How large a staff did you supervise? Did you develop innovative programming? You may be able to transform something as nondescript as this:

PROGRAM DIRECTOR, Amani Arts Council, 1979-81
Directed the performing arts series for community high schools, churches, and parks. Responsible for all arts activities throughout the county.

into this:

PROGRAM DIRECTOR, Amani Arts Council, 1979-81
As program director for the third-largest arts council in the state, I was responsible for—
- Programming sixty concerts per year that involved local talent, and booking professional stage performers and international talents, such as Peter Nero, Yehudi Menuhin, and Julian Bream
- Supervising a staff of three administrators, a staff of two technicians, and a volunteer support staff of fifteen

- Controlling an annual budget of $200,000

Selected accomplishments during my two years in the position:
- Formed a statewide booking consortium that reduced per-performance fees by 18%
- Remained $2,000 below budget for the first year and $4,000 below for the second year while increasing the performances by 50%
- Increased audiences by 60% through the use of public service announcements on radio and by writing and placing human interest stories in local newspapers
- Formed a standing committee of volunteers to assist in concert production and fundraising activities

You may not want to write such a detailed description for each job you've held, but when assembling your job history, you should document your responsibilities and accomplishments as fully as possible. Then select the best items for the *particular* resume you're writing. In fact, keeping a job history should be an ongoing activity. It's easier to keep a current file or record of your chores and achievements than it is to reconstruct events, facts, statistics, and dates after you've left a job. Ask yourself this: If your company folded, if you were laid off, or, heaven forbid, if you were fired tomorrow, how easily could you get the information you need to compile an effective new resume? Be on the safe side: Keep an updated file or diary and then, when the time comes, pick and choose the facts you need to impress a particular employer for a particular job.

Remember to be selective and to make your former positions sound as impressive as possible. Perhaps the program director described above also answered correspondence for the arts council president; took turns on the office switchboard; and hauled out the trash every day—these facts should not be included in a resume or mentioned in an interview.

The format for presenting the facts on your resume is not as important as the content. But do use short sentences and a staccato style to bombard a future employer with your accomplishments. You may indent and number the items or use asterisks, plus signs, or other symbols to facilitate readability. Three or four real accomplishments are more powerful than a rehash of your job description.

If your job history shows a logical progression from advertising director to marketing director to vice-president of marketing, for example, then your resume should be organized chronologically, listing the most recent position first. But not all careers move that logically. You may have worked as an artist before deciding to pursue an arts administration career, or you may have held a variety of jobs in the arts: performer, teacher, technician, and administrator. If this is the case, your professional experience should be organized using the functional resume format.

Instead of leading off with a statement about your career objectives, begin by summarizing your qualifications in the form of a preamble:

Qualifications: Ten years of successful marketing and promotion experience. Includes directing a national marketing campaign for a major book publisher, as well as sales and promotion for two nationally recognized arts institutions. Extensive experience in board committees, volunteerism, group sales, and direct mail.

This statement must attract attention and focus your skills in a specific direction. It should tie together pertinent experiences, however diverse, with a common thread. Follow your preamble with something like this:

Selected Accomplishments

- Increased profits for trade-paperback sales division through a direct-mail campaign. Reduced operating costs by 55% and increased volume by 80%.
- Designed an identifying look for a national opera company through logos, campaign copy, slogans; and redesigned brochures, programs, and posters. This campaign won a regional advertising award.
- Developed a direct-mail sales campaign for a cultural organization that netted $400,000 over three years and increased the donor list by 250,000.
- Led conferences, seminars, and workshops for management staffs on marketing an organization. Designed written materials for follow-up and practical applications.

This marketing specialist may have had little experience working directly with an arts organization, but the accomplishments are highlighted in such a manner that they may be attractive to such an organization. It could be that some of the accomplishments were achieved when the applicant was a board member, a special project director, or a consultant. That in no way diminishes their importance.

The accomplishments section in a functional resume is followed by a chronological work history. For example:

Work History:

1982–present	DIRECTOR OF MARKETING, Newton Books, Ltd., NYC
1978-1982	DIRECTOR OF MARKETING, Chicago Lyric Opera, IL
1975-1978	CONSULTANT, Media Metro, Inc., NYC
1973-1978	MARKETING ASSISTANT, New Haven Opera, CT
1972-1975	FIELD CONSULTANT, Connecticut Arts Council

The field consultant position may have been on a per diem basis, and the Media Metro position may have been a door-to-door salesperson for a cable television company. The functional format is designed to emphasize accomplishments rather than work history, an approach greatly to the advantage of many job hunters.

At this point in both a functional resume and a chronological resume, you

should list your educational credits if you did not list them above your work experience.

Other Activities
This section, like the others, should include only items that will strengthen your chances of getting an interview. List your professional affiliations and any offices you've held, but do not list fraternities, sororities, and other social, political, or religious affiliations. If you have served on boards for nonprofit or commercial organizations, list those here, as well as your service on panels and advisory boards. But keep this section brief, sensible, and to the point.

Hobbies and Extracurricular Activities
Here you may be tempted to list your professional or avocational experiences in the arts as a performer or in some other creative capacity. The slightest hint of an active artistic career in your resume will sound the death knell for an interview. And keep that type of activity out of your work experience section! An employer will immediately suspect that you would rather perform on stage, direct films, or whatever, than manage an office. Many competent arts administrators find it difficult to secure new positions because they insist on listing their performances, creative awards, and even reviews in their resumes.

As a rule, hobbies and other activities do not belong in a resume. If you happen to know that the museum director to whom you've applied for a job collects Italian wines, and you, too, are an oenophile, perhaps you should mention it. Otherwise, keep your personal interests out of your resume.

References
Many people list the names and addresses of references at the bottom of their resumes. But suppose your reference is a lifelong enemy of the person receiving your resume? Or perhaps the person you've listed is so well known in the field that everyone who receives your resume calls that reference? This may be so annoying that your "good reference" will start sounding less than complimentary about you when asked for an opinion for the umpteenth time.

Omit references on your resume. You may even omit the phrase "References furnished upon request." This is understood. So, if asked, be prepared to supply references. By the time you are asked, you should be able to identify someone who would be regarded favorably by your potential employer. During the interview you should also be able to sense which people or organizations the employer dislikes. It is permissible to ask if you may phone the employer's office the next day to provide reference names and phone numbers. This will give you an opportunity to select your references carefully and to prepare them in advance of their being contacted.

Gaps in Work History
There are many circumstances that can cause a gap in your work history:

pursuing an independent project, returning to school, having a baby. If the gaps are frequent, they may cause employers to think that you can't hold a job for very long. The functional resume format will help to minimize them, but you must be prepared to explain them during an interview.

Lying in Your Resume

If you left a job in June of 1980, traveled until March 1981, and began a new job in May, you could list your employment as follows:

> 1978-80 General Manager, XYZ Company
> 1981-82 General Manager, Opera, Inc.

There is a difference between this technique and lying about degrees, accomplishments, affiliations, and positions. If it is not found out immediately, your lie may be discovered at the interview or during a reference audit or even after you've been hired. Remember that you can only kill your reputation once!

Format

As with a newspaper advertisement, your resume must first invite someone to read it. The format should contain a generous amount of white space. It is better to use two pages than to overcrowd one page. The copy should read easily and never contain long paragraphs of wordy prose. Think of your resume as just one of several hundred that an employer receives—like one advertisement buried in that bulky Sunday newspaper. Use different type styles and sizes, and whatever else you can think of to invite the reader to read on.

Color, Size, and Type of Paper

A small, nonprofit arts organization—the kind that reuses old press releases as scrap paper to cut stationery costs—may easily be turned off by an expensive-looking resume. The organization may feel that you would be uncomfortable in such comparatively impecunious surroundings or that you're simply not very budget-conscious. However, if you're applying for a position as the corporate grants officer with a Fortune 500 company, you may want to use gray, 100 percent rag paper with a border around the text. In other words, base such choices upon the type of position and organization you're going after. But never use pink, dark brown, or other artsy paper or ink. They are distracting and appear juvenile—and they don't reproduce well on copy machines. You're safe with white, buff, or gray paper, and blue or black ink. Also, stay away from onionskin paper, glossy stock, or cardboard-weight paper, which doesn't fold well in an envelope. Use 8½" x 11" paper; legal size has a way of sticking out of files, and monarch size is unbusinesslike.

Typed, Typeset, or Photocopied

A resume typed on a high-quality electric typewriter is always perfectly acceptable. Using a dual-pitched machine with different elements can afford a

varied style and make the copy visually appealing. Or, you may use a word processor. You can then easily and inexpensively have the original version of the resume photocopied.

Typesetting is an expensive process and must be done by a professional. Typesetting will give you access to hundreds of different typefaces and can give a very polished look to your resume, but the big drawback, aside from the cost, is that your resume is then fixed in place; if you wish to alter it, you must begin the expensive and time-consuming task all over again. Furthermore, a typeset resume is usually reproduced by the hundreds, which indicates to a potential employer that it's being circulated from shore to shore.

Regardless of the format you select, make certain your resume is typed or set *perfectly*: no strikeovers, erasures, skipped spaces, wrong dates, or misspellings.

There is a story about a public relations director who, during a day of frustration over his job, typed a resume on the office word processor and had it delivered by a messenger to the city's leading search firm. The head hunter read the resume, circled "liason" in red, and had it returned to him by messenger. The next day a corrected resume arrived with a covering note that read, "I wrote the word 'liaison' two hundred times on the blackboard!"

Ask friends to proofread your resume before you send it out. Be consistent in style and spelling. *Nonprofit* is not hyphenated. *Liaison* has two *i*'s. *Commitment* has only one *t* in the middle. Your good shoes and interview outfit will remain unworn in your closet if you represent yourself with a sloppy or careless resume.

Now, let's return to Jane J. Smith and see what her resume looks like after the advice in this chapter (Chart 3). Notice how her new resume speaks specifically to an employer looking for a marketing expert—such an employer couldn't afford *not* to interview her—while the first Ms. Smith would have been thrown into the wastebasket!

Chart 3

JANE J. SMITH

1000 Appalachian Way	(500) 400-2000 (home)
Naples, NJ 50100	(500) 401-0002 (service)

Employment

1982-present

DIRECTOR OF MARKETING: New Jersey State Symphony Orchestra

Responsibilities
- Supervise a marketing staff of 3 people
- Plan all advertising and marketing campaigns

Chart 3—Continued

- Supervise an annual budget of $75,000
- Contract with and supervise graphics and advertising agencies
- Conduct market research and analyze results

Accomplishments
- Increased 1982 ticket sales by 50%
- Increased subscription sales in 1983 by 42%
- Planned, designed, and set up a symphony gift shop that netted $30,000 in concessionary revenue in 1983
- Designed and implemented a symphony gift catalogue (mailed to 75,000 annually) that netted $17,000 in 1983

1978-1982

MARKETING ASSISTANT:Naples Opera Company, NJ

Responsibilities
- Supervised season-ticket campaign
- Supervised an assistant and the box-office staff
- Accountable for all subscription income reports
- Designed and implemented all season-ticket brochures

Accomplishments
- Increased season ticket sales from 500 to 1200 annually
- Introduced new business systems that reduced staff by 30%
- Invested subscription income to increase interest by 6%
- Reduced brochure printing and design costs by $8,000 annually

1976-1978

CONSULTANT: Media Metro, Inc. NYC

1974-1976

FIELD CONSULTANT: New Jersey State Arts Council

Education
1972 M.F.A. Yale University (Theatre Administration)
1969 B.A. New Jersey College

Professional Affiliations

ACUCAA (Member and Marketing Workshop Coordinator)
American Association for Ethics in Advertising (Board Member)
American Symphony Orchestra League

The Covering Letter

After you have composed a focused, accomplishment-filled resume, or resumes, you are ready to respond to various job announcements and openings. This often entails mailing out your resume, in which case it must be accompanied by a covering letter. Write something brief and to the point.

> Dear Mr. Jones:
>
> I would like to be considered for the position of business manager for station WQUE-FM. As you can see from my enclosed resume, I have had seven years of experience in business and finance within the radio and television industry.
>
> I look forward to discussing this further with you and will phone your office next week. I hope that we can arrange a personal interview.
>
> Sincerely,

Use either your personal stationery or a simple bond paper and attach your resume to the letter. Do not use your present employer's stationery. It leads one to think, "If she's using her present employer's paper to get a new job, she may do the same when she's working for me." Also, think of the embarrassment if the application is for some reason returned to sender.

The Broadcast Letter:
An Alternative to Resumes

A broadcast letter differs from a covering letter in that it is not accompanied by a resume. It can be used when seeking a specific job, or a number of different jobs in the same category. It can also be mailed blind to a large number of employers. If a resume can be compared to a newspaper advertisement, a broadcast letter can be compared to the direct-mail approach for soliciting magazine subscriptions. You know the tactic: A personalized letter is sent that introduces you to the contents and style of a magazine, inviting you to sample it. You don't receive a copy of the magazine, just a point-by-point description. The pitch usually begins something like this:

> Because you are a person who enjoys the great outdoors, we think you should know about the advantages of reading *Outdoor Life.*

It then goes on, in telegraph style, to itemize the benefits of the magazine and closes by inviting you to sample a copy in your home.

The broadcast letter is based on the same principle and is written in the same style. Your opening sentence responds directly to the precise requirements of the job sought:

> Because you are looking for a marketing director with several years experience in the performing arts, you will be interested in my accomplishments. For instance, as marketing director for the San Diego Opera, I have:

Then go on to list, in short sentences or in bullet form, five or six accomplishments that also respond to the requirements of the position. *Limit the accomplishments you list to those.* You may, however, include a sentence about your education if it is relevant to the position. Finally, stress your desire for a personal interview. You may even take the initiative and state that you will phone the following week to arrange an appointment.

Each letter of this type will be different. Each will respond specifically to the qualifications requested by the job description, making it virtually impossible for the employer *not* to interview you. In fact, because so few applicants take the trouble to write a broadcast letter, your application may stand out above all others—even without a resume! Chart 4 provides a detailed illustration of how this approach works.

Chart 4

Broadcast Letter

JOB OPENING: Music Program Director for a state arts council. To direct music programming activities for the state. Includes providing technical advice on concert setups. evaluating grant requests, working with sponsors and performers, representing and articulating the music policies of the council to its constituents. B.A. required, advanced degree preferred.

Your response should be as follows:

Dear ———:

Because your job listing for a Music Program Director appears to describe a specialist with my exact qualifications, I believe that I may be the person you are looking for.

As concert chairperson for State College and manager of a contemporary string ensemble, I have—

· Insured smooth technical operations for a sixty-concert annual schedule by personally overseeing backstage operations;

· Evaulated booking requests, negotiated artists' contracts, and participated in consortium-booking arrangements, totaling over $600,000 of bookings per year;

· Established a record of excellence for sponsorship, recognized by an annual ACUCAA award; and

· Led workshops and seminars on music programming and spoken frequently as a representative of State College and the community arts council.

I hold a B.A. in music and an M.F.A. in arts administration from State University.

Because I am frequently out of my office due to the requirements of my present position, I will phone your secretary next week to arrange an interview at your earliest convenience.

Sincerely,

The broadcast letter should not include classes you taught, ensembles you conducted, committees you served on, or any other activities not directly related to that job description. If you are requested to mail in your resume, ask if you may bring it to the interview and discuss it in person. Remember that your first objective is to get that interview, and if an employer shows interest in you based on your broadcast letter, seeing your resume should wait until you meet in person. Use every possible tactic, without, of course, seeming difficult or rude, to secure the interview without using a resume. Once you have your foot in the door, you'll be able to explain your resume and answer any questions the employer may have about it.

Third-Party Letters

Some employers are lazy about checking references. If you are being considered for a particular job, you may want to ask a former colleague, teacher, or friend to write a reference letter on your behalf. Naturally, you must be certain that the person will sing your praises. And, of course, such letters are always more effective if they're written by someone who knows or is known by the employer.

The third-party letter can also serve another function: It can help you search for a job in secret! If you don't want your current boss to know that you're looking—not an unusual situation—ask a friend or colleague, not someone else in your own office, to write a broadcast letter for you. It should begin something like this:

Dear ———:

It has recently come to my attention that an acquaintance [former student, former employee, colleague] of mine is seeking a challenging new job in the marketing field. This person's accomplishments include:

Continue with the list of accomplishments from your own broadcast letter, rewritten in the third-person singular. Then the third party concludes.

If these qualifications interest you, and I believe they will, please contact me, and I will arrange for you to meet this promising marketing expert in person.

Sincerely,

The employer may be more intrigued by this approach than by receiving your own broadcast letter, and you may get an interview. It may also be a good

method to use if you're responding to a job listing that omits the name of the employing organization—it could be your own!

The Information Release: Another Alternative

If you are looking for a bolder method for getting the attention of employers—one that is more aggressive than either a resume or a broadcast letter—consider sending out an information release (Chart 5). This is designed to resemble a press release, except that rather than promoting an event or an organization, it promotes you!

Chart 5

INFORMATION RELEASE: From: Jane J. Smith
 1000 Appalacian Way
 Naples, NJ 50100
 (500) 400-2000
 [date]

Successful Marketing Expert Seeks New Challenge in The Arts Field

Jane J. Smith, presently the Director of Marketing for the New Jersey State Symphony Orchestra, has announced that she will leave that organization upon the completion of her contract this season. "While my three years with the symphony have been mutually beneficial," says Smith, "the time is ripe for me to apply my skills to a larger or more diversified arts enterprise."

The marketing department at the State Symphony plans and executes all promotion, advertising, and marketing campaigns for the organization and has an annual budget of $75,000. During her tenure there, Ms. Smith has increased ticket sales by 50 percent; increased subscription sales by 42 percent; designed and established a symphony gift shop that nets in excess of $30,000 annually; and designed and implemented a symphony gift catalogue that nets in excess of $17,000 annually.

Prior to her present position, Jane J. Smith was the Marketing Assistant at the Naples Opera Company in New Jersey, where she supervised the season ticket campaign, managed the box office, and designed all season ticket brochures. Among her accomplishments were an increase in ticket sales from 500 to 1,200 annually, and reductions in staff and printing costs.

Ms. Smith holds a B.A. from New Jersey College and an M.F.A. in theatre administration from Yale; she has also gained experience with the New Jersey State Arts Council and in the field of commercial television. Arts organizations seeking aggressive, imaginative, and proven solutions to their marketing and promotion needs will undoubtedly arrange to interview Jane J. Smith.

—(500) 400-2000—

An information release should summarize the job responsibilities and accomplishments that are most appropriate for the type of new position you're seeking. You may also quote yourself and include a few words about your education and other salient matters. There is, of course, something a little tongue in cheek about this device, but that may work to your advantage by showing that you have a sense of humor. For the moment, at least, this is a very new device, but it has been tested successfully by a few individuals who have courageously taken our advice. It is particularly appropriate if you are seeking a job in the marketing and/or promotion area, because it can demonstrate your writing and selling skills. Yet it has also worked effectively for artists' representatives and even for artists themselves. If it seems like an appropriate device for you, you should easily be able to adapt Jane J. Smith's information release to suit your own purposes.

Conducting a Direct-Mail Campaign

While there are usually hundreds of arts management openings being announced or advertised at any given time, there are even more that are not widely publicized. Some perhaps have been open and unfilled for many months, while others are just being contemplated by an employer. This vast, unknown job market can be tapped by means of your own direct-mail campaign.

The strategy here is to target your market and saturate it. Begin with an honest self-evaluation of your skills and interests. What do you do best and what do you like doing best? What sector of the industry could best use someone with your qualifications? What particular type of position are you most qualified to hold?

Now compose a resume, broadcast letter, or information release similar to the sample given for Jane J. Smith. Because this is a general mailing aimed at unknown positions, the content cannot be targeted as specifically as you would like. Nonetheless, limit the content to a specific job category. Use business-size stationery and envelopes, and don't forget to include your full address and phone number on the letterhead! It's amazing how many people merely print an address on the envelope, which gets discarded, and don't think to put it on the letter or even on the resume itself. And be certain, too, that your full name appears typewritten below your signature; nobody will phone you if they can't decipher your name.

Because office addressess and the names of managers and directors are always changing, compile your mailing list from the most recent information available. Go to the library and consult the annual directories for the professional organizations in your field of interest; or you can purchase such lists from professional associations. Mail your letters to the chief management person in the organization—unless that's the position you're after yourself, in which case write to the chairperson or president of the board. Although such

names are public information, you may not be able to obtain private or personal business addresses for them. If you cannot, mail the letter to the organization and mark it "personal."

If you have access to a word processor, you'll be able to personally address each letter on your list. Otherwise, if the mailing is a large one, the salutation "Dear Sir or Madam" will have to suffice.

Interviewing

Your first contact for an interview in response to your resume, broadcast letter, or information release will probably come through a phone call from the manager, director, staff person, or from the member of the search committee who will be interviewing you. This initial contact is very important in establishing a good impression of yourself. If you happen to be in the middle of a party; if you have just awakened; or if you are preoccupied in any way, avoid a lengthy conversation and ask if you may call back. If you use a telephone answering machine, be certain that the message you record is simple and straightforward during periods when you're conducting a job search. Many people find background music and cute messages to be offensive. If you answer the phone yourself and the caller wishes to conduct a telephone interview, exercise caution. This technique is only used to prescreen applicants in order to eliminate as many as possible. You will never get a job offer through a phone call alone. If the caller insists on this procedure, which is common if you live in another city, try to schedule the call for the best time possible. Then prepare as you would for a personal interview. During the call try to secure a personal interview. Don't offer to send additional information, and don't answer questions about salary.

Should you be invited to travel to another city for an interview, clear up the question of reimbursement right then. Such reimbursement is standard. Reach an understanding on costs for travel, meals, and lodging. Confirm this in a short letter, summarizing the conversation and the reimbursement agreement. This is appreciated by professionally run organizations. If the organization hesitates to pay your expenses, it may indicate that its interest in you is lukewarm at best. Try at least to obtain partial travel coverage. Rarely should you assume all expenses yourself.

Be Prepared

Preparedness is a concrete and demonstrable way to impress your potential boss. It says—

1. You really care about the organization and the job.
2. You are inventive and intelligent enough to research the organization.
3. You are industrious and can work on your own.

When you set up the interview by phone, ask the caller to send you a press kit, the latest annual report, a foundation proposal, some reviews, old programs, catalogues, and anything else that may be helpful. What you cannot get in this manner, get from the library. You can acquire information on nonprofit organizations from the National Endowment for the Arts and/or the National Endowment for the Humanities, or from the appropriate state arts council. Most of the information held by such government agencies must, by law, be made available to anyone who requests it.

Find out about the organization through your own network. Perhaps an actor friend has worked at that theatre or a former classmate is now living in that city. Construct a profile of the organization:

Size, scope, point of view, artistic mission

Financial situation: earned and unearned income, audience size, long-term debt

Type of community: cost of living, other cultural and entertainment outlets, climate, economy

Board members: names and occupations

Size of staff and staff turnover

Reputation in the community and the profession

Personal traits and habits of the person(s) who will be interviewing you

Organize a set of notes, including questions you wish to ask, and bring it to the interview. You may refer to the notes, further illustrating your preparedness. This should relieve any nervousness you feel by giving you something specific to talk about.

Punctuality

Make every possible effort to be on time. Allow time for traffic jams, subway breakdowns, and wrong directions. It's much better to sit in a nearby coffee shop for an hour before your appointment than to sit in downtown traffic for an hour after missing it. However, should you be late, apologize quickly and forget it.

What to Wear

Always dress for an interview in a manner that most closely suits the image of the organization. You should certainly know enough about your prospective place of employment to know if its executives wear standard business attire or jeans. Generally, however, it is better to overdress rather than dress down. Always appear neat and clean. And avoid flamboyance and eccentricity, which may work in favor of performers at auditions, but seldom for managers at interviews.

Beginning the Interview

Start with a firm handshake and a smile and establish eye contact. Then survey the room with a quick glance. Avoid—

1. Being seated on an overstuffed chair or sofa; this will probably place you physically below the interviewer's eye level, making you feel subservient rather than equal;
2. Having the light from a window or lamp shining in your face; or
3. Accepting refreshments, especially of an alcoholic nature; being made to feel too much at home can easily put you off guard.

If the interviewer is holding your resume and has focused attention on it, you're in trouble. Get the interviewer to react to *you*, not to your resume. Take command and win the person over. Say something like, "Yes, I can tell you much more about that in my own words," or "My resume just touches on the things I accomplished in that position."

If you find yourself in a situation in which the interviewer is constantly being interrupted by phone calls, colleagues, or secretaries, ask whether it would be more convenient if you were to return later in the day. The interviewer will usually get the hint and pay attention to you and respect you a little more. The same tactfulness should also be displayed when you encounter a person who is obviously feeling ill or otherwise out of sorts. Remember that everyone has bad days. If both parties at the interview aren't having good days, the conversation should be postponed.

Focus

You will meet a number of interviewers who are unprepared or who are distracted by the events of the day, or who have misplaced your letter or resume, forgotten your name, or even forgotten the reason you're standing in front of them! Always greet the person by stating your full name, even if you're meeting for the second or third time. If he or she doesn't seem to light up with your reason for being there, find a casual way to refresh the person's memory. Then ask questions and get the interviewer to do most of the talking. Use your prepared notes and keep the focus on the job area in question. For instance, "I notice that your federal grants account for 30 percent of your total income. What are your plans against anticipated reductions?" or, "How have you achieved such a large membership compared to the other museums in the city?"

As for yourself, you must be prepared to answer the following questions:

What can you tell us about yourself?
Why would you want a job like this?
Why would you leave your present job?
Where do you see yourself five years from now?

Mold your answers so they touch on important and salient points related to the job opening. Don't wander from the subject or offer extraneous information. Above all, don't ask questions about salary, benefits, and vacations. These are inappropriate at this time.

Among the questions you should be prepared *not* to answer are:

How much are you making at present?

What do you think is a fair salary for this job?

How much do you need to earn?

You can easily parry such questions by saying, "Although I expect to be paid what I'm worth, money isn't my biggest concern at this point," or "I'd rather not discuss salary until you have a clear picture of what I can do for you." Only talk about compensation after an offer has been made. At that point you will know the employer wants what you've got, and you can negotiate from a position of strength.

More Don'ts

Don't try to solve the problems of the organization. It's presumptuous to believe that in one hour you can come up with a solution to a problem that the management has been grappling with for two years. Offer opinions if requested to, but don't be dogmatic or glib.

Don't name-drop. It won't impress any secure person and will only serve to expose your own insecurities. Besides, not everybody is loved in this business, and name-dropping can easily backfire.

Don't argue with the interviewer. You can never win. Don't gossip about or bad-mouth anyone or any organization. Never discuss your personal life except in the most general terms, and never talk religion or politics.

You may be asked to talk about your weaknesses and bad points. Minimize these by phrasing them in positive terms: "I'm sometimes too hard on myself," or "I have a tendency to let my work consume my personal life."

Don't linger after the interview is concluded; don't overstay your welcome.

If an offer is made, you may be wise not to accept it immediately—unless it comes at the end of several interviews and some honest soul-searching, and with a clear understanding on both sides regarding the terms of your contract. The job offer places you in a strong position and you should take advantage of it. You may, for example, wish to give your present employer the opportunity to make a counter-offer. Or perhaps you interviewed for another, more desirable position and can now use the concrete offer to elicit the offer you would prefer. If you are reasonably certain that you will accept the job, you may give a conditional yes when the offer is made, subject to mutual agreement of terms once they have been put into writing.

At the end of the interview, thank the interviewer, express again your interest in the job, and leave on a positive note with a second firm handshake.

Following Up

Immediately after your interview, write a short follow-up note that restates salient points made at the interview, adds information you forgot to mention, confirms your interest in the position, and thanks the interviewer. Don't be apologetic, overly thankful, effusive, or sentimental. Keep the note businesslike, polite, and brief without being curt.

If the interviewer is an easily accessible person, you can also follow up with a phone call to keep in direct contact—not with a secretary, but with the boss. Call with the information on references; call to provide other information you might have promised during the interview. Don't be a pest, but do be aware that many job seekers have beat out their competition by showing the greatest interest and enthusiasm for a position.

This is also the time to ask for a few friends and colleagues who are known by the interviewer to phone or write on your behalf.

Second Interviews

When the position is an important one, you may be called back to meet other management leaders in the organization. While this indicates you are even closer to an actual offer, take the following advice:

1. If you've decided after the first interview not to take the job, save everyone's time and decline it right then.
2. Demonstrate at the second interview that you've done further research and thinking about the organization and its leaders since the time of your first interview.
3. Without seeming overly self-confident, allow yourself to relax a little, to smile more, and to otherwise show that you'd make a good team player. Remember that a first interview is likely to concentrate on your professional skills and qualifications, whereas the second interview is often requested in order to take a closer look at you as a person.
4. Be wary of multiple interviews. They could be a sign that the organization doesn't know what it's looking for and is really using these interviews to get free advice.

Everything Is Negotiable

If you have researched the position and know the field, you should have an idea about the salary that will be offered. Let's say that the job is listed at $18,000 to $25,000. The organization will probably begin by offering you the lower amount, and you will feel that you deserve the higher sum. Everything is negotiable, and don't forget that there are more items to the compensation package than the salary.

If you're single, a large portion of your salary will be withheld for tax

purposes, and even if you have dependents, that salary deduction can still seem enormous. Consider certain nonsalary items that may be more advantageous to you and to the company. Discuss and negotiate the following:

1. Medical and dental benefits
2. Sick days and personal days
3. Vacation time and holidays
4. Moving and relocation expenses
5. Professional membership, affiliation, and education cost reimbursement
6. Business travel reimbursement
7. Conference attendance expenses
8. Periodic promotion and salary reviews
9. Personal expense accounts—business entertaining and the like
10. Use of a company car, or local transportation reimbursement

Most of us are not in the arts for the salary alone. Salaries in general are lower than in other fields. Many arts organizations will not be able to meet your salary demands without upsetting the pay structure of the entire staff. But you may still come out ahead by negotiating the right combination of benefits. Even nonprofit organizations must contribute to FICA, unemployment insurance, and worker's compensation funds. These payments are based on your salary. You could remind your prospective employer of this and show, for instance, how it can be less costly for the company to offer you an expense account and a somewhat lower base salary than you are seeking.

Unless you are incorporated and file your own income taxes and deductions, or unless you are being hired as a consultant, you should not agree to work for a straight fee or to be paid under the table. Some small businesses may offer to pay their workers in this manner in order to save money for themselves and to give their employees increased take-home pay. If this seems tempting, despite the fact that it is illegal, consider that if you are injured on the job, you will not be covered by workmen's compensation; and if you are fired or the job ends, you will not qualify for unemployment insurance. Both you and your employer may also face legal charges from the Department of Labor and/or the Internal Revenue Service.

If you keep the above negotiating points in mind, you will be able to reach the best possible compensation package. After spending so much time and effort to secure a job offer, it would be foolish to accept it blindly.

☆5☆

How the Arts and Media Industry is Organized—and What the Top Jobs Are

T he first chapter provided a history of the arts and media industry in America from the economic viewpoint; this chapter describes how the industry as a whole is structured and how its various components, or sectors, are organized. Emphasis is placed on corporate organizations, because that is where the majority of management jobs are to be found. After a consideration of unincorporated as opposed to incorporated business structures, we will look at the differences between the commercial and the nonprofit sectors and also discuss their similarities. Finally, we will survey the specific types of arts and media organizations in terms of particular organizational needs, executive leadership, and common career paths. You will begin to see that in many cases job titles, functions, and qualifications within different organizations are similar and, therefore, that many job skills are transferable from one sector to another. In almost every case, there is a nonprofit counterpart for each commercial arts organization: Regional theatres are nonprofit ventures, and Broadway productions are almost always commercial enterprises; public television stations are nonprofit, and local network affiliates are commercial corporations. Furthermore, there is sometimes a close relationship, if not an interdependence, between the nonprofit and the commercial companies: A theatrical property may be developed in a nonprofit regional theatre and end up as a commercial release on cable television; or the funding office of a commercial business corporation, together with the funding office of a nonprofit foundation, may jointly support the work of an individual artist whose paintings are sold by a commercial gallery and eventually end up hanging in a nonprofit museum. So, while clarity demands that we examine each branch of the arts and media industry separately, bear in mind that each part relates to the whole. (See Chart 7 for an overview.)

Unincorporated Companies, Associations, and Partnerships

Everyone is free to acquire a space, hang up a sign, and declare "open for business." In fact, this is a common occurrence in the arts world, although the vast majority of such businesses fail due to insufficient capital, lack of sound legal and financial advice, or because the market for their product is too small or even nonexistent. Nonetheless, many artists, as well as entrepreneurs in the arts, begin an unincorporated company, often because they failed to gain corporate employment or sponsorship. The unincorporated company, whether individually or jointly owned, is financed exclusively by the owner(s), who enjoys full decision-making powers and considerable freedom from various legal regulations, excluding the tax laws. However, these owners also assume full personal liability, which means that all their personal assets may be attached in order to settle any debts incurred by their business dealings. Few people are willing to take this risk for very long.

If you are employed by an unincorporated individual or company, be certain that you are covered by workman's compensation, unemployment insurance, social security, and other standard types of insurance. Some of these businesses, as well as small incorporated outfits, may offer to pay their workers under the table. This is an illegal arrangement that saves the employer money and gives the employee increased take-home pay, but which leaves the employee without such protections as health insurance, workman's compensation, and unemployment insurance. Even if you initiate direct legal action to claim such benefits, you may still be out of luck.

One type of unincorporated business structure used in the commercial arts world that insures legal protection for the investors and requires accountability of its principals is the Limited Partnership Agreement. This is an especially effective arrangement for attracting investors for Broadway shows and independent film projects; it's also offered to attract investments in race horses, gold mines, and other highly speculative ventures. The general partners, or producers, control these ventures fully. The limited partners—also called investors, or angels—only lose money or earn money by sharing in the losses or profits according to the amount of their individual investments. Again, each project financed in this way is a separate legal entity; neither the investments nor the jobs related to them are guaranteed if the project is a flop or comes to an end.

Corporations

A corporation as an entity is legally separate from the lives of its officers, shareholders, or participants; the corporation has perpetual life unless it is legally dissolved. The three basic, and most common, types of corporations in the arts and media industry are defined below; these definitions vary

somewhat as stipulated by the laws of the state in which a business is organized. Most people who earn their living in the arts and media industry work for one of the following types of corporations:

A private corporation

Law stipulates that all corporations must have officers and a board of directors. In the most simple arrangement only two people may fill the roles of president, vice-president, secretary, and treasurer. Often these people are close relatives and usually the president-treasurer is the top executive for the business while the vice-president and secretary may be merely a figurehead, as is the case with many stock and dinner theatres, small recording companies, independent publishers, and for most talent and advertising agencies. Other private corporations are operated as partnerships in which a small number of people share the company's assets and liabilities. This arrangement is often used in the operation of art galleries, large talent agencies, and production companies. Of course, private corporations may involve private investors who are not partners, officers, or directors in financing independent theatre and film projects.

A public corporation

This type of corporation offers shares to the public through the stock market and conforms to additional regulations, such as those of the Securities and Exchange Commission. Its board of directors and officers are elected or ratified by vote of the shareholders, who also share the profits or losses of the company in proportion to the amount of their investments. This arrangement is common for commercial television and radio networks, film studios, and large publishing and recording companies.

A not-for-profit corporation

This is a corporation that is prohibited by law from distributing any of its assets as profits per se. It may offer salaries and pay its bills like any other business, but it may not award dividends of any kind to its participants. It has gained nonprofit and usually tax-exempt status from the appropriate federal, state, and local agencies. This structure is utilized by virtually all noncommercial ventures and institutions in the arts and media industry.

Large commercial arts organizations—which are either private or public corporations—include such well-known companies as Warner Communications, ABC, the Shubert Organization, and HBO. Large, not-for-profit arts corporations include the Kennedy Center, Lincoln Center, the Metropolitan Museum of Art, and National Public Radio (NPR).

Commercial Arts and Media Corporations

William Paley, the founder and former chairman of CBS, was once asked by a

newly appointed station manager, "Well, what do you want? Do you want ratings? Revenue? Profit? Community service? Image? What do you want from this television station?" Paley answered, "I want all those things." (Interview with Van Gordon Sauter, *New York Magazine,* January 23, 1984).

People often think that the only purpose that companies in the commercial sector of the arts and media industry have is to make money. And certainly a shareholder in CBS is interested in maintaining dividends and watching the stock price rise. But Paley's mandate to his station manager is much closer to reality. Leaders and managers in both the commercial and nonprofit sectors of the arts and media industry must maintain broad interests and diverse goals in order to operate successfully.

While the process of forming a private commercial corporation as a method of self-employment is discussed in the last chapter of this book, here we are concerned with the larger corporate structures, which have many employees, an active board of directors, and which are owned by numerous shareholders.

If earning profits is not the only mission of a commercial organization, it is certainly the primary one, and unlike income earned by nonprofit organization, these profits are subject to taxation. A publicly held corporation, like CBS, Inc., has shareholders: individuals, trusts, or pension funds that own or control shares of the corporation. The shareholders may participate in open shareholder meetings and vote for board members. Shareholders also receive a percentage of any profits made by the corporation—dividends are earned according to the number of shares owned. If the profits of a corporation are healthy and its image in the mind of the public is positive, the value of the shares often rises, which results in a nice capital gain on any shares that are sold.

The policy-making authority and managerial control of a corporation rests largely with its board of directors. This group, composed of officers and outside directors, is organized into committees: executive, finance, ethics, and others, and is usually headed by a board chairperson. In many instances, as is the case at CBS, Inc., the chairperson is also the president and chief executive officer (CEO). A more usual management configuration has the president, as CEO, reporting to the board and to the chairperson. Larger corporations, including conglomerates consisting of numerous separate companies, are organized into divisions or groups, each of which has centralized functions and operational independence up to a point. Each is headed by a president, or executive vice-president, and all groups report to the corporate headquarters, which coordinates finance and overall policy-making. For example, CBS, Inc., is organized into four groups: the Broadcast Group, which includes the network and its owned-and-operated affiliates, as well as the sports, entertainment, news, and the theatrical films divisions; the Records Group, which produces classical and popular music recordings, and which also includes a song division and a direct-mail record distribution division; the Publishing Group, which publishes magazines such as *Women's Day* and

Chart 6
Structure of An Organization: CBS, Inc. (1984)

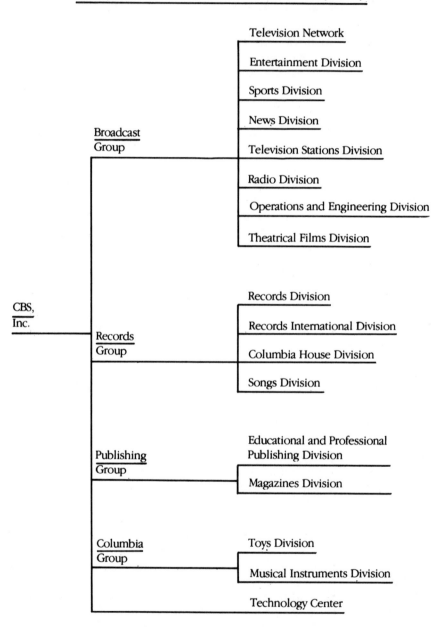

Family Week, and which also has a division for the development and sale of educational material; and the Columbia Group, a producer of video games, toys, and musical instruments. (See Chart 6.) Each group has a president, and a management structure with specialists in the areas of operations, marketing, finance, personnel, and others. It is a typical pyramid structure with the parent corporation and its board chairman at the pinnacle. The presidents of the many divisions and the corporate vice-presidents for such areas as finance, corporate affairs, and legal affairs, make up the overall CBS management committee.

The division presidents, or production chiefs, of large broadcasting networks and film studios make basic decisions, which are really megabuck gambles, about which programs or properties will be produced and/or financed. Despite the availability of sophisticated marketing data, a high percentage of such decisions are based upon the executive's intuition. The ability to read the market is of major importance to the success of management and production throughout the commercial arts world—on Broadway as well as on television, in the art galleries as well as in publishing. While the success of a nonprofit organization is properly judged by how well it fulfills its stated, nonpecuniary mission, a publicly owned corporation is judged according to the daily stock quotations for the company, which can create considerable job stress. Executives of radio, television, or cablevision corporations have the additional stress of responding to the program rating polls as an indicator of policy decisions. It is little wonder, then, that such executives can easily lose sight of the quality, integrity, and value of the artistic products. Film studios often consider scripts only of the specific genre that their market research indicates will appeal to their target audience. Multiple endings may be tested on preview audiences to determine the final cut of a movie. The mindless subject matter of many sit-coms is ample evidence that artistic compromise is frequently the price paid for increased ratings.

Happily, there are at least a few leaders in the industry who trust artistic quality—these individuals usually have a background in the creative areas of the business. For example, Norman Lear, head of a successful television production company, began in television as the creator/producer of "All in the Family." And there *are* producers who give their managers, directors, and designers full artistic control. Ultimately, though, profit determines the life or death of a property in the commercial sector. There are no patrons and no subsidies to help keep even the highest artistic success in the theatre or on the screen.

Certain functional responsibilities in large corporations are handled by professionals in specific disciplines who may not be people with a background in the arts. Corporate controllers, human resource managers, and tax attorneys may not have any special interest or background in an art form. The skills required of them are dictated solely by the exigencies of the business situation as are their management decisions. A corporate controller

for an entertainment company is probably a specialist in finance and cost control, trained in a business school and holding a CPA, with prior experience in public accounting.

As one gets closer to the art itself, a specific knowledge of the art form is needed. For instance, marketing, as a measure of audience response and manipulation, requires an understanding of the product. It would be an asset for the marketing director of an opera company to know a great deal about opera and about the artists who create and interpret an operatic work. However, there is a tendency in the commercial sector to value specific functional skills more than knowledge of an artistic product. The theory is that if you can market toothpaste, you can market any consumer product, including an opera or a film. Chances are good, however, that the new generation of specially trained arts administrators will dispel this belief and that their arts-specific skills and knowledge will soon give others the brush, as it were.

Although companies in the commercial sector must pay taxes on their profits, they may lessen their tax liabilities through write-offs and deductions related to the cost of doing business. Herein lies another difference between the commercial and not-for-profit sectors. By investing in the development of talent and artistic products, a commercial company may actually reduce its costs by reducing its tax burden. The nonprofit company, on the other hand, must finance such development out of precious operating budgets. Film companies may spend millions of dollars optioning properties, developing scripts, hiring consultants, and conducting market research. Few nonprofit arts organizations are able to invest on this scale, although the production opportunities they provide to artists on a smaller scale are, ironically, vital to the health of the entire industry.

From small, struggling stock theatres and film companies to huge broadcasting networks and film studios with multimillion-dollar budgets, the commercial sector of the arts and media industry runs the gamut. You may be the general manager of a dinner theatre who lives in a mobile home that doubles as a dressing room at show time, or the CEO of a film studio who lives on a lavish estate and owns a private plane. More likely, you will have a position and a life style somewhere in between. But wherever you work in this sector, you will rarely forget about money, though you may forget about art.

Nonprofit Arts and Media Corporations

A nonprofit or not-for-profit or noncommercial corporation—the terms are used interchangeably—is not necessarily one that doesn't earn revenue over its expenses or one that is unbusinesslike. It simply means that the equity of the corporation, its earnings and assets, cannot be shared among the board members, managers, and directors of the company. For example, the considerable revenues earned by *A Chorus Line* are not shared by the board members and Joseph Papp, the director of the nonprofit New York

Shakespeare Festival, which produced the show. Rather, they are returned to the corporation and used to support less lucrative projects. Furthermore, if a nonprofit corporation is dissolved, its assets must be turned over to another nonprofit organization. The pictures hanging in a museum cannot be distributed among the board members if the museum closes its doors forever.

When goals are formalized through the creation of a not-for-profit corporation, several basic rules of operation are established:

1. None of the profits may inure to the benefit of any private individual.
2. The officers and employees of the nonprofit corporation may, of course, receive salaries, and these may be increased with the budgetary growth of the corporation.
3. Control rests with a board of trustees rather than with an individual producer, manager, or owner.
4. The organization may not lobby for changes in legislation.

In the academic world most arts programs, facilities, and centers are operated under the not-for-profit seal of a college or university. Most civic arts groups and agencies function under the legal umbrella of municipal or government protection, as do those in the public education system. In these cases the arts program executives are appointed by the academic administration or by elected political officials.

The trustees of a nonprofit corporation are nominated and elected by the current board, maybe upon the recommendation of the general manager and/or artistic director. The only exception to this is when a nonprofit organization is first formed, at which time the board is handpicked by the organizers of the venture. In the arts field some ongoing companies are the inspirations of specific, individual artists or entrepreneurs, such as Joseph Papp, Twyla Tharp, George Balanchine, Tyrone Guthrie, and Martha Graham. A founding artistic director usually commands unquestioning support from board members because they are, after all, enthusiastic believers in the founder and his or her company. It is when the founding artistic director leaves the project that the board must make its most important decisions, starting with the hiring of a new artistic director.

A board of trustees is most effective when it is comprised of committed individuals from the community who share a deep interest in the artistic work of the organization. Historically, board members have come from the upper social classes. Today boards retain influential people, but most have also added members with various kinds of professional expertise and connections. Board members are expected to contribute their time, knowledge, connections, influence, and money to the nonprofit organization without receiving salaries or honoraria.

Robert Crawford wrote in his book *In Art We Trust,* "The basic role of the board of trustees for a not-for-profit professional arts institution is to provide through its actions and its efforts the best possible environment conducive to

the fullest implementation of the artistic purpose of the institution, consistent with prudent management." (Published by FEDAPT, New York, 1981) The specific structure of the board is established in its bylaws, and decisions are reached through a vote when a quorum is present. Most boards have an executive committee—which often consists of a president, vice-president, treasurer, and secretary—and a number of standing committees and members-at-large. Typical responsibilities of a board are—

1. To make and/or approve policy (executive committee and full board)
2. To hire artistic and managerial leadership (executive committee and search committee)
3. To develop long-range planning (planning committee)
4. To approve and monitor the budget (finance committee)
5. To raise the unearned income needed (fundraising or development committee)
6. To promote ticket sales and raise other earned income (marketing committee)
7. To nominate new board members (nominating committee)
8. To volunteer personal time and services for special events (volunteer or special programs committee)
9. To approve large capital expenditures and leases (executive committee and full board)

Other committees, whose responsibilities are self-explanatory, would be education, public relations, endowment, legal, acquisitions, and programming. The number of trustees that comprise a board is determined by the constitution of the organization and varies from a mere handful to many dozens.

All of the above committees work with the executive director, the artistic director, and often with staff managers on the many aspects of the organization. When fully utilized, board members can provide volunteer leadership, professional expertise, and valuable insight into the personality of a community.

A board chairperson is elected by the other board members and vested with whatever powers are specified in the bylaws. It is usually assumed that the chairperson is the most important figure in the whole organization, since this position appears at the top of any organizational chart. In reality, he or she may not be the most active or influential member of the board, perhaps having been elected for qualities of neutrality or passivity. Usually, however, the chairperson is the chief communicator, who informs the executive management of board decisions and informs the board of management actions, problems, and accomplishments. The chairperson must also, on occasion, represent the organization to the outside world and, conversely, serve as a conduit for communications from outside the corporation.

If you presently serve on a board of trustees or ever consider doing so, you

should know that a trusteeship is more than just an honorary position—it carries very real fiduciary and legal liabilities. If a trustee's actions can be proven to be negligent, prosecution is a possibility, depending on state corporate laws. In New York state and many other states the law holds that a board member of a nonprofit corporation is legally required to act "with that degree of diligence, care, and skill which ordinarily prudent men would exercise under similar circumstances in like positions." If actions to the contrary can be proven in court, then the trustee is held personally liable to share losses or damages with the other trustees, unless he or she has previously submitted a written statement of dissent for inclusion in the appropriate board minutes or unless, suspecting an illegality, he or she has notified the state attorney general's office. Trustees in all states are forbidden by law from realizing any personal financial gain from their positions, although they may receive per diem fees or expense reimbursements.

Chart 7

Senior Management Jobs and Functions in the Arts and Media Industry

(Excluding agents, personnel in service and support organizations, union members, and other functions in nonproducing areas)

Organization Type	Commercial Theatre	Small Nonprofit Performing Companies	Large Nonprofit Performing Companies and Centers	Independent Film, TV, Cable and Radio Companies	Large Network TV, Cable Corporations, and Film Studios	Medium-to-Large Museums	College or University Arts Centers
Leadership	Producer(s) and Landlord	Board of Trustees	Board of Trustees	Owner or Executive Producer	Board of Directors and Stockholders	Board of Trustees	Board of Regents or Trustees
Top Management	General Manager	General Manager or Executive Director	Board Chair, President, and General Manager or Director	Owner, Producer or Executive Director	Board Chair, President, CEO, and Subsidiary Division Presidents	Board Chair, President, and Director	President Arts Dean, and Center Director or Manager
Product Development	Producer(s)	Managing or Artistic Director	General Manager and/ or Artistic Director	Owner, Producer or Director of Programming	Division President, VP, or Director of Creative Development	Chief Curator, Director of Research and Acquisitions	Dean, Center Director, and Department Chairs

Finance	Producer, with General Manager and Accountants	Business Manager or Controller and Fund-raiser	VP or Director of Finance and Business Manager and Development Officer	Owner, with Business Manager or Controller	VP or Director of Finance	Treasurer, with VP or Director of Finance, and Development Officer	College Budget Director and Center Business Manager
Marketing and Promotion	Press and Advertising Agents	Press and Promotion Director	VP or Director of Marketing or Audience Development	Sales, Distribution, and Franchising Directors	VPs for Sales, Marketing, and Distribution	VPs or Directors of Membership and Marketing	College Admissions Director and Center Promotions Manager
Operations	Company, House, and Production Stage Managers	House, Tour, Stage, and Technical Managers	Director of Operations and House Managers	Unit, Traffic, or Studio Manager	VP or Director of Operations, with Unit, Studio, or Traffic Managers	Facility Manager, Registrar	College Buildings Director, and Center, House, and Stage Managers

Commercial Theatre

The commercial theatre is largely comprised of—

Broadway productions
Off-Broadway productions
National touring productions
Bus-and-truck productions
Stock theatre productions
Dinner theatre productions
Industrial shows

In each of these categories an individual producer or packager acquires the rights to a theatrical property, raises the necessary capital, and hires the managerial and artistic personnel. Although anyone who owns the rights to a property may become a producer, only those with long experience are likely to be successful. Among the small number of producers who have enjoyed repeated success over many years are Emanuel Azenberg, Alexander H. Cohen, Morton Gottlieb, Elizabeth McCann, Nelle Nugent, and David Merrick.

A Broadway producer—as shown in Chart 8, which outlines the executive organization for a Broadway production—is forced to work in close partnership with a theatre landlord. The Shubert Organization, the Nederlander Organization, and Jujamcyn, Inc., own most of Broadway's thirty-eight theatres. These landlords often contribute to the financing of a show and provide the theatre facility as well, through a complicated licensing procedure that involves a large rental fee based on box-office income and on services and personnel provided by the landlord. The landlord may share some advertising costs for a show and, if provided for in the licensing agreement, has the right to evict the show from the theatre if ticket sales fall below a specified point for a specified time period.

A general manager in New York commercial theatre is an independent specialist who is often incorporated and may maintain a permanent office and staff. The general manager earns a livelihood by handling virtually all the business supervision for specific productions when he or she is hired to do so by a producer. In effect, the general manager is an executive producer. On behalf of the producer, the general manager is responsible for negotiating theatre licenses, setting up the production staff, accounting for the finances, and dealing with the theatre landlord or the landlord's executive staff. The general manager may work for a single producer or manage a number of different productions simultaneously. Many producers have been general managers themselves and some function in both roles for their shows. Many producers were also at one time company managers or press agents. This is a common career path and a proven way of learning the business.

A company manager on Broadway and on the road is contracted to the producer but reports to the general manager and is hired to insure the smooth day-to-day running of the production and its cast. The company manager is

also accountable for the box-office receipts and daily expenditures, including payroll. The landlord's counterpart is the house manager, who must supervise box-office, ushering, and other house personnel employed by the landlord. So the company and house managers have different bosses but they work together and must reconcile any differences regarding staff, operations, and box-office receipts.

Since the advent of not-for-profit theatre companies, more and more plays have been developed in the noncommercial sector before being produced on Broadway. With production budgets of $1 million to $4 million there is little room for experimentation on Broadway, and the Broadway theatre is becoming increasingly dependent on film companies and cable television companies, many of which help finance a theatrical production in return for the rights to adapt and distribute it.

Chart 8
Executive Organization for a Broadway Production

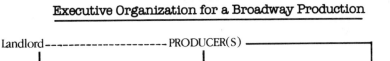

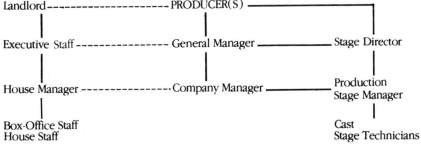

National touring companies, also called first-class touring companies, are organized and controlled by the producer of the original Broadway production. These companies play the large theatres in such cities as Boston, Philadelphia, Detroit, Chicago, Los Angeles, and Washington. After audiences for these tours diminish, the bus-and-truck rights are sold to a packager, who then organizes tours of smaller cities for shorter engagements. American Theatre Productions and CAMI Theatricals, Inc., are among the largest of such packagers. Eventually, the rights to a recent Broadway hit, assuming it was an original property, are sold to a play publishing company, such as Samuel French or Dramatists Play Service, which, in turn, licenses the property for production in stock, dinner, community, and amateur theatres around the country and in foreign nations.

Off-Broadway theatres are rented to producers on a "four-wall" basis, which means that the landlord provides nothing more than the theatre facility. Both commercial and not-for-profit productions are presented Off-Broadway, *The Fantasticks* being the longest-running example of the former. Many Off-Broadway employees—including actors, directors, company managers, and stage managers—are unionized, although salary scales are considerably lower

than on Broadway. Other employees, including stagehands, technicians, designers, box-office personnel, and house managers are usually not under union contract. These factors, combined with the Off-Broadway tradition of mounting smaller productions in smaller theatres, make it possible to produce a play Off-Broadway for about one-third the cost of a Broadway production. Financing is usually raised from private investors through the device of a Limited Partnership Agreement, as is the case on Broadway. Most Broadway producers and landlords belong to the League of American Theatres and Producers, while the comparable Off-Broadway association is the League of Off-Broadway Theatres and Producers.

Stock and dinner theatres are categorized by Actors' Equity Association according to the type of entertainment they produce—musical, dramatic, indoor, outdoor; by whether or not they maintain a resident acting company; and by the amount of their potential weekly gross. Virtually all stock theatres operate on a seasonal basis, summer or winter, whereas dinner theatres usually have a longer or year-round season. Stock and dinner theatre managers may either produce their own productions or buy them from a packager. While administrative salaries are low, the opportunity to learn is considerable and certainly makes for valuable entry-level experience for someone seeking a theatre career.

Industrial shows promote or demonstrate a product or line of products. They are presented by the manufacturer at sales conventions, trade shows, world fairs, and the like. *The Milliken Breakfast Show,* long an annual fashion industry event in New York City, has a budget exceeding $1 million. Most "industrials" are planned by the manufacturer's advertising agency, which hires a theatrical producer or packager to produce them. This is similar to the process by which manufacturers and others hire an advertising agency to produce a television commercial.

Everybody in the commercial theatre, it seems, dreams of working on Broadway. For all its problems and failures, or perhaps because of them, arriving on Broadway is a very sweet achievement. While the competition for artistic opportunities is great, a management or administrative position on Broadway is far from impossible if you have the right background and enough perserverance. Broadway executives are impressed by a resume that includes experience with leading Off-Broadway, stock, and regional theatres: They are more impressed by the school of hard knocks than by college credits, although a combination of both is gaining favor. Starting as an intern, secretary, or administrative assistant with a producer's or landlord's office is a good beginning after you've earned some experience in another branch of the theatre business. As you become acquainted with the most active professionals in this rather small community of workers, seek out an apprenticeship with the Association of Theatrical Press Agents and Managers (ATPAM), which will mean several years at a good salary assisting an ATPAM company manager, house manager, or press agent. The greatest opportunity for such employment,

both for apprentices and union members, exists with the touring companies, because most ATPAM members simply prefer not to travel.

ATPAM, which is a small union, recently announced that it would severely limit the number of apprentices it would accept. Furthermore, apprentices are required, after a specified amount of employment over a two- or three-year period, to pass a written exam. ATPAM's jurisdiction covers all Broadway and first-class touring productions as well as most major road theatres in the larger cities. This means that all company managers, house managers, and press agents employed by such theatres must be ATPAM members. A general manager, on the other hand, need not belong to the union, although most do, or did at one time.

Nonprofit Theatre

The nonprofit theatre is comprised of—

Resident theatre productions
Off-Off-Broadway and showcase productions
College and university productions
Civic and community theatre productions
Children's theatre productions

However, some stock theatres and Off-Broadway productions are presented under nonprofit status, and a number of children's theatre companies are for-profit ventures.

Resident theatres are nonprofit organizations that maintain an ongoing management staff and sometimes an acting company that is under a season-long contract to present a season of productions. They are professional in that they use union performers and are members of the League of Resident Theatres (LORT), an association that, among other functions, negotiates a basic contract with Actors' Equity on behalf of its theatre members. The eighty LORT theatres around the country include the American Conservatory Theatre in San Francisco, Washington's Arena Stage, the Arkansas Repertory Theatre, and Circle in the Square in the heart of Broadway in New York City. Measured by the number of people employed, weeks of work, and the number of performances given, LORT theatres represent the single largest segment of the theatre industry. Managerial and artistic standards are high in these theatres and the salaries offered for professional management positions are competitive with those offered in other types of nonprofit arts organizations.

Annual operating budgets for LORT theatres range from about $60,000 to over $7 million. The LORT theatres employ middle managers in the areas of fundraising, marketing, finance, operations, and, sometimes, educational and touring programs. Management positions with a theatre company require the same kind of specialized experience required of managers with symphony orchestras, and ballet and opera companies of equivalent size. The salaries

offered by these various performing arts companies are competitive, and job-hopping among them is common.

The "producer" of a LORT theatre is called a producing director. This person, who reports directly to the board, has total responsibility for the artistic and managerial decisions affecting the company's operations. Ideally, the board, which has the authority to hire and fire a producing director, will select an individual whose artistic philosophy and achievements they respect. The board then relinquishes the realization of that philosophy to the producing director, who must accomplish the artistic goals of the theatre within a framework of financial accountability. The producing director in a regional theatre, therefore, must often combine the knowledge and abilities of both a general manager and a stage director; he or she must also possess an artistic vision and philosophy that can sustain the work of the theatre—not just through one production, but through a series of productions over a number of seasons.

Given the scarcity of people who qualify as outstanding producing directors, it is common for LORT theatres—and many community, civic, and amateur theatres—to divide the artistic and managerial responsibilities between two persons, an artistic director and a managing director or general manager. Both

Chart 9
Executive Organization:
A LORT Theatre Budgeted Over $1 Million

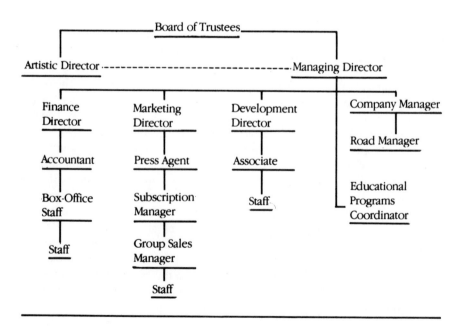

report to the board and, in theory, have equal authority. (See Chart 9.) In this configuration, the managing director is responsible for all nonartistic decisions, such as marketing, budgeting, staffing, long-range planning, and fundraising. The artistic director is responsible for selecting plays, casting, choosing directors, and managing key technical personnel. This relationship is, of course, complicated by the fact that every artistic decision has an impact on management and vice versa. In practice, these two executives must work very closely together—something that is almost as difficult to achieve as finding one person who is qualified to do both jobs.

Off-Off Broadway productions are works presented in theatres with less than one hundred seats. In these productions, as well as in the showcase and workshop productions that are produced for very limited runs in Off-Off Broadway theatres, the actors work for car fare or a very small stipend. There are hundreds of such productions each year. Most are organized by a single producer or, perhaps, by a playwright or an actor who becomes a producer so that his or her work can be seen by the public. The ongoing Off-Off Broadway theatre companies, such as Ellen Stewart's LaMaMa Experimental Theatre Club and Miriam Colon's Puerto Rican Traveling Theatre, have boards of trustees and several paid staff people who perform artistic and managerial functions. Budgets for these companies are astonishingly small and the tenure of paid personnel is often quite short.

Most civic and community theatres utilize volunteers instead of paid staff. Board members often perform staff functions, and whatever income is raised or generated is usually spent on production expenses and on hiring a professional director or professional guest artists for leading roles.

There are hundreds of college and university theatre companies that present works with student casts and faculty directors. However, there are also professional companies, such as the Yale Repertory Company in New Haven and the American Repertory Theatre in Boston, that are supported financially by a university but employ professional actors and staff, some of these positions also being filled by students. The largest of these theatres, such as the two mentioned, are members of LORT and function in a manner similar to other LORT theatres, except that the university administration usually replaces the function of a board of trustees.

A wide variety of children's theatre companies flourish across the country. Most are run by a small administrative staff and, as do community theatres, depend on volunteers. Some of the higher-quality childrens' theatre productions come from LORT companies that have established special productions that may tour in local schools, sometimes statewide; these companies often have their own administrative and technical staffs as well as separate boards of advisors. Most companies that hire professional actors belong to the Producers League of Theatre for Young Audiences (PLOTYA).

Career paths in the nonprofit theatre can be traced up through the management ranks from assistant or secretary to managing director. It is

possible to begin in a middle-management position if you have business skills in payroll, bookkeeping, marketing, or accounting. Most LORT theatres have internship programs and will often hire people for assistant positions directly from college and arts management programs. Developing your skills and expertise in a particular area, such as fundraising or business management, will make you more valuable and give you more upward mobility. The route to managing director positions in nonprofit theatres is well established. LORT managers usually move from small theatres to larger ones, and/or from a middle-management job to managing director, after a tenure of two to five years in a position. The network is so tight and job reputations so well known in professional theatre that any exceptions to this are noteworthy.

Although theatre in this chapter has been discussed in terms of methods of producing in the commercial and nonprofit sectors, there is no actual dividing line in terms of employment opportunities. Many people have worked in both commercial and nonprofit theatre, although this is much more common for artists than for managers. And in the management field, it is easier to move from the commercial sector to the nonprofit sector than the other way around—perhaps due to the persistent myth that commercial theatre is tougher and more aware of the nickles and dimes than the nonprofit theatre. But don't kid yourself. No theatre in America is about to catch fire because somebody is burning money!

Opera

Opera is logistically the most complicated of the performing arts to produce. It requires organizing a symphony orchestra, a chorus, and a ballet company and necessitates the production capabilities of a large theatre. For these reasons opera is also the most expensive to produce of all the performing arts. For example, the cost of a season of four fully staged productions of only two performances each can easily exceed $500,000. The 1983 annual budget for New York's Metropolitan Opera Association was in excess of $70 million, by far the largest budget for any nonprofit performing arts company in the nation.

Most opera produced in this country takes place on college and university campuses, which serve as an excellent training ground for young singers, directors, musicians, composers, and conductors. However, in addition to New York, other cities, such as Boston, Washington, Dallas, Houston, Santa Fe, San Francisco, Seattle, and Chicago, can boast major professional opera companies. With very few exceptions, most notably the Broadway production of Gian Carlo Menotti's *The Consul* and *The Telephone* in the 1950s, opera is produced by nonprofit organizations.

The trade association that represents the professional nonprofit opera field, OperaAmerica, lists almost 100 companies as members, including several from Canada and South America. Each has an annual budget of over $50,000 and each performs staged productions annually. Companies affiliated with

OperaAmerica are categorized as full members or as correspondent members, the latter being the smaller companies with fewer productions.

As with symphonies and theatre companies, the size of the opera company staff and the degree of decentralization of the management is proportional to the size of the operation—the more productions there are, the larger the budget and the staff. Furthermore, in companies with budgets under $100,000 there is more direct involvement in the day-to-day operations by the members of the board.

Many opera companies are headed by one person, a general director or managing director, who has ultimate control over both the artistic and management decisions. This is the same role as the producing director in nonprofit theatre companies. The Michigan Opera Theatre, the New York City Opera, and the Charlotte Opera, to name a few, are presently headed by general directors. The position is a highly specialized one. It requires strong managerial skills combined with artistic instincts and a vast knowledge and understanding of opera repertoire, singers, conductors, directors, designers, as well as many other aspects of opera production and performance. (Chart 10 shows how a fairly large opera company may be structured.)

Most general directors begin their careers in the artistic area of opera. Beverly Sills, general director of the New York City Opera, had an illustrious career as a singer; Robert Driver, general director of the Syracuse and Indianapolis opera companies, began as a stage director. The knowledge and experience required for the job are such that one cannot become the general director of a sizable opera company overnight. Some have, however, begun in opera or music management, such as Sir Rudolf Bing, former general manager of New York's Metropolitan Opera; and Terrance McEwen, current general director of the San Francisco Opera, who was a record company executive. Because there are comparatively few opera companies that offer full-time, salaried employment, the competition even for entry positions is keen. Experience in college or community opera would be an asset, as would specific business skills in accounting, marketing, or development.

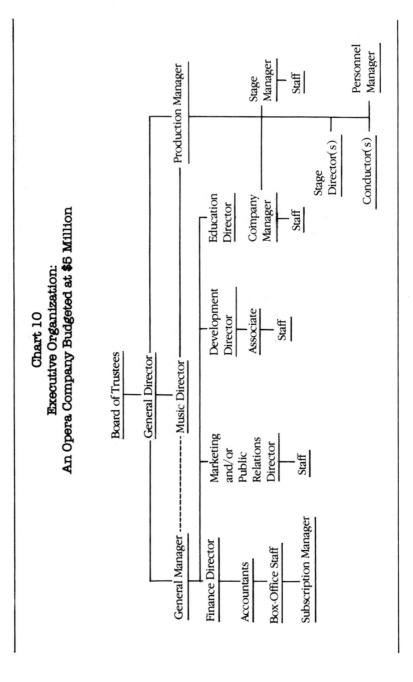

Chart 10
Executive Organization:
An Opera Company Budgeted at $5 Million

Symphony Orchestras

Symphony orchestras are the oldest and best established of America's performing arts institutions. They are also the most numerous. There are over fifteen-hundred symphony orchestras in the United States and Canada. Even small cities with populations of less than fifty thousand have symphony orchestras, and some larger cities can boast of having four or five. With the exception of a few orchestras that are formed for specific projects or exclusively for recording purposes, most established symphony orchestras that perform the classical repertoire are nonprofit organizations. And almost all of these are members of the American Symphony Orchestra League (ASOL), a memberhip and service organization. ASOL membership classifications are as follows:

Major orchestra: annual operating income in excess of $3.25 million—in the United States there are thirty-six orchestras in this category, some with budgets in excess of $16 million

Regional orchestra: annual operating income of $900,000 to $3.25 million

Metropolitan orchestra: annual operating income of $250,000 to $900,000

Urban orchestra: annual operating income of $115,000 to $250,000

Community orchestra: annual operating income of less than $115,000

College orchestra: orchestras composed exclusively of faculty and students of a college or university

Youth orchestra: orchestras composed of junior high school, high school, and/or college students and not affiliated with a single educational institution

The salaried leadership of a professional orchestra is shared between a music director, who is usually the conductor, and the general manager—or executive director or managing director. (See Chart 11.) Both report to the board of trustees and each has specific areas of responsibility, similar to the directors of theatre and opera companies. The general manager of an orchestra obviously must have strong management skills, particularly in major orchestras that have large budgets and a management staff of over fifty people. In the smaller orchestras, such as urban and community orchestras, the general manager assumes most of the management functions with only volunteer assistance from board members. Because so many management decisions are based on the length of a musical piece, the number and types of musicians required, rehearsal demands, and the requirements for guest artists, the orchestra manager must also have a good working knowledge of the classical orchestral repertoire. Although not directly responsible for choosing repertoire or hiring soloists, the general manager's input in such areas is often

sought out and valued. Knowing, for example, that it is more expensive to rehearse and perform a Mahler symphony than an early Haydn symphony can greatly simplify programming discussions and translate more readily into budgetary decisions.

The general manager, or executive or managing director, is also the chief spokesperson for the orchestra. Because it is common for the music director to be away from the city for up to half of each year—performing with other orchestras or opera companies—the general manager becomes the representative of the orchestra to the community, the press, the funders, the union representatives, and the board.

An important management position unique to symphony orchestras is the personnel manager, sometimes called a contractor. This position requires a person who can supervise the musicians and represent them to management. The personnel manager must also organize auditions, hire extra musicians when needed, monitor management's compliance with union contracts, and serve as liaison with the music director and the general manager. The personnel manager in small organizations is a member of the orchestra who is paid extra for undertaking these management responsibilities. He or she must know musicians and understand their concerns, and must be an able negotiator.

There are two other positions unique to symphony orchestras that also require specialized musical knowledge and artistic ability as well as administrative know-how: music administrator and music librarian. The music administrator is responsible for the day-to-day music-related decisions and works closely with the music director regarding rehearsal scheduling, soloist contracting, and program planning. The administrator also works with the general manager on budgetary, planning, and operational matters. Typical duties of this job include planning program and subscription series, engaging guest conductors and soloists, scheduling rehearsals, making contingency plans for all performances, and finding last-minute replacements when individual artists are unable to perform.

The music librarian in a small orchestra is usually one of the musicians. In a larger orchestra, the position of librarian is a full-time administrative job; responsibilities include renting and purchasing music parts and scores, controlling the costs for such expenditures, organizing and maintaining the music library, and supervising assistant librarians.

As the size and complexity of an orchestra's management increases, the general manager concentrates more effort on long-range planning, fundraising, board-related duties, and community relations. This requires that much of the routine supervision of the organization be delegated to an orchestra manager or operations manager. A number of management positions below that of the general manager require a strong knowledge of classical music and repertoire. This is less important for people in fundraising and finance, but essential in areas such as marketing, operations, and music administration.

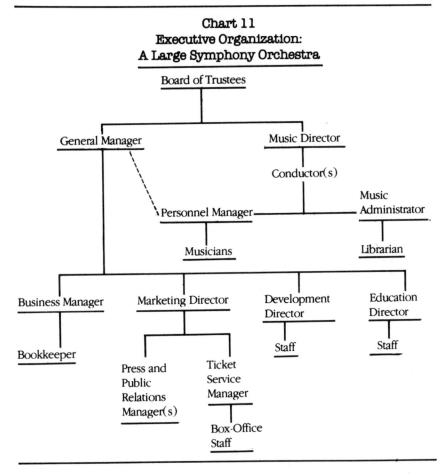

Chart 11
Executive Organization:
A Large Symphony Orchestra

Board of Trustees

General Manager

Music Director

Conductor(s)

Personnel Manager

Music Administrator

Musicians

Librarian

Business Manager

Marketing Director

Development Director

Education Director

Bookkeeper

Press and Public Relations Manager(s)

Ticket Service Manager

Staff

Staff

Box-Office Staff

In earlier days much of the management personnel for orchestras was drawn from the musicians themselves, but the current generation of symphony orchestra managers is entering the field directly from a management track. There are two typical career paths: beginning as a general manager or managing director of a small orchestra and gradually moving to larger orchestras, or beginning in an entry-level position with a larger orchestra and being promoted within the organization. Those who have been successful in following the latter route have usually developed a mentor relationship with a managing director as well as contacts on the board level. In either case, the careers of most symphony managers have been helped along by the American Symphony Orchestra League. ASOL concentrates much of its efforts on training, career development, and placement in the field. Younger symphony managers are emerging from the seminars, regional workshops, and fellowship programs offered by ASOL, and from graduate arts management programs. Through these training forums people are learning the principles of

orchestra management and are developing personal contacts with experienced managers and board members. ASOL also acts, informally, as a referral service for boards and managers, sometimes suggesting candidates for openings that may not even be public knowledge. During the annual ASOL conference, a great amount of interviewing and hiring takes place.

Modern Dance and Ballet

Both modern dance and ballet companies present dance on stage, usually with live or recorded musical accompaniment, and both require similar management support. However, individual companies can vary greatly depending on the dance idiom being presented and the size of the company, its budget, the length of its season(s), the amount of touring it may do, whether or not it operates a school or education program, whether its staff and artists are employed year round or part-time, and what special projects the company may undertake in such areas as film, television, and cablevision.

The modern dance field has experienced unparalleled growth over the past several decades. There are now hundreds of incorporated companies and many more unincorporated companies and solo performers in the field. Unfortunately, comparatively few companies are able to offer a year-round living salary either to their artists or to their administrators. Although artistically diverse, most of the so-called emerging modern dance companies have very similar management structures—or lack of same. Most represent the vision of a particular artist who leads the company both artistically and managerially. If incorporated, these groups begin with a "paper board"—or trustees who are friends of the artist and who lend their names to the papers of incorporation, but who do not control artistic policy or influence the management of the company. Such boards seldom contribute financially. Rather, the entire administration is likely to be handled by the founding artist-artistic director. Some companies have existed for many years in this manner, recruiting dancers for secretarial and part-time office work.

Because small modern dance companies are usually in a state of growth or crisis, there are frequently openings for administrators. Entry into the management ranks in the modern dance field requires a belief in, even a passion for, the particular aesthetic of a given company—a passion greater, perhaps, than that required for any other performing art. For this reason, and because their artistic careers are comparatively short, many former dancers have become dance administrators, while others have become dance educators.

Perhaps the most pressing problem faced by small dance groups is that of keeping the company together—a necessary condition for artistic accomplishment and growth. Among other considerations, this may involve scheduling the right number of employment weeks in the right period of time to guarantee that the artists can collect unemployment insurance between engagements. Or it may require that the company manager sell presenters not only public performances by the company, but also "residencies," during

which a company remains at a campus or community center for a number of days to offer special classes and lecture-demonstrations, thereby lengthening its term of employment.

A recent development in the management of small dance companies has been the formation of consortiums in which several small companies hire the services of the same general manager, fund raiser, press agent, accountant, or a group of these specialists. If the giants of the performing arts industry, such as Lincoln Center and the Kennedy Center, can provide certain services for their performing constituents, a similar type of centralized support should be, and is, possible for small companies, even if they do not share a facility in common. Several firms—such as Pentacle/Danceworks, Inc., in New York City—now offer a wide range of management services to small dance and other performing arts companies.

Once a company earns the critical acclaim and audience support necessary for budgetary growth, professional management must be introduced. This often begins with the expansion of the board and its greater involvement in policy, planning, and fundraising. The general manager probably supervises all administrative functions with the assistance of outside agencies that specialize in booking, financial management, and advertising. As managing a company becomes more demanding with the increase in its activities, more staff must be added in the areas of development, business management, marketing, and operations. The general manager—or, now, the executive director— concentrates on long-range planning and board development, delegating routine management chores to staff members. The founder-artistic director is thus freed to develop the company artistically and to choreograph new works. Theoretically, the structure becomes bilateral in terms of authority, with the executive director's status equivalent to the artistic director's—a situation often found in symphony orchestra, opera, and theatre company management. In practice, however, the artistic director usually has veto power over the executive director. This happens because the company strongly identifies with the artistic director and the veteran board members retain their original allegiance to the founder-artistic director. To illustrate this, imagine that an impasse between the manager and the founder of the Paul Taylor Dance Company is resolved by firing Paul Taylor. Obviously, such radical action is rarely taken.

The ultimate crisis occurs when the artist who founded a company retires or dies—this is especially traumatic when the company bears the artist's name. Only a loyal company and a strong board can sustain such a loss, as was accomplished after the death of José Limon, who had founded a company bearing his name; and after the death of George Balanchine, the founding director of the New York City Ballet.

Modern dance companies are concentrated in the nation's larger cities, but many smaller communities can boast the cultural asset of a civic or regional ballet company, usually supported and run by a board of trustees. The board

hires an artistic director who recruits and trains dancers, sets classical dances, or creates new works for the company. Many regional companies operate a ballet school that is owned by the artistic director or by the nonprofit corporation; many also operate in-school programs that give employment to the dancers and encourage local funding for the company.

While the majority of dance companies are minimally staffed, the major companies—such as the Joffrey, Eliot Feld's Original Ballet Foundation, the Alvin Ailey Company, the American Ballet Theatre, the Dance Theatre of Harlem, the National Ballet of Canada, and the San Francisco Ballet—maintain ongoing operations that employ dozens of administrators, technicians, and artists on long or year-round contracts. Their engagements include national and international tours, taping sessions, and an annual season in New York or in their home city. With budgets in the millions, large unearned income goals, and high production costs, these companies require sophisticated management and active board members. Development, marketing, finance, and operations become separate departments, each with managers, staff, and board involvement. Ideally, the executive leadership is shared by a strong artistic director and a proven executive director, who together are able to sustain and vitalize a complex artistic enterprise without stepping on each other's toes, as it were.

Dance, U.S.A. is the professional association of the major modern dance companies and the large ballet companies. It provides a forum for the managers and artistic directors to discuss mutual problems and common issues and acts as an advocate on the national level for increased support and touring opportunities. The National Association of Regional Ballet (NARB) has a membership of small-to-mid-size civic and professional ballet companies. Both associations have annual conferences and some regional meetings and are good sources of information for job openings and trends in the field.

Presenting Organizations and Performing Arts Centers

A presenting organization hires live attractions and presents them to a community. All but a few operate as nonprofit corporations. There are four types of presenting organizations:

Independent presenters
Community and civic presenters
College and university presenters
Presenting-producing organizations or performing arts centers

If one takes a low figure and estimates that there are two thousand presenting organizations nationwide that offer an average of twelve performances annually, then this branch of the industry is responsible for twenty-four thousand live performances each year, involving symphony

orchestras; opera, theatre, and dance companies; rock groups; circuses; and acrobatic acts. They also present soloists—singers, instrumentalists, poets, mimes, puppeteers, comedians, and one-person shows—and many sponsor film series. Presenting organizations provide performing groups and individual artists a touring circuit, which allows them to increase their performance seasons, often to a year-round schedule. Equally important are the opportunities for artistic growth that touring provides for incipient companies and developing artists who lack the resources, reputations, or levels of accomplishment that would enable them to perform in the major houses of our largest cities. Columbia Artists Management, Inc., a leading talent and booking organization, has made a particular contribution to the field through its Community Concerts Guild, which is a national network of presenters who book young and often unknown talent into small concert halls, where volunteer committees sell tickets and thereby provide audiences.

Even though almost all presenting organizations operate on a nonprofit basis, many of the soloists, popular music groups, bus-and-truck tours, and guest artists function as for-profit entities. The nonprofit groups that are presented, of course, also earn fees and, sometimes, a percentage of the box-office income.

Independent presenters are really private impresarios who seek to earn their livings from their booking activities. Most work out of a permanent office but seldom own a facility; rather, they rent a hall or performance space as needed. Most are small, low-budget outfits that have little if any support staff. The independent presenter arranges performances with the owners of the performing space or with another presenter, such as a performing arts center. For this the independent presenter receives a fee or commission based on the performance fee. Other independent presenters operate within a particular city and usually reserve certain dates in the performing halls available to them. Then they bring in and present the performing artists or groups. In these cases, the presenter pays the group a fee that is expected to be more than covered by box-office receipts. This type of presenter must also pay for the support staff—box-office, security, house-management, and technical personnel—as well as advertising and publicity costs, and earns a profit only after all such expenses are covered. The element of risk is considerable.

Community and civic presenting organizations operate in much the same manner, except that they are nonprofit corporations and can supplement their ticket receipts with unearned income from their fundraising efforts. The typical community presenting organization is run almost completely by volunteers, usually members of the board, who wish to import certain cultural events into their community. Perhaps a number of citizens are interested in bringing the great ballet companies to a community that is too small to support its own company. Typically, they form a board, raise money through special events, receive a grant from the local arts council, and then negotiate with a booking agency to present a dance series. The volunteers rent a hall, contract with a

local public-relations or advertising agency—or they do this work themselves—and try to sell enough tickets to cover the cost of the event. As such groups become more successful, they hire paid staff, beginning with an executive director or general manager. The board continues to raise unearned income and to participate in special activities, while the general manager assumes all the other organizational duties.

Some community presenters have raised enough money to purchase an old vaudeville or movie theatre. With the support of local government and the blessing of local business, these restored theatres are operated by the presenters, who also rent them to outside groups to earn additional income. There are a number of well-known renovation projects that are now regarded with great pride within their communities—the Grand Opera House in Wilmington, Delaware; the Ohio Theatre in Columbus, Ohio; and the Bardavon 1869 Opera House in Poughkeepsie, New York, are just a few examples. In these and in similar cases, a nonprofit corporation is the part-time presenter for the facility and the full-time landlord. The executive director of such a presenting organization is responsible for the artistic decisions involving the booking of events and the rental of the facilities, as well as the day-to-day administrative duties. The executive director reports to the board and may supervise a staff of three to twenty people. (See Chart 12.)

Chart 12
Executive Organization:
A Medium-size Presenting Organization with a $500,000 Annual Budget

Board of Trustees

Executive Director

Director of Operations	Business Manager	Development Director	Marketing Director
Technical Director	Bookkeeper	Associate	Press and Public Relations Manager
House Manager	Box-Office Staff		Audience Development Director
Ushers			

Executive directors of presenting organizations must be very familiar with performing arts groups and artists in order to understand which are most appropriate for their community. A presenter once booked an ethnic dance

group into his center, which happened to be a very conservative, religious community. Because he had never seen or read up on the group, he was not aware that both the male and female dancers performed topless! There are many other more subtle judgments that the executive director must be able to make in order to best satisfy the cultural tastes of a given audience. The position also calls for the skills and experiences required of managers in other types of nonprofit arts organizations: the ability to work with a board, the ability to hire and supervise staff, the ability to represent the organization to the community, the ability to develop budgets and stay within them, and the ability to work with the board in raising unearned income.

College and university presenting organizations, which use the campus theatre or auditorium as a performance space, are usually headed by a member of the faculty or administration who books and supervises the presentation of film and lecture series and one or more performing arts series. A large college or university with a very active series of events, such as Brooklyn College, Stanford University, and Dartmouth College, employs a full-time director and a permanent staff. (See Chart 13.) In all cases, the events that are booked have to be coordinated with the performances of the university's music, theatre, and dance departments, as well as with other activities that require the space, such as faculty meetings and commencement ceremonies. Because the demand for the campus theatre or auditorium is usually high, animosities can easily arise among the factions vying for space. This may be complicated by the fact that the director of the professional series must usually book events a year or two in advance. Whoever holds this position, then, must be realistic about the diverse needs of an academic community and must be able to accommodate them. The director may also have to answer to a faculty-student advisory committee that has the authority to suggest and to veto programming decisions.

Some campus presenters operate out of an academic department, others out of a dean's office, or the student union. Most are ultimately responsible to the college president. When the cash flow from a series is substantial, it may represent one of the president's few sources of unencumbered or unrestricted funds. Also, a professional arts series has a highly visible public-relations factor that can strengthen or weaken campus-community relations. While the presentation of a distinguished artist adds to the college's luster, the presentation of a rock group that attracts an audience of drunken or drugged teen-agers does not! Hence, the interest and input of the college administration is important, although it may not always be appreciated by the manager of the series. The service organization that represents college and university presenters, as well as many community presenters, is the Association of College, University, and Community Arts Administrators (ACUCAA).

Large, successful presenting organizations that own or lease their own facility sometimes produce as well as present events. The Victory Theatre in Dayton, Ohio, used to produce a series of plays during the spring and summer,

Chart 13
Executive Organization:
A Large-Campus Performing Arts Center

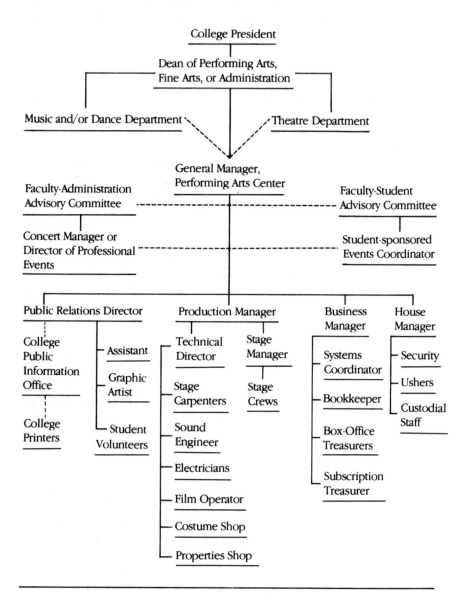

bringing in guest directors, designers, and actors. During the remainder of the year, it presented the Dayton Contemporary Dance Company, the Dayton Ballet, and other arts events. The Brooklyn Academy of Music (BAM) is a presenting-producing performing arts center that has enjoyed long success in presenting ballet and dance companies. BAM has also served as producer of its own resident theatre company for several seasons and hosts the Brooklyn Philharmonic as a constituent; and, recently, it has been the producer of The Next Wave, an annual festival of performance art.

The largest presenting organizations are the large performing arts centers: Lincoln Center, The Los Angeles Music Center, and the Kennedy Center being the big three. These organizations are operated as nonprofit corporations, with their own boards of trustees, and serve as landlords, presenters, and producers, while also accommodating a number of constituent performing arts companies. (See Chart 14.) Constituents of the Kennedy Center include the National Symphony Orchestra and the Washington Opera Society. The Kennedy Center also produces or coproduces new plays and revivals, which it then moves to other theatres and sometimes to Broadway; it also books into its halls a wide variety of touring attractions, making it a presenting-producing organization. Lincoln Center, Inc., is a holding company that oversees the land and buildings that make up the complex: the Metropolitan Opera House, Avery Fisher Hall, the Vivian Beaumont Theatre, the Performing Arts Library of the New York Public Library, the Juilliard School, the New York State Theatre, and the parking facilities. It produces the Mostly Mozart Festival, the Chamber Music Society of Lincoln Center, and an outdoor summer series, and is involved in television projects, including the "Live From Lincoln Center" series that is broadcast on PBS. Lincoln Center, Inc., raises funds through its board of trustees and through a united corporate fundraising campaign, some of which funds go toward the general operating cost of the complex and some of which are distributed to its constituents. The Lincoln Center board, through its chairman and its president, oversees the policy of the center. There is also a council composed of representatives from its constituents: the Metropolitan Opera Association; the New York Philharmonic; the New York City Ballet; the New York City Opera; the Juilliard School; the Vivian Beaumont Theatre Company, which also operates the Mitzi Newhouse Theatre; the Chamber Music Society of Lincoln Center; the Lincoln Center Institute, which is the educational arm of the Center; and City Center, Inc. The latter is itself a holding company for the State Theatre and rents space to the opera and ballet companies in residence there. City Center also presents other arts events and rents the hall to outside tenants.

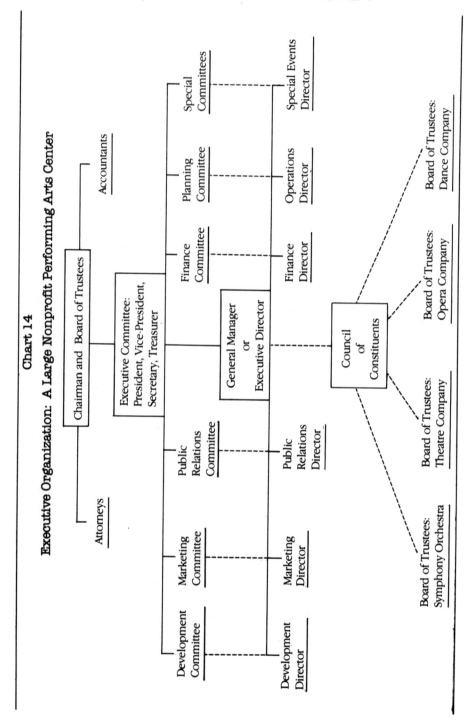

Chart 14

Executive Organization: A Large Nonprofit Performing Arts Center

In some ways Lincoln Center, Inc., is a nonprofit corporate conglomerate. However, it is important to understand that the constituents are independent, nonprofit corporations, with their own boards of trustees, and each is largely responsible for its own operating and program-related fundraising. In the early days of Lincoln Center there was concern, especially in regard to fundraising, that the efforts of the Center would conflict with those of its constituents, but this has not proved to be the case. The most glaring problem to date has been with the operation—or lack of it—of the Vivian Beaumont Theatre. Notably, this was the only facility at the Center that was not built to house an established performing arts company.

In general, the large performing arts centers have had a positive impact in helping to foster high standards and achievements in, and to bring national attention to, the performing arts. While most top-level managers in a large performing arts center are recruited from outside, middle-level positions are often promoted from within or are open to qualified applicants with the necessary experience and training. Most performing arts centers sponsor administrative internship programs that provide good short-term training but seldom guarantee a job at the end of the internship.

Museums

There are over five thousand museums in this country, the largest single category of arts organizations. Some are very small, operated only by a board and volunteers with no paid staff. Yet the number of management positions and the employment possibilities within the museum system are vast.

Museums are more than buildings with paintings in them. As defined by the Association of Art Museum Directors in its 1972 pamphlet *Professional Practices,* a museum is "a permanent, nonprofit institution, essentially educational or artistic in purpose, with a professional staff, which acquires objects, cares for them, interprets them, and exhibits them to the public on some regular schedule." The museum profession encompasses much more than art musuems like the Museum of Fine Arts in Boston or the National Gallery in Washington, D.C. In fact, only about 15 percent of the five thousand museums are art museums. Others include history museums, representing 50 percent of the total; and science museums—including zoos, botanical gardens, and arboretums—representing 18 percent of the total. The remaining ones, from the greatest in number to the least, are general museums, specialized museums, park museums, visitor centers, and children's museums.

As institutions, museums are like symphony orchestras in that they are typically among the older, more established arts organizations. Many were founded during the last century by influential citizens who supported them financially and who eventually donated their own collections. Thus, many museum collections were built from the estates of these founding patrons. Most museum buildings and facilities are owned by the museum corporation

or housed in buildings leased by the corporation from a city or local government. More museums have endowments than any other type of arts organization, and their boards are usually larger with members serving for longer periods of time. These factors, in addition to the fact that the primary mission of most museums is to preserve and exhibit works of the past, explain the generally conservative policies and management styles in the museum system.

The size of a museum staff depends upon its budget and the scope of its activities. A small museum may have only one employee, a generalist who manages all aspects of administration, acquisition, exhibition, and conservation. Some of the larger museums have hundreds of employees, much more than most other nonprofit arts organizations. These museums have departments of finance, fundraising, marketing, public relations, and operations, with managers and staff carrying out duties similar to their counterparts in orchestras, and in theatre and opera companies. Museums also have specialized management positions unique to the field, with responsibilities specifically related to the type of collection or the particular focus of the museum. These positions include the following:

Conservator: responsible for the care, preservation, and repair of objects in the collection

Exhibition designer: designs and oversees the installation of the exhibits

Education director: in charge of programs designed to enhance public understanding of the collections, such as lectures, art classes, field trips, and tours

Registrar: organizes, documents, and otherwise keeps track of objects in the museum

Research director: oversees visiting researchers using the collections, in-house or field research sponsored by the museum, and special educational research programs

Collections manager: works with the conservator in maintaining a catalogue of the collection and oversees the moving and storing of museum items

Director of acquisition: works under the museum director to coordinate the purchase or acquisition of new items, often using consultants or independent agents, and helps to search out, suggest, and/or acquire objects either on a permanent or loan basis

The top-ranking management person, responsible for overseeing the staff and executing the policies set by the board, is the director. This is the most common title for the chief museum executive, although president and executive director are also used. The museum director reports to the board and manages the organization. Responsibilities of the job include hiring staff, budgeting, fundraising, marketing, long-range planning, serving as the liaison

with the community and government agencies, and maintaining professional contacts in the field through personal associations with other museum leaders. The director must also provide artistic leadership. It is essential that the person have expertise and experience in the particular focus or subject matter of the museum. In fact, the director's interest in a particular type or style of art can influence the focus of the museum. Consequently, a museum known for contemporary art, for example, will seek a director whose expertise is in that area. A historian, as director, will influence the research and collections of a particular history museum. The ideal museum director will impart an artistic vision and provide leadership in program development as well in management areas. In art museums, expertise is usually gained through a curatorial position. Curators of large collections usually have, in addition to curatorial responsibilities, management duties: supervising a staff of assistant curators, controlling exhibition budgets, working with board committees, preparing grants, speaking to the membership, and participating in conferences as a representative of the museum, to name a few.

There are many museums connected with universities and colleges. These are often part of the art department and fall under the control of the department chairperson, or they may be operated by the office of the president or the dean of fine arts. The director must usually hold advanced degrees and have a reputation supported by scholarship, lectures, and publications.

Entry into the field of museum management may begin in college, where internships and work-study positions are often available in the campus museum or gallery. Most communities have a museum of some kind; in smaller cities these may have only one full-time staff person, who usually welcomes volunteers or docents to assist with tours, exhibitions, and openings. Expertise or knowledge in the particular holdings of a museum is obviously helpful, but there are many entry-level positions in public relations, membership, accounting, and development that do not require such specialized knowledge. Several graduate programs have a concentration in museum management and several offer degrees in museology or museum management. In addition, there are dozens of seminars, workshops, courses, and classes offered by museum associations and management assistance organizations. (See Career Kit.) The American Association of Museums, one of the nation's largest professional arts associations, sponsors an annual conference with attendance in the thousands. There are also many smaller associations designed to meet the interest of science and history mueums, and these often have regional affiliates. Such organizations should be contacted when considering a career in museum management.

Art Galleries

A gallery is a space that exhibits art works for the purpose of selling them. Most galleries exhibit the works of living artists: paintings, drawings, sculpture,

photographs, and so on. Galleries also exhibit craft items, such as ceramics and textiles. There are three ways in which a gallery can be organized: on a commercial, privately owned basis; on a commercial, cooperative basis; and on a nonprofit, cooperative basis.

The purpose of a commercial gallery is to earn profits for the owners and investors through the sale of art works, although some wealthy individuals support the operation of a commercial gallery as a tax shelter and actually hope to lose money. The commercial gallery is operated by a dealer, who is often the principal owner. (See Chart 15.) He or she has managerial and artistic control of all gallery operations. The dealer makes a profit through commissions on sales, but is much more than a salesperson. Successful dealers not only attract potential buyers, but also control the market for certain art works, influencing the value of the works and having a direct impact on the careers of the exhibiting artists. The dealer becomes, in effect, a personal agent or manager for a select number of artists. His or her personal tastes can often influence the artists, and as the artist's works are sold, the dealer can often demand a specific type of work from the artist. Thus the dealer can choose which works of the artist will be exhibited and sold. By promoting and providing for the artist, a dealer maintains control over the work. By setting prices, the dealer also influences the market value for the work. The most successful dealers have not only chosen good works to exhibit and sell, they have also had a part in determining which works are "good" and therefore "valuable." Dealers often serve a function similar to managers of performing artists. They guide the careers of promising artists, support artists and their work—sometimes providing them with stipends—and provide both artistic and business advice.

It requires capital to own and operate a gallery, to invest in artists and their works. Rent, maintenance, insurance, entertainment, promotion, and staff expenses can add up to a tidy sum. In some cases the gallery owner is a wealthy individual or a professional from an unrelated field. When this is the case, the owner hires a gallery director to manage the business. The director provides the expertise and management for the owner, who supplies the financing. The dealer-owner or the gallery director clearly must have experience and knowledge at least in a particular art form and period, must be able to recognize the potential of an artist and know how to help in developing that potential, and must understand the art market and have contacts with potential buyers. The successful gallery director is also an accomplished salesperson.

There is no clear path to becoming a gallery director. Some of the established directors have built their careers and businesses through the successes of artists whom they have discovered. Others began with money, or with contacts with monied people, and have developed a knowledge of the business. Taste, good business skills, sales sense, and entrepreneurial flair are important ingredients. Some curators and other museum professionals have made a successful career move into gallery management.

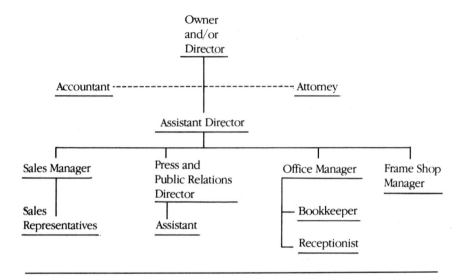

Chart 15
Executive Organization: A Large Art Gallery

By way of combating the tremendous power that private galleries and dealers exert within the art world, some artists have joined together to operate cooperative galleries. In the cooperative gallery, or artists' co-op, the control exerted by the dealers' personal tastes is replaced by a committee composed of the members of the co-op. This committee decides the policy of the gallery and also chooses the works that are exhibited. In small cooperative galleries the artists are also responsible for the management and maintenance of the gallery. In large co-ops a gallery director is hired. However, it is the board or membership committee that decides policy. Some cooperatives are for-profit organizations and some are nonprofit. Nonprofit cooperative galleries cannot sell the work of their artists directly. However, they do help to promote the work and assist in arranging for sale of the work away from the premises of the gallery.

The larger galleries, both independent and cooperative, have a full professional staff, which reports to the director. The positions, as illustrated in Chart 15, are similar to those in museums, having similar titles and job descriptions, and requiring similar skills and training. Works of art must be cared for and handled properly, and exhibitions must be professionally conceived, designed, and executed. The successful opening of an exhibition requires the effective management of publicity, press releases, personalized invitations; and the ability to involve art critics and supporters. Openings often become media events, complete with live performances, catered food and beverages, and glossy promotional material. Large galleries employ professional services to accomplish this. The sale of art also requires good marketing and selling techniques, which must be accompanied by careful accounting and record-keeping and appropriate administration of copyright and other contractual obligations between the gallery, the artist, and the buyer.

Commercial Radio Stations and Television Networks

Until recently, the broadcast industry was dominated by the three major networks: CBS, ABC, and NBC. These companies, which are owned by large entertainment and communications corporations with diverse interests in film, publishing, recordings, news, and other unrelated businesses, captured home audiences through their prime-time schedules and their sports and news programs. They also had a significant impact on local radio and television through their owned and operated stations—called O & O's—in the major markets, meaning in the larger cities.

The networks purchase programs from independent producers; buy or rent movies from film companies; sometimes participate in the financing of movies and serial entertainments; produce sit-coms and soap operas as well as news and documentary programs; cover national events, such as presidential elections and space launches; and broadcast national sporting events, such as the World Series and the Olympics. Networks supply these programs nationally to their own stations and to affiliated independent stations called network affiliates. In the larger markets—a market is roughly determined by numbers of households with television sets in a specific geographic area—all three major networks have affiliates. There may also be stations affiliated with other networks, such as Group W. In small markets served by only three or four broadcast channels there may be only one or two affiliated stations.

Networks provide prime-time and special-events programming to their affiliates without charge. They also provide publicity, marketing expertise, and other services designed to help stations maintain and increase their audiences. Networks work hard to keep their affiliates happy, satisfied, and loyal. In return, the networks get viewers. In commerical broadcasting the more viewers there are, the larger the audience share and the more competitive and

valuable the advertising time. It is advertising revenue that supports commercial broadcasting and earns profits for the owners or stockholders of its stations and networks. Each advertising minute during a network program such as the evening news or the World Series may be sold for $100,000 or more. If a situation comedy or adventure series is watched by a substantial percentage of the viewing audience, advertising time becomes more valuable and the program will generate greater profits. If that audience share is small or diminishes, the program will lose money and will be cancelled or dropped from the schedule.

Each network is organized differently, although just as network goals are similar, the functional areas are basically alike. These may be summarized as follows:

Programming: purchases and produces programming, and is organized into departments or divisions for such areas as news, sports, special events, weekly series, movies

Station management: provides support services, including financial planning and legal services, to the managements of the affiliate stations

Marketing and public relations: supplies advertising and promotion for network programming

Sales: sells time to national advertisers, works with advertising agencies and clients who use broadcast advertising

Research: provides documentation to assist programming and marketing decisions, to determine advertising rates, and to assist affiliates

Finance and administration: provides general management of the network corporation; coordinates relations with other corporate entities and government agencies; oversees legal affairs and obligations; supervises fiscal planning and control; and offers support in these areas to the O & O's

Upper-management positions in the networks are among the highest paying of all positions discussed in this book. Vice-presidents can earn over $100,000 per year and, in addition, usually receive bonuses and stock options. Such positions are very competitive and are held by the sharpest, most experienced executives in the industry. There seem to be two general career paths that lead to heading up a network division: one involves developing a strong business or legal background, holding a position such as chief financial officer or corporate counsel; the other involves working up through one of the programming divisions of a network. Van Gordon Sauter worked his way up through news reporting to station-level management and eventually to the network-level at CBS. Top managers for the network corporations are frequently recruited from management at the station level. Executives in network sales have come from advertising and sales positions at local or independent stations, from other industries such as packaging or consumer goods, and from advertising company positions. The most important

credential is clearly the sales ability, not the prior experience in broadcasting.

Entry positions at a network often exist in the areas of accounting, sales, and research. These positions do not require prior experience in broadcasting, although it is always an advantage to learn all you can about the field of your choice. There are numerous cases of secretaries who have been promoted to entry-level management positions. For management-track positions, networks offer very competitive starting salaries and can attract graduates with M.B.A.s or degrees in communications or broadcasting. The networks hire interns and have formal intern programs from which they recruit entry-level management talent. On the corporate level the networks employ hundreds of administrative and management staff people. They all have personnel departments that are responsible for entry-level hiring and for many of the internal promotions. Within such a large corporate structure one's career can develop and progress very nicely because the networks and large broadcasting corporations look within to promote. This policy encourages professional growth, is good for morale, and makes the corporation attractive to the best people.

The networks also recruit from their own television stations and from other stations around the country. A typical career path to a middle-management position with a network or a corporate management position in broadcasting would be from an independent or affiliate television or radio station. Many of these positions, except for technical and engineering jobs, require similar skills and experience so that career changes from radio to television or vice versa also occur.

There are numerous broadcasting networks other than the big three. These include the Madison Square Garden Network and the Hughes Television Network, which broadcast sporting events; and there are also those that specialize in religious and other types of programming. Some networks provide programming to independent stations. Because most networks are modeled after the big three, they have similar management departments and functions.

Independent Commercial Radio Stations and Television Stations

Independent commercial radio stations and television stations are as varied in management size and structure as the audiences they serve. An independent station in a large metropolitan area may have separate departments for programming, sales, finance, and engineering, each with department heads and staff. (See Chart 16.) In smaller stations the station manager may also be the program manager, who has a secretary to keep the financial records; or the general manager may also be an owner or part-owner of the station. In any case, the general manager is the top person in the organization, reporting to the stockholders in a public company or directly to the corporate headquarters if the station is owned by a network.

The general manager is responsible for the proper business management of the station: hiring personnel and developing a staff, supervising short-term and long-range planning and fiscal management, and serving as liaison to the community, the Federal Communication Commission (FCC), and the broadcast industry. In addition, the general manager has ultimate authority and influence over the programming of the station. This, in effect, gives this executive both management and artistic control, like the general director of an opera company or the executive director of a museum. An effective general manager in broadcasting must understand the specifics of the station and its market, and be able to translate this knowledge into policy and programming that earn profits. This requires a background and training in broadcasting; in fact, it is very rare for a general manager to arrive at this position from a different field. The career path to the job is usually from the technical-engineering area, the sales area, or from an announcing position. As with symphony orchestras and theatres, general managers move from the smaller companies to the larger ones, supervising progressively larger staffs, budgets, and programming schedules.

The FCC, the agency that regulates the broadcast industry, defines four principal areas of radio and television organization, as reflected in Chart 16: general and/or administrative, sales, technical, and programming. Positions in sales and promotion, as well as those in business management, utilize skills that can be learned in other fields. A controller for an opera company or arts council, for example, would have skills that are transferable to a television station. Likewise, someone who has sold advertising for souvenir programs or promoted ticket sales for concerts could transfer those skills to a position in sales or promotion for a radio station. Some positions, however, are unique to broadcasting. A traffic manager, for instance, is responsible for tracking programs and commercials on a second-by-second basis; also for scheduling announcers and other on-air assignments and for working with the sales department to schedule the placement of commercials. A program director collaborates with the station manager and the sales manager to select programming that will increase audience share and conform to the policy of the station. Most radio stations have specific formats and are identified with a particular programming emphasis: all news, all classical music, easy-listening music, all talk, or whatever. The program director must know the medium as well as the format of the station. Radio program directors usually begin as announcers or disc jockeys. Most colleges have a radio station and many also have a television station where students can gain on-air experience that can lead to programming positions.

Chart 16
Executive Organization:
A Medium-Size Independent Radio or
Television Station

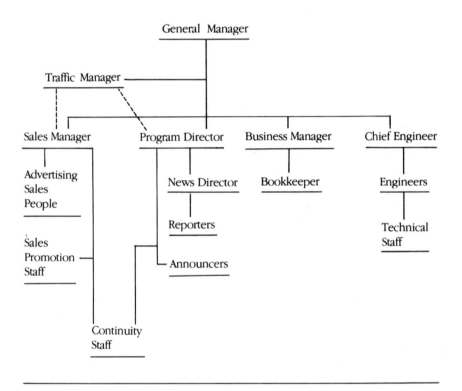

In small radio stations the general manager takes on the responsibilities for sales and sometimes even programming. In some stations the sales manager is also an announcer, which can be advantageous because the element of celebrity stimulates advertising sales.

In both radio and television there is a direct relationship between the market size and the size of the administrative staff. Small radio stations, serving a market population of less than ten thousand, may have as few as six full-time employees, including technical personnel; whereas a television station in one of the larger markets will employ over one hundred people.

The positions that are most scarce and most sought after in radio and

television are the on-air and programming positions. The glamor of performing and the promise of fame and fortune are big motivating factors. Anchor people for a network O & O become celebrities and can earn over $500,000 annually just for reading the news. On the other hand, there are often openings for salespeople in the advertising departments that go unfilled for lack of job seekers. In fact, this is one of the best entry positions in broadcasting. A new sales representative will be trained in the operation of the station and learn about its programming, and will be in contact with the research department and interact with the continuity and traffic managers as well. More important, success in sales is easily and clearly documented. Overshooting sales quotas receives immediate recognition, not only from the sales manager but even from the general manager of the station. Since sales people usually are compensated by commissions, the successful sales people can directly influence their salaries from the day they begin work. Also, a salesperson with a record of success can be promoted within the station and has a greater chance of moving to another station. In short, though less glamorous than other areas of broadcast management, positions in sales are probably the best for short-term success and long-term career advancement in commercial broadcasting.

Public Broadcasting

Public broadcasting is the generic term for noncommercial and educational radio and television. A distinction should be made, however, between the national organizations that help support public broadcasting stations and the stations themselves.

Public broadcasting became firmly established in 1968 when the United States Congress passed the Public Broadcasting Act, which created the Corporation for Public Broadcasting (CPB). The purpose of this quasi-independent, nongovernmental agency is to help in the development and support of noncommercial radio and television stations. It is a service organization that provides research, programming libraries, and information, as well as assistance in building stations. It also makes grants to nonprofit broadcasting stations that meet its criteria; to producing organizations that present programming proposals; to the Public Broadcasting Service (PBS), and to National Public Radio (NPR). CPB's funding criteria excludes stations that have a small staff and very limited programming and audience potential, as well as those with religious, political, or special-interest programming policies.

National Public Radio, established in 1970, supplies programming to its nonprofit member stations and to others that are licensed through colleges, universities, and municipalities. With studios in Washington, D.C., and a sizable staff, NPR is able to produce such programming as "Morning Edition" and "All Things Considered," which would be beyond the means of independent nonprofit stations. By raising the programming quality of such

Chart 17
Executive Organization: National Public Radio (NPR) 1982

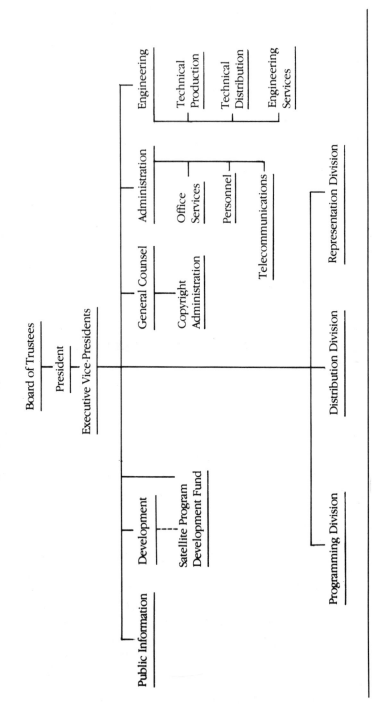

stations and by offering other kinds of assistance, NPR has become a potent force in the growth of public radio broadcasting throughout the nation. Chart 17 illustrates the actual organizational structure of NPR as it was in 1982.

The Public Broadcasting Service, like NPR, is an independent nonprofit corporation that also receives funding from the Corporation for Public Broadcasting. And, likewise, it provides programming and other services to independent nonprofit television stations. Aside from producing and coproducing its own programming, PBS also obtains programming from member stations. For example, WGBH in Boston, WNET in New York City, and WQED in San Francisco produce original programs that are supplied to other stations through PBS. Or PBS may purchase programs from nonprofit producing groups, the best known being the Children's Television Workshop (CTW), which has produced "Sesame Street" for over ten years. PBS also obtains programs from independent producers and from other broadcasting systems, the most notable being the British Broadcasting Corporation (BBC), which produced "I, Claudius" and "Upstairs, Downstairs."

CPB, NPR, and PBS together provide many of the same services for the nonprofit broadcasting stations as the networks do for their commercial affiliates. An important difference, however, is that affiliates do not pay for the network programming they receive, whereas nonprofit stations are billed for their NPR or PBS air time. These national organizations, then, are dependent upon their individual member stations, and also serve as advocates for their members in the halls of government and with major corporate and foundation grantors. The larger the membership of an affiliate, the greater its clout.

Public broadcasting stations are organized as nonprofit corporations— according to Internal Revenue Code (IRC) 501 (C) (3)—and are controlled by a board of trustees. Some are independent nonprofit organizations while others, as mentioned, as are licensed under the aegis of a college, university, or municipality. All are monitored by the Federal Communications Commission and must abide by its regulations in order to satisfy the license renewal requirements. Neither NPR nor PBS own or operate their own stations, as do the commercial networks. There are, however, a number of nonprofit broadcasting networks—or clusters of stations that are operated by a single nonprofit corporation—such as the Minnesota Public Radio Network and the Maine Public Radio Network. For the most part, however, the public broadcasting stations are separate and independent. Some subscribe to membership with NPR or PBS, some do not, though both types may purchase programming from the national organizations. All nonprofit broadcasting stations also produce their own programming—which they are required to do by the FCC—in order to serve the needs of their specific communities. Clearly, the viewers of WGBH in Boston are different from those in Tempe, Arizona. Through their programming departments, nonprofit stations provide programs of local interest, such as local news programs, a community affairs series, or a

health and science series produced in cooperation with the local hospital.

Nonprofit stations are organized in the same way commercial stations are, except the nonprofit stations do not have an advertising and sales department. In fact, they are prohibited from selling advertising time, and the amount of public recognition nonprofit stations give to corporations for their support is regulated. So, just as in other nonprofit arts and media organizations, public broadcasting stations must raise funds from government, corporate, foundation, and individual sources. On-air fundraising appeals are also an important method of generating contributions for many nonprofit stations. Major corporations and foundations have become interested in supporting PBS programs that have wide appeal and large audiences. Instead of directly advertising their products, the corporations receive benefits through an association with the program. Just as Texaco has been associated for many years with the Saturday radio broadcasts from the Metropolitan Opera, Exxon and IBM have associated their corporate identities with quality arts and science programs on public television, and many foundations have supported programs that reflect their interests in science, education, the arts, and other areas.

The general manager for a nonprofit broadcasting station reports to the board of trustees and is responsible for station management and programming. He or she also represents the station to the community and to CPB, and to PBS or NPR. While the manager is not responsible for making a profit, there is a financial obligation to balance the annual budget and to provide sufficient funding for projects, programming, and growth. The general manager hires and supervises the staff and works closely with the board, which is ultimately responsible for fundraising.

Career opportunities and financial rewards are not as great in public broadcasting as they are in the commercial sector, mainly because there is no ownership of public stations and no possibility of equity or a share in the company. Furthermore, nonprofit stations by their nature can never be cash rich or profitable. General managers for nonprofit stations, like their commercial counterparts, must know television—the technical, programming, and on-air aspects. Therefore, it is unlikely that general managers in the broadcasting field will come from another area of the arts and media industry. Rather, they usually move from the small public stations to the larger ones. They may also move to general manager from a middle-management position in public radio or television, such as director of development or business manager. Because of the monetary rewards, there is more movement careerwise from the nonprofit to the commercial sector rather than in the reverse direction.

Cable Television Systems

Cable television is a rapidly growing area within the arts and media field,

despite competition from video cassette recorders and satellite discs. Small companies are still being started by entrepreneurs who perceive an open marketplace, while large corporations are entering the industry by purchasing already existing cable systems: For example, Warner Communications in a joint venture with American Express began Warner-Amex, a corporation that owns cable television systems in cities around the country. Newspaper chains are purchasing systems and bidding on franchises for new systems while religious organizations, among others, are forming programming networks to take advantage of unused cable television channels.

Performing arts organizations are welcoming the proliferation of cable television and the opportunities it provides for the programming of symphonies, jazz, opera, theatre, and dance, just as in earlier years the advent of movies, records, and television was hailed as a boon to the lively arts. For serious art forms, however, the benefits to date have been disappointing, although the arts have enjoyed an expanding audience through public television. Cable television will not create a revolutionary change in the arts, although it will have a positive effect on audience development.

In 1970 less than 10 percent of American homes received television programming through cable transmission as opposed to receiving it through the airwaves. In fact, most cable programs were merely broadcast signals that were relayed through a wire. By 1982 over 25 percent of American households had cable and by 1990 that figure will be over 60 percent. More significant, programming originated by or for cable will have greatly increased.

When discussing the field it is helpful to distinguish between the transmission of the signal and the supply of the programming. A cable television system provides audio and video transmission to individual receivers via a cable. The cable is attached to a television set, replacing the need for an aerial. The cable television company supplies the transmission to a geographic area through a cable system. Cable systems were started by local entrepreneurs who recognized a need for quality television reception. These operators built the antennae, arranged for the cables to be strung or to be laid in the ground, and marketed the service to the community. The systems increased viewership, which made broadcasters happy, and subscribers happily paid a monthly fee to the system operators. But cable made it possible for the systems to deliver more channels than those that were allowed to receive transmissions through the airwaves; with this capability, operators soon began delivering additional programming for an additional charge—first-run movies, sporting events, and so forth. The increased number of channels opened the market for increased programming and this led to the formation of cable television programming companies, which, in turn, led to an expansion of the market. Cable television systems became lucrative ventures and attracted the interest of other entertainment corporations. One of the first developments was the formation of cable television networks, called multi-system operators or MSOs. There are now hundreds of MSOs operating

regionally and, in some cases, nationally. As with broadcast television, the more viewers, the more valuable the service. Because MSOs can attract more viewers than individual cable television systems, they are more attractive to advertisers.

MSOs are corporate entities that purchase, produce, and deliver programming to subscribers. Some large MSOs are subsidiaries of giant corporations, such as Warner, Cox, and Times-Mirror. An MSO is headed by a president, who is usually a director within the parent company as well. Under his or her supervision are departments of programming, finance and/or administration, advertising sales, marketing, and franchising. Each of these is headed by a vice-president or director, who is reported to by regional or city representatives from the affiliated systems.

Much of the activity and growth of an MSO occurs when it is acquiring or renewing franchises. In order for a system operator to install cable, permission must be obtained from the city or local government. Because a cable television franchise is a potentially valuable asset, the competition to obtain franchises is very lively. MSOs form franchising teams to win these permits. Although activity in this area has slowed since most of the franchises were initially awarded, there should be renewed efforts as existing ten-to-fifteen-year franchise agreements expire and refranchising becomes necessary.

A franchise team moves into a city that is accepting bids and develops a campaign designed to win the monopoly rights. The team, which reports back to the corporate headquarters of the MSO, includes the following personnel:

Franchise manager: supervises the staff, reports to corporate head-quarters, and negotiates for the MSO with city representatives

Engineer: determines the feasibility and cost of constructing a cable television system and recommends needed equipment

Market analyst: prepares surveys to determine the potential size of the market and the programming it desires

Financial analyst: determines the cost of the system and helps to determine the franchise bids

Public relations manager: markets the concepts of the MSO proposal to the local press, community and government; works closely with public-access interests

Each cable television company's franchise bid is evaluated, and a contract is awarded. Large cities may divide their areas geographically and award franchises to different operators. The systems then build studios, erect receiving stations, and wire the communities in anticipation of gaining subscribers. When a franchise agreement expires, a similar franchising process complete with teams is activated.

Eventually, a general manager is hired to run the cable television system and, having a function similar to the general manager of a network O & O, is

responsible to the MSO, or to cable network headquarters. (See Chart 18.) While supervising a staff of engineers, technicians, administrators, public-relations and marketing personnel, the general manager's primary responsibility is to maximize profits by increasing the number of subscribers to the system. Subscribers pay a basic monthly charge to receive a package of programs, which include broadcast programs, some cablecast movies, sports, information programming, and some local programming. The cost of this service to subscribers and the cost of any additional pay services are determined by the franchise agreement, which may be further renegotiated by the general manager or at the corporate level.

Chart 18
Executive Organizatiion:
A Local MSO Cable Television System

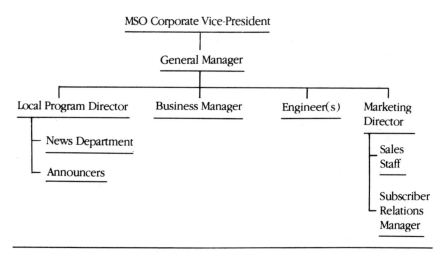

Many cable television system general managers have a background in television broadcasting. Important skills necessary for the position include a knowledge of programming, an ability to understand the technical aspects of television, and an ability to market the service. Also necessary is the ability to evaluate and supervise the required professional staff and to maintain budget and control functions for the system. The organization of a cable television system is similar to that of an affiliated or independent television station.

The easiest and surest entry into cable television is through sales. The system becomes more profitable as more subscribers are signed up. As is true throughout the arts and media industry, successful sales people quickly receive recognition and advancement. An initial door-to-door selling approach

is followed by direct-mail and on-air pitches to maintain and increase subscribers and to sell additional pay services. Most systems pay commissions to their sales people and such jobs are plentiful for tirelessly aggressive candidates. There are also frequent openings for other cable television system jobs, most of which can utilize skills transferred from other types of arts and media organizations.

Cable Television Programming Companies

Many cable television systems have a capacity of over one hundred channels, which has greatly increased the programming market and the types of services available to subscribers. Fees paid by subscribers are divided between the system operator and the programming company that delivers the service; or the program is provided free and the programming company sells advertising time.

Programming corporations deliver their signals to cable television system operators via satellite, in effect becoming a national channel that is distributed through the cable television systems. Many programming companies are subsidiaries of larger communication or entertainment corporations: the Playboy Channel is owned by its publishing parent, the Disney Channel is owned by Disney, Inc., and Bravo is owned by ABC, Inc. The latter offers performances of classical music, plays, opera, and ballet together with interviews and features related to the arts. Some programming organizations produce original programs while others, such as Disney and Warner Communications, rely heavily on their large inventories of feature films. Other services are entering joint ventures with film and television companies to coproduce programs that are shown in movie theatres, on network television, and on cable television channels, and that are also sold as video cassettes.

The president of a programming corporation is usually an officer of the parent company and is the link with that corporation. The middle-management positions reporting to the president, usually with the title of vice-president, are responsible for finance, marketing, sales, company operations, and both the acquisition and production of programs.

Local-Access Television Channels

Local-access television channels enable ordinary citizens in a community to originate or select their own programs, if not to participate in them as well. Many communities with cable television systems have designated local-access channels for the presentation of programs in such areas as health and social services, local sports, the performing arts, community events, and government affairs. Sometimes the cable television system operates these channels and

sometimes they are operated by the local government, through the office of parks and recreation or through the mayor's office. Many communities have also chosen to form their own nonprofit local-access corporation to operate the channels independently.

A nonprofit local-access corporation is often funded through provisions made in the franchise agreement with the cable television system operator. Under such provisions, the operator supplies equipment, studio space, start-up funds, and ongoing annual support based on the number of paying subscribers within the system. A local-access corporation serves a number of functions: It operates the designated access channels and insures that these may be used by local residents for reasonable purposes; it educates and trains the community in the use of the equipment; it programs the channels that it controls. The executive director of a local-access corporation reports to the board of trustees, serves as the liaison to the cable television system operator, and functions as an advocate for the board and the community, insuring that the details of the franchise agreement are carried out. The executive director also controls the budget, supervises the staff, serves as chief spokesperson and fund raiser, and sets up educational and training programs for the community.

Local-access corporations raise funds through grants, corporate underwriting, memberships, and individual contributions. Most have a small staff: executive director, secretary, and a studio manager and/or engineer. Those with annual budgets over $350,000 also have a business manager, a local-access coordinator, a development director, a membership director, teachers, technicians, and camera people. Local-access channels are relatively new, so there is no established career path to the executive director position, although experience in fundraising, educational programming, and, importantly, a technical knowledge of television are prerequisites. Almost every cable television system has some form of local access. Communities that do not have separate local-access corporations have channels managed by the cable television system operator, and each operator usually has an access coordinator. Obviously, the job opportunities in this area are numerous and the experience gained provides an excellent stepping-stone to higher-paying positions with larger media corporations.

The major trade association for the cable television industry is the National Cable Television Association (NCTA), and the national service organization for local access, based in Washington, DC, is the National Federation of Local Cable Programmers (NFLCP).

Film Studios

Large film studios today, such as the MGM/UA Entertainment Company, are publicly owned corporations that are as active in the television, including cable system, markets as they are in producing for the traditional movie-theatre market. Because they are organized, staffed, and managed in a manner very

similar to the television networks discussed above, our description of the film business will focus on its fundamental organization and the areas where it differs from the television business. (See Chart 19.)

Film studios are headed by a chief executive officer (CEO) who manages the daily activities of the corporation and its divisions and subdivisions, including relations with the banks and exhibitors. The title may be board chairman, vice-chairman, or president, or, simply, chief executive officer; but, in any case, he or she is responsible to the board of directors and ultimately to the stockholders. Reporting to the CEO are a number of division presidents or vice-presidents who are responsible for the functioning of the following areas:

- *Acquisition and Creative Development:* The department that scouts for and assists the studio in acquiring film properties. These may be finished films that have been produced independently, or "treatments" of novels or story ideas that the studio acquires and then develops and produces itself, or that it has produced by an independent company in which it invests.
- *Production:* The department that assembles a scripted project and actually makes the film for the studio. An executive producer may be assigned to oversee details and to represent studio interests in the project—especially in matters of a monetary nature.
- *Business and Legal Affairs:* An area staffed by accountants, business managers, and lawyers who oversee studio finances, bookkeeping, licenses, and contracts. Executives in this department may work for the studio as a whole or may be assigned to specific film projects.
- *Marketing and Promotion:* This department attempts to determine the best method of selling a film by analyzing—often with the help of independent marketing researchers—the potential audience, by deciding where and when to release the film, and by coordinating efforts of the publicity and advertising executives.
- *Distribution and Sales:* Each film studio maintains its own distribution department, which leases films the studio has produced or acquired to movie-theatre operators around the nation, attempting to secure the most desirable theatres and showing times. The sales department negotiates the specific showing rights to such outlets as television networks, cable television companies, video-cassette distributors, and foreign distributors.

The president of a studio's film division, sometimes known as the production chief, reports to the CEO and is responsible for the acquisition, development, and production of film properties. In the old days, when the studios were less departmentalized and the production chief was more autonomous, production chiefs included such luminaries as Louis B. Mayer, Jack Warner, Harry Cohn, and Darryl Zanuck. Today the film division president

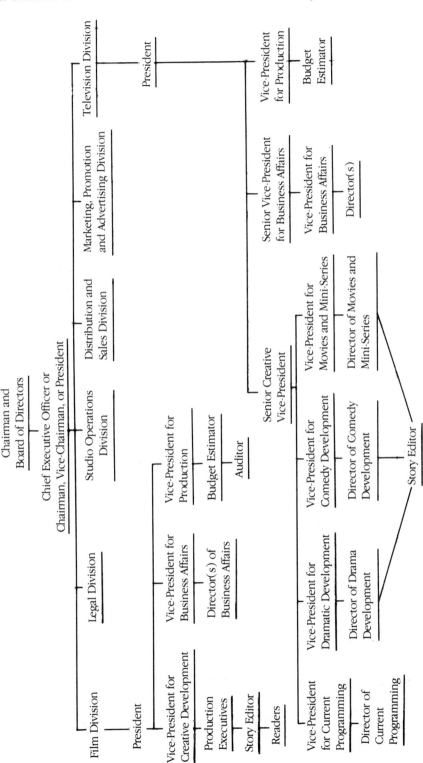

Chart 19
Executive Organization: A Major Film Studio
(With detail of the film and television divisions only)

Chairman and
Board of Directors

Chief Executive Officer or
Chairman, Vice-Chairman, or President

Film Division | Legal Division | Studio Operations Division | Distribution and Sales Division | Marketing, Promotion and Advertising Division | Television Division

President

Vice-President for Creative Development

Vice-President for Business Affairs

Vice-President for Production

Director(s) of Business Affairs

Budget Estimator

Auditor

Production Executives

Story Editor

Readers

President

Senior Creative Vice-President

Senior Vice-President for Business Affairs

Vice-President for Production

Vice-President for Business Affairs

Budget Estimator

Director(s)

Vice-President for Dramatic Development

Vice-President for Comedy Development

Vice-President for Movies and Mini-Series

Vice-President for Current Programming

Director of Drama Development

Director of Comedy Development

Director of Movies and Mini-Series

Director of Current Programming

Story Editor

or chief is still the person who nurtures relationships with leading creative talents, such as Steven Spielberg, George Lucas, William Goldman, and Robert Redford. Like most branches of the arts and media industry, the film business is a people business. Personal relationships and strong bonds are the basis upon which many projects are hatched and deals made; such business is conducted as often in restaurants and at cocktail parties as in the office.

A film division president oversees a staff in the creative development area, and in the production department. In development there are executives at various levels who maintain daily contact with writers, directors, agents, and producers, developing ideas and concepts that are then fed to the executive for consideration. On a lower level there is a story department, where all material is also sent and evaluated. The story editor, who heads the department, usually assigns the material to a reader who provides written evaluation. If the material is recommended, the story editor will usually give it a second reading and offer a second opinion.

The production department is responsible for physically assembling a project from script to screen, as it were. Here the screenplay is broken down, put on a story-board, and budgeted. Story-boarding is the method used to determine a shooting schedule. Estimates are then prepared to establish the length of time needed for each set, character, location, and day's or night's filming. The budget, of course, determines the approximate cost of the entire production and is prepared by a budget estimator. Once a film goes into production, the business affairs department works very closely with the producer and the production manager with regard to the amount of hours the cast and crew work each day, the number of pages filmed in relation to the previously planned schedule, and whether or not the project is on budget for the day.

The business affairs department generally makes the deals with the above-the-line participants, such as the producer, writer, director, and cast. This department is largely comprised of lawyers. Upon completing a negotiation they set forth the terms of the deal in a deal memo, which is a temporary agreement that binds the two parties until the legal department prepares a more formal and extensive contract. It is not unusual for a contract to be completed and signed long after the services it defines have been performed.

Film distribution is the sales process by which a company sells a motion picture to exhibitors for screening. The distributor and the exhibitor split the box-office receipts. Profit-participants, such as the producer, the director, and the stars, get their shares from the distributor's net.

The television production division of a film studio works in a manner similar to the film division. The major distinction is that while the film division obtains its financing from the studio, the television division gets its primary funding from the buyer, which in most cases is one of the three television networks. In essence, the network commissions or licenses the studio to put together a specific production. In exchange, the network will pay for the rights

to broadcast the presentation twice within an agreed-upon period of time, usually a couple of years. This payment by the network is called a license fee. Although the network provides most, if not all, of the production cost, it doesn't own the property. This gives the producer, in this case the studio, the right to generate additional income by distributing the property for syndication and in foreign and other ancillary markets.

The television division's president, whose role is similar to that of the film division president, oversees all development and production and answers to the studio CEO regarding all matters pertaining to the division—from shows coming in over budget to making a deal for the exclusive services of a particular writer. Answering to the president is a creative senior vice-president and a business affairs senior vice-president. The creative vice-president is responsible for the development of all new programs, as well as for overseeing current programs already in production. Like the president, the creative vice-president is also interested in bringing various properties and creative talent to the studio. The senior vice-president of business affairs oversees a staff that arranges all deals involved with the television division, from negotiating an actor's salary for a series episode to negotiating the license fee for a multi-million-dollar mini-series. The business affairs department is usually brought in at the very beginning of a relationship between a development executive or producer and a writer. Even before the writer's concept is put on paper, the development executive will have business affairs make a deal with the writer's agent to cover every aspect of the concept's possible growth. In the event that the idea is successfully sold to the network and a script is subsequently ordered, all fees have already been negotiated.

Reporting to the senior creative vice-president are vice-presidents of drama development, comedy development, movies and mini-series, and current programming. Each area usually has a director of development and a story editor as support personnel. To illustrate how the system works, let's imagine that an independent producer contacts a studio executive and presents an idea or concept for a television series. If the studio executive shares the producer's enthusiasm, a number of studio meetings take place to work out the concept and to prepare a pitch for a television network. If the executive representing the network finds merit in the project, a pilot script is ordered. The producer and the studio then ask the business affairs department to negotiate a deal with a writer to write a story and screenplay based on the concept. If the network likes the script, it orders a pilot film to be made. The production department breaks down the script, prepares a budget, and employs a director, cast, and crew. When the pilot is completed, the network decides if it meets its current programming needs and, if so, the series is entered into the network's schedule.

The responsibility of the vice-president of movies and mini-series is to develop movies for television and limited-run series. These programs are geared for a one-time showing. Two to three hours is the standard length for

television movies, while a mini-series may run anywhere from four to twelve hours.

The executive in charge of current programming is the liaison between the studio and the producer of a television series that is in production, and also between the studios and the network. This person will be involved with all stages of script development for each episode of a series or project; he or she must view the "dailies," or "rushes," of the film or tape shot the previous day, and must make certain that the production is conforming to the original plan.

Independent Film Companies

A majority of films today are produced by independent film companies. These are usually headed by a president, who also serves as the producer or executive producer. Financing may be based on money earned from past productions, funds acquired from a studio in advance of production, or capital raised from private investors. If the independent film company has established a financial arrangement with a bank, it may underwrite the cost of producing a motion picture itself. Once the film is completed, a deal can be made with a studio for distribution. This is called a "negative pick-up," because the studio is buying a completed negative for distribution. Usually, however, the independent aligns itself with a studio for both financing and distribution purposes.

With the exceptions of a creative development executive, who solicits material for consideration, and a production and/or business affairs executive, most personnel who work for independent film companies are hired as needed for particular projects. These include the same types of specialists employed by studios, excluding those in the distribution and sales area.

Film studios and many independent film companies produce films for television, cablevision, and cassette distribution as well as for movie theatres. But this activity, as productive as it is, represents only one portion of the American film industry. There are literally thousands of other independent companies, many located outside Los Angeles and New York City, that specialize in educational, military, documentary, and industrial film production, not to mention those that produce television commercials. The majority of such companies are headed by an owner-producer, who conceives, develops, and produces films with the assistance of a small staff. But many entry-level and apprenticeship positions are available with such companies and provide good training for a career in the film business at large.

Talent Agents

Talent agents represent creative artists, such as performers, writers, and stage directors, and must be licensed as businesses by the state in which they

operate. Some must also be franchised by the labor union to which their clients belong, such as Actors' Equity Association or the Screen Actors Guild. Many agents work without any staff, while others establish a large, corporate office with numerous sub-agents and a support staff. Individual agents tend to specialize in one type of talent—literary, acting, musical, or whatever—while large agencies often handle a great diversity of talents. Not surprisingly, a majority of agents once were or aspired to be artists themselves, and this is very helpful in understanding their clients' abilities, problems, and needs. Nonetheless, agents serve a managerial function in the arts and media industry—a function that is central to the entire production process.

Agents work to accommodate the talent needs of producers, presenters, and publishers. Their payment, however, comes from their artist clients and is a flat 10 percent of whatever fee—including royalties and residuals—that their clients receive as a result of the agents' efforts. Some clients sign on with an agent for the purpose of obtaining a single employment or publishing opportunity, while others sign an agreement that permits the agent to be their exclusive representative for all opportunities over a specified time period. Even if a client finds work on his or her own or someone else does during this period, the agent still receives 10 percent of all earnings. This 10-percent fee is standard throughout the industry and is not negotiable. What is highly negotiable, however, is the compensation that the artist will receive from the employer, and it is the agent's primary task to make that compensation figure as high as possible, thereby increasing the value of the 10-percent fee.

Successful talent agents possess business and negotiating skills together with a thorough knowledge of at least one artistic discipline, an understanding of the market for that discipline, and a very sharp eye for talent. It is common for people to enter this field in a secretarial or assistant position; then become a sub-agent; and then move up to a larger agency—often taking their clients with them—or establish their own agency.

Mention should also be made of casting agents, who are similar to talent agents except they are paid by producers to identify and deliver most if not all the performers needed for a particular project, be it a Broadway musical or a television commercial. The casting agent does not have agreements with a "stable" of clients but, rather, works with talent agents and individual artists. He or she must maintain a large file of resumes, photographs, and audition tapes, and must necessarily have something close to a photographic memory. Casting agents must also develop keen insight into the artistic tastes and visions of the producers, directors, and writers whose projects they are hired to populate. Needless to say, literary agents must be tireless readers, while agents for performing artists must spend much of their lives in an audience of one kind or another.

Artist Management

Artist managers provide the same services for their clients as talent agents, but they tend to serve them for longer periods of time, give more individualized attention to artistic and career development, and perform more services. In return for this they receive a fee ranging anywhere from 10 percent to 25 percent of their clients' contractual earnings. Most handle more than one client and specialize in a particular type of talent, such as classical pianists or film actors. The best managers are seriously concerned with developing and protecting their clients' careers, while also promoting them and negotiating their employment contracts. In the classical music and opera fields young artists often sign long-term contracts with artist managers, understanding that there will be few important engagements during the early years of their careers when they must continue to study, develop, and perform with lesser-known orchestras or opera companies. The manager "plots" the artist's career, sometimes foregoing large booking fees and intensive touring schedules for which the client is not artistically prepared. Then, when the artist has matured, the best and most lucrative venues are secured and both artist and manager benefit.

The best artist managers are very selective in choosing the talent they represent and have well-educated taste in their area of specialization. In addition, they must have extensive contacts and a reliable reputation among those people and organizations that hire or book artists: presenters, managers of concert halls, performing arts centers, theatre and opera companies, symphony orchestras, recording companies, not to mention casting agents, film companies, and others.

Artist managers, like agents, may function as a one-person business or within a large firm. In the larger companies—all but two or three of which are for-profit corporations or proprietorships—functions are decentralized and artists are handled through departments headed by vice-presidents. (See Chart 20.) Some divide talent by artistic discipline and some by the geographical regions of the nation and parts of the world in which their clients perform. Obviously, such positions require people who have specialized knowledge. Someone who has worked as a presenter in the Midwest would probably have good contacts among the presenters in that region and may, therefore, qualify for a position in an artist management firm, as may the former general manager of an orchestra who booked numerous soloists and guest conductors. Artist managers, among other things, are sales representatives and spend much of their time on the phone or in the field trying to garner employment for their clients. In a large firm other executives are responsible for marketing, publicity, touring, and contractual arrangements. The president and senior vice-presidents for talent are responsible for signing the talent and developing new talent. A few of the largest artist-management companies are Columbia Artists Management, Inc. (CAMI), and International Creative Management, Inc. (ICM).

Chart 20
Executive Organization:
Music Division of a Large Corporate
Artist-Management Agency

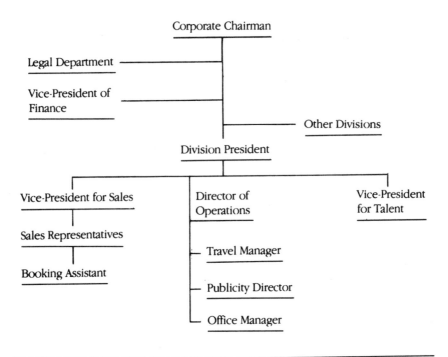

It is not unusual for an artist-management company to work closely with a promoter, presenter, or producer in putting together a "package" of talent for a particular film, play, television series, opera season, music festival, or other project. The firm may sell a novel written by one of its clients to a film company, for instance, and then suggest one of its film directors, a few of its actors, and perhaps another of its writers to script the adaptation. It should be mentioned, however, that it is neither ethical nor legal for artist managers, talent agents, or casting agents to receive payment from both artist clients and management regarding the same set of contractual arrangements.

Highly successful artists may also employ a personal manager in addition to an agent or management firm. This person usually works full time for the artist and handles such personal matters as finances, investments, transportation, living and hotel accommodations, and maybe even the artist's legal affairs. It is possible, therefore, for an artist to be paying an agent 10 percent, a business

manager or attorney 20 percent, and a personal manager 25 percent, leaving only 45 percent of earned income for personal use!

Some of the most successful artist managers began their careers in secretarial or clerical positions in the field, then moved into sales, and then up the ladder to talent development. This is a field with a tradition of promoting from within, so if it is of interest to you, plan to start at the bottom and keep your eyes open for advancement opportunities.

Arts and Media Service Organizations

Although service organizations that provide funding, technical assistance, and management and labor support for the arts and media industry are treated with detail in Chapter 8, they also deserve mention in a chapter that describes how that industry is organized. This is especially true because so many executive jobs with service and support organizations require knowledge and experience in the production areas that they serve. For example, an experienced fund raiser for an arts organization would be a good candidate for an executive position with a fund-*giving* organization; a finance director or legal counsel for an arts or media company would be qualified to work as a consultant for a management or legal assistance group; and one cannot imagine the executive head of a professional association, union, or guild who does not have direct experience in the profession or trade whose practitioners he or she represents.

Moving from arts and media management into arts and media service and support can be a gratifying career step, because, as in teaching, one is able to channel one's experiences, both good and bad, into helping others, benefiting the profession as a whole.

Arts and Media Schools and Educational Programs

There is an old saying that those who can't do it teach it. While this does not hold up under scrutiny—education is a vital facet of any profession—it nonetheless seems appropriate to conclude this chapter about the organization of the arts and media industry with a look at the executive structure of the relevant training programs. As with positions in the service and support area, the field of education requires job candidates, both teachers and administrators, with professional experience.

There are thousands of different schools and training programs in the arts and media industry, and most require at least one professional administrator. Many have large, sophisticated management staffs, comparable to those in other arts organizations. Skills and qualifications are easily transferable.

Educational programs that prepare students to work in the arts and media industry may be categorized as follows:

College and university schools or departments
Conservatories that grant degrees and/or diplomas
Professional schools and training programs
High schools and preparatory schools
Community schools
Summer training programs and workshops
Independent schools

Except for some of the independent schools, all of the above are operated as nonprofit organizations with a board of trustees, and all need to raise unearned income as well as tuition and other types of earned income. In most secondary and higher education programs the chief administrator holds an academic title, or "line," and is also an instructor. This program chairperson reports to a principal, dean, vice-president, or president and is responsible for managing a budget, hiring and supervising teachers and staff, fundraising, recruiting students, and, usually, producing or supervising live or electronic productions or exhibitions that are shown to the public. The demanding position of chairperson or program director in a major academic setting requires someone with leadership ability, strong professional and/or academic experience and reputation, and, usually, advanced degrees.

Colleges with sizable arts and media curricula also operate special television, theatre, and exhibition facilities—if not an arts center that incorporates all three. These are usually managed by a professional staff, which is independent of the academic departments and programs, but which must work in a collegial manner to accommodate the needs of those programs. Campus arts and media facilities, as discussed earlier in this chapter under "Presenting Organizations, and Performing Arts Centers," provide countless administrative jobs that require qualifications comparable to those in other branches of the industry. Also, most do not require teaching or other academic credentials, even though many carry benefits similar to those enjoyed by faculty members.

During the past decade there has been a proliferation of academic courses and programs that concentrate in arts and media management on both the graduate and undergraduate levels and, what is more, academia has been eagerly seeking instructors and program heads who have a proven professional track record. Yet, the career option of working in academia seldom occurs to a working professional. The advantages of a faculty position in higher education often include the security of tenure or long-term contracts, liberal health and pension benefits, the comparatively calm campus atmosphere, and the psychic reward of sharing knowledge and experience with students who respect professional accomplishment.

There are also many opportunities for managers in independent schools and training programs. Many ongoing performing arts companies and visual arts institutions operate schools that hire executive directors, business managers, registrars, development directors, recruitment or marketing managers, not to mention instructors. Such schools can offer entry into arts and media management and can also provide valuable contacts within the profession.

Yet another option in career development is to move from an academic to a professional institution. As mentioned throughout this chapter, many types of arts and media companies and institutions fulfill some kind of educational function. This may entail art classes offered by a museum, technical training programs given for local-access users by a cable television system, appreciation discussions sponsored by an opera company, or the educational programming provided by a noncommercial radio or television station. Arts and media teachers or academic administrators have the knowledge and expertise to qualify for many of these jobs if they feel inclined to put their school days behind them.

☆ 6 ☆

Jobs in
Financial Management

While most American industries were quick to adapt modern technology to their business needs, arts companies lagged stubbornly behind. Only recently, for example, have many box offices accepted credit cards. And the use of computers by arts organizations is still a relatively new phenomenon. One strongly suspects that this was because of the dominance of old-school managers. Also, the performing and visual arts are "handcrafted" products, which make them economically anachronistic. Production-line manufacturing techniques don't work in the performing and visual arts, a factor that has created a long-standing economic dilemma. One cannot trim costs by eliminating the second movement from Beethoven's Fifth Symphony, for instance, or by reducing a string quintet to four players or by cutting two or three characters out of *Hamlet*—at least not without replacing musicians with synthesizers or replacing actors with robots. However, the presentation of the live arts on television and cablevision and the use of modern technology as a management and marketing tool have begun to assist the arts economically.

What Is Financial Management?

The task of raising the capital necessary to start up an arts company or project is the responsibility of entrepreneurs, producers, or founding directors. After the initial funds have been raised, however, they must be prudently managed to insure that they are put to optimum use. And then revenues must be generated to cover operating costs, to sustain and expand production, and, in the commercial sector, to generate profits. Financial management is primarily the supervision of all funds and other assets for a company or organization.

The various jobs related to financial management play a vital role in facilitating the creative work of arts groups; these functions can also be creative in and of themselves. There is a story about an executive who interviewed three finalists for the job of accountant. He began by asking each candidate to add three plus three. The first two candidates immediately answered "six." But

121

the third candidate paused for a moment, then asked the executive, "How much would you *like* it to add up to?" Guess which applicant got the job!

Sitting all day at a ledger or a computer dealing with numbers and balancing columns of figures requires an exacting mind as well as one that is able to come up with creative *and* honest solutions that may facilitate a particular project or even determine the existence of a project or of an entire organization. The financial or business managers for arts companies are often asked such questions as—

Where will the cash come from and when?
How can this grant proposal be presented so the funder will think we're solvent?
How can we avoid appearing to overfund this project?
Should we buy a new piano or rent one?
Which creditors can wait a little longer to be paid?
Will there be enough money to meet the next payroll?

Furthermore, the finance person is sometimes expected to answer these questions for artists who do not understand finance, for board members who do not understand art, for investors or funders who think they know more than the finance manager, and for hostile creditors who want fast payment instead of fast answers. Communication skills are essential to good financial management.

In a small organization there may be only one general manager or business manager to handle all pecuniary tasks and responsibilities. Large institutions and companies have a finance department in which responsibilities are divided among a vice-president or director of finance, controller, accountant, box-office or admissions manager, bookkeeper, and others. The main areas of concern for the finance person or department are—

1. Budgeting and budget control
2. Payroll and benefits
3. Insurance
4. Taxes
5. Banking, including loan procurement
6. Cash-flow projections and management
7. Periodic financial reporting, internal and external
8. Maintenance of daily ledgers and journals
9. Purchasing, renting, and inventory control and depreciation schedules
10. Supervision of the box office; accountability for ticket sales and other earned income
11. Management of grant and other contributory income
12. Investment of available funds

The head of finance reports directly to the executive director or president. If there are directors or trustees, the chief financial officer is also accountable to

the board treasurer, who is probably also chairman of the board's finance committee. Although annual financial reports based on audits are prepared by an outside CPA with in-house assistance, with the results presented directly to the board, a busy organization will employ one or more accountants to handle the daily routine. Large organizations require a sizable staff to conduct the affairs of the business and financial department, which may include collecting, accounting for, and managing income from a wide variety of sources, as well as the management, control, and reporting of expenditures.

As illustrated by Chart 21, the finance department must work closely with other departments and, in fact, probably has more interdepartmental dealings than any other. For example, while the marketing department is responsible for generating ticket sales and other types of earned income, actual ticket orders, as well as mail orders for catalogue merchandise are usually processed by personnel who work under the finance officer. Similarly, the development director generates grants and other contributed income, but the money itself is received and managed by the finance department, which must also prepare financial reports for the grantors. Film and television companies depend upon sales and distribution departments, but once contracts and sales agreements have been made, they are turned over to a business affairs department for execution and income collection.

The most valuable business managers are those with the ability to offer their superiors clearly articulated sets of options regarding the possible use of money and other assets. This should be done objectively, without questioning the value of the policies and projects under discussion—that is for the board or top leadership to debate. On the other hand, if the organization cannot afford certain expenditures, the president or board must be so informed. The more familiarity the finance manager has with the arts or media product and the more experience he or she has with the company or organization, the more valid the financial projections and recommendations are likely to be. Knowing the track record of a company and its relations with markets, vendors, and funding institutions is of tremendous help to a finance officer.

Chart 21
Executive Organization:
Finance Area for a Large Nonprofit Arts Institution

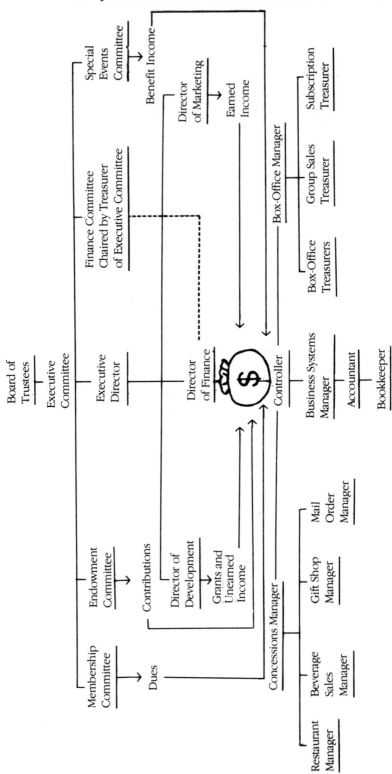

Note: While concessions and box-office management often fall under the supervision of the marketing department, they are accountable to the finance department.

Many people who take finance jobs in the arts and media industry have no special background in the field and many soon leave those jobs for more lucrative positions in other industries. Entry-level salaries, especially in the not-for-profit sector, are usually lower than qualified candidates can command elsewhere, although finance jobs with large nonprofit and commercial arts organizations often pay very well. However, financial directors can earn salary increases by saving money for their organizations through skilled and creative management, just as a fund raiser can earn increased compensation by increasing the level of contributed income. Arts organizations are best advised to hire people who have a special background and love for the arts, and managers of small companies should acquire business skills to assist them until they can afford to hire specialists.

Director of Finance

A director or vice-president of finance is the manager of the department and supervisor of a staff of specialists that may also include assistants and secretaries. The director usually has hire-fire authority and is involved in the long- and short-range planning for the organization; he or she also has responsibility for anticipating cash needs, securing loans, reinvesting cash, managing an endowment or investment portfolio, and personally representing the company or organization to the business and financial community, and to the board through a finance committee.

The finance director must obviously have a strong business background, perhaps an M.B.A. in finance or equivalent training. Because most arts and media organizations large enough to hire finance directors have their businesses computerized, these directors usually are required to have knowledge of data processing and computerized business systems. Their value to their employers, as mentioned, would be enhanced by a knowledge of the particular art form, since many judgments are based on familiarity with arts-related materials, salaries, consultants' fees, royalties, equipment rentals, contracts, and other expenditures that directly affect the quality of the artistic product. This is obviously not an entry-level position. Responsibilities include designing financial systems, participating in policy-making, filing of all governmental reports in a timely manner, and organizing the accounting function.

Business Systems Manager

Large arts and media corporations often require a specialist in computer technology who can assist with the purchase, operation, and maintenance of computer hardware and software and also design computer programs. This is an operations position that may be included in the finance department, although the job will obviously involve all departments that utilize

computers—the systems manager may be hired by the operations or marketing department. While a knowledge of the arts is not necessary, it would be helpful. This is especially true in regard to technological applications for stage, film, and television production. Specialists in these areas are often scene, lighting, or sound designers who have acquired additional skills in technology.

Small outfits that cannot afford a full-time systems manager must meet their needs by hiring consultants. Also, systems time-sharing is increasingly popular today. While there are numerous computer specialists available to handle such part-time work, comparatively few have a knowledge of the arts field, which makes it somewhat risky for small arts groups to hire them.

Controller

A controller—sometimes referred to in the archaic form, comptroller—has the main accounting responsibility in a business organization. The controller reports to the finance director or, in small companies, takes on many of the finance director's tasks and reports directly to the executive director or president. The controller must oversee production and other budgets, make realistic estimations of costs—revising these as required—and negotiate on behalf of the organization with suppliers, unions, renters, travel agents, and others. The job also calls for constant monitoring of expenses in relation to budgets.

The controller must be able to understand financial reports, budgets, and cash forecasts and must be creative in manipulating expenses and controlling costs. Although an advanced degree in finance may not be required, a facility with numbers is essential. The most qualified controller for a particular position will have hands-on experience in the arts field and will know, for example, how many work-hours it will take to build a set, restore a painting, rehearse a new symphony, rehearse a symphony already in the repertoire, or rehearse a replacement for an ailing tenor. The controller is also often asked to project expenses for extending an engagement, for example, or for videotaping a live performance, or for touring a production, or for renting the facilities to an outside group. For such reasons, controllers and, hence, finance directors, often begin their careers in some area of production management.

Production Estimator

A production estimator's job is similar to that of a controller, except that this is the job title used in relation to film and television production. Here, for example, budgets are determined by story-boarding a screenplay, or breaking it down into scenes to determine the sets, characters, locations, and shooting

time required to shoot each scene. Obviously, the person who estimates the exact costs for these elements must be very knowledgeable about media production; he or she probably has experience as a production, studio, traffic, or unit manager and, just as probably, is hoping eventually to move into a higher job in the business-affairs department of a media organization. Both controllers and production estimators are financial analysts of sorts and most combine a business background with a special interest in the arts and media field.

Accountant

The accountant in an arts or media organization performs the same duties as an accountant in any other field and, therefore, requires little specialized knowledge of the arts—unless, of course, the person is required to assume additional responsibilities and become involved in the policy-making process, or unless the individual has aspirations to a higher position in the arts and media field. Excluding such possibilities, an accountant familiar with accounting in the nonprofit sector outside the arts world could make an easy transition to a nonprofit arts organization. Or one could easily move from most any accounting position in the commercial sector into a commercial arts or media company. Job duties usually include managing the payroll, keeping the ledgers and journals, compiling monthly statements, balancing the books, checking box-office and other sales statements, and providing the financial information necessary for grants applications or other special documents. The accountant should also have the technical knowledge needed to assist independent auditors in preparing for the audit at the end of the fiscal year.

An undergraduate degree in accounting would be a desirable qualification for this job, in addition to some knowledge of data processing. Some arts organizations operate on a cash-accounting basis, but there is a clear trend toward accrual accounting, and most large organizations already operate on this system. In fact many funding organizations require the accrual method as a condition for being considered for a grant.

Bookkeeper

A bookkeeper is responsible for recording all financial transactions in a daily journal and later transferring them to a ledger. The bookkeeper may also prepare the payroll, computing taxes and other withholdings as well as royalties, percentages, and commissions. When this position is supervised by an accountant or controller, it can be performed by someone with little rudimentary training who has a feel for numbers. It is a good entry-level position for someone interested in a career in financial management.

Business Manager

The generic term for all finance positions in an arts organization has always been *business manager.* This term could be expanded to include everyone from the director of finance to the bookkeeper and, in some cases, may even include the executive director. If you apply for a job with this title, we suggest that you look at the entire staff of the organization, and the specific responsibilities assigned to each person, in order to determine the business manager's functions. For example, if there is no executive director or general manager, the business manager will usually function as both director of finance and executive director. If the position requires that you report to the executive director *and* to the finance committee or board treasurer, the position will be similar to that of finance director. However, if the main duty of the position is to keep books—no matter what the title—it is basically a bookkeeper's position.

Box-Office Manager

Jobs related to the overall supervision and management of a box office in both the commercial and nonprofit sectors often involve an executive who works outside the box office itself. This may be the general manager, finance director, business manager, marketing director, house manager, or one of their assistants. In large theatres the job often requires an executive who can diplomatically impose management policy on unionized box-office personnel, called "treasurers." Such employees often have greater job security than their supervisors and are usually resistant to any changes in the way they handle tickets or customers, so the box-office manager's job may not be an easy one. Nonetheless, box-office operations must provide the accountability demanded by the finance office; must be consonant with the image that the marketing and promotion office is attempting to project to the public; must serve customer needs as efficiently and politely as possible; and must provide assurance that security of funds and accountability will be preserved.

Box-Office Treasurer

Box-office treasurers, sometimes unionized employees, are responsible for handling, allocating, distributing, and selling tickets, and probably have more direct contact with actual and potential ticket-buyers than anyone else in the organization. They may report to the business or finance director, to the general manager, to the marketing director, or to one of their staff members who serves as the box-office manager. Honesty and an ability to deal well with the public are desirable qualities, together with a disciplined accuracy in handling cash, tickets, telephone orders, and credit transactions. But there is no special training that cannot be learned on the job, so this may be

considered an entry-level position and, unless one wishes to make a career as a unionized treasurer, a good beginning for a future in marketing or financial management.

☆ 7 ☆

Jobs in Marketing, Public Relations, and Sales

Executive directors and presidents of arts and media companies may be adept at managing computerized mailing lists, market surveys, and advertising, but the time involved makes it necessary, when the budget allows, to hire specialists in marketing, public relations, and sales who have the education and skills to devote themselves exclusively to these areas. These specialists possess expertise that may be applied to similar jobs outside the arts and media field. But, as with a finance or development officer, the marketing executive is valued according to his or her contacts and track record within a particular industry, discipline, and community. It takes a while to cultivate relationships with the press and media people who make decisions about which press releases and stories will get space or time and which will not; it takes time to research and understand the demographics of a community, thereby identifying the highest potential market for a product. And it takes time to develop profitable relations with the buyers of a product—presenting organizations, film studios or distribution companies, independent television or radio stations, art dealers, or whomever.

Jobs in marketing, public relations, and sales exist in all types of arts and media organizations excluding service and support groups such as unions, foundations, arts councils, and technical assistance organizations—although these organizations may have a public information officer, as described below.

What Is Marketing, Public Relations, and Sales?

If you can get someone's attention, pique their interest, plant the seeds of desire, and then make them take the action of buying the product or service, you are marketing. These four steps in the process of making a purchase— attention, interest, desire, and action—have been called the "Aida" marketing model.

Until recently, the marketing of arts and media products was overly bound by tired traditions. For example, Broadway shows only began to be advertised

on television in 1973—which was only shortly after television ads for films and novels began appearing. Even the largest nonprofit arts institutions didn't have a marketing department and didn't attempt to earn income through such devices as mail-order catalogues until recently. While press agents have long flourished on Broadway, very few marketing experts are employed there to this day. And, apparently, there is still only one way to design a circus poster. Diminishing subsidies in the not-for-profit sector, however, and rising costs industry-wide have necessitated an increase in earned income and, therefore, a need for imaginative third-century managers who can bring marketing theories and techniques from their graduate schools and apply them to the arts and media industry.

The out-of-date method of selling the arts is to rely exclusively on a press agent or public relations director. Such specialists remain important, but they are simply not marketers in the full sense of that term. Marketing encompasses all aspects of a product, including price and physical distribution, as well as promotion. Marketing relies heavily on research and analysis—studying past box-office records, for example—whereas promotion alone is usually concerned only with the media and printed publicity. The press agent gathers lists and makes contacts among editors, critics, feature writers, and media executives. The marketing expert studies not only those who communicate to consumers, but also the consumers themselves. Based upon the findings, he or she is then able to advise a company or organization as to what, when, and how much to produce or exhibit, as well as how to develop a plan to earn the income that is needed or desired. Viewed in this perspective, the work of a marketing department logically precedes most other activities. Until one can determine a need or desire for an artistic product, identify a large enough group of high-potential buyers, and map out a strategy for attracting those buyers, why purchase the grand piano, option the play, buy the building, acquire the art collection, or commission the composer? Yet, many arts and media managers still believe that a press agent alone will be able to fill the house.

Although some arts organizations maintain a marketing department that is separate from the press and/or public-relations departments, these areas are increasingly being combined under the direction of one executive—usually a marketing specialist. In most performing companies and visual arts organizations the marketing department also supervises all box-office and concession operations, although the income that is generated by marketing efforts immediately becomes the responsibility of the business or finance department. Television, film, and cablevision companies usually have a sales and/or distribution executive, or such a department that functions independently from the marketing and public-relations areas. This is because most of their products or programming are sold or leased to exhibitors, networks, affiliates, or independent media outlets rather than directly to the consumer. After sales or rentals have been made, however, the marketing

departments for such companies work with the buyers to promote products.

While marketing and public-relations specialists both work to generate sales, the job qualifications are somewhat different. The archetype of the modern public relations director is the sideshow barker of carnival tradition. Technology and the media have broadened the process of enticing the public, but the most successful promotion and public-relations people still have a bit of the barker in them, and successful entrepreneurs have always had a flair for selling tickets that is a show in itself. The names P. T. Barnum, Mike Todd, David Merrick, and Rudolf Bing immediately come to mind.

Press and public-relations executives may report to the marketing director or to the executive director or president. Titles in this area vary and the terms *press, promotion,* and *public relations* may be used interchangeably. Responsibilities also vary. Before accepting a public relations job, look carefully at the composition of the staff. There are few other areas in arts and media management in which there are so many go-fer chores that need to be done. Is the position you're being offered really an executive one, or does it require endless hours of running to the printer, delivering ad copy, distributing posters, and chauffering performers and VIPs around town? Small organizations will only require one employee to handle all press, public relations, and advertising duties, while large organizations divide these among various staff members.

While these days the top executives in marketing, press relations, and sales usually hold an undergraduate degree and, often, a graduate degree, most support-positions in the area are at the entry level and do not require specialized training. However, most such positions require good writing, proofreading, typing, word-processing, and speaking skills. To advance in the field, a winning personality combined with quick thinking and lots of imagination will also be necessary.

Director of Marketing

The director or vice-president of marketing is the manager responsible for conducting market research, for developing a marketing plan, and for organizing the staff to accomplish it. This executive usually reports directly to the executive director or president and to the marketing committee of the board, if such a body exists. It may be said that only fairly large arts and media organizations can afford to hire a marketing director, while small ones can't afford not to! (See Chart 22.)

Chart 22

Executive Organization: Marketing, Promotion, and Sales Area of a Performing Arts Center

Board of Trustees

Executive Committee

Executive Director

Marketing and Promotion Committee

Membership and Subscription Committee

Director of Marketing and Promotion

Members Guild

Audience Development Director
- Membership Coordinator
- Community Relations and Tour Coordinator

Marketing Manager
- Market Analyst
- Systems Specialist
- Ticket Service Manager
- Subscription Manager
- Group Sales Manager
- Box-Office Treasurers

Public Relations Manager
- Press and Media Representative
- Photographer

Advertising Manager
- Program Advertising Salesperson
- Copy Editor
- Graphics Designer

The marketing director targets high-potential buyers for a product—an exhibition, concert series, television program, or whatever—and then advises those who have an interest in selling the product on how to develop promotion strategies that will reach those buyers. Hence, the marketing director may be responsible for a subscription campaign; the campaign for a single event; special offers, such as discounts, groups sales, multiple-event purchase; and all types of advertising. In addition, the marketing director may conduct or assist in the negotiation of tours, distribution deals, or sales. The latter would include the sale of any concessionary items, such as souvenir programs, food and beverages, and gifts. In the broadest sense, the position requires a person who, through a combination of data analysis skills and intuition, can perceive the public's attitudes regarding the company or institution and its products, and recommend specific methods for bringing the two together. Imagination and a sense of showmanship, combined with a graduate degree—preferably an M.B.A.—are among the best qualifications for the job. A marketing specialist may move into the arts and media industry from other fields, given a willingness to absorb and understand the goals and nature of the artistic product at hand, and an individual style that is consonant with that of the hiring organization.

Marketing Manager or Market Analyst

A marketing manager—the title could also be market analyst—reports to the director of marketing and is responsible for compiling and analyzing data for presentation to the director, much in the manner of a research assistant. Responsibilities also include compiling and refining mailing lists, supervising the preparation and dispatch of bulk mailings, and assisting with the details of special events, tours, and promotional campaigns. The job's emphasis is on the quantitative, the analytical, and the scientific as compared to the more creative, idea-generating responsibilities of the marketing director. The marketing manager also tracks the expense budget for each project; determining, for example, how much it costs to attract each new subscriber compared to the cost for each renewal. Required skills are specialized, but may be learned through workshops and in vocational college courses. Knowledge of statistics and computers is necessary.

Director of Membership

Many nonprofit performing and visual arts institutions seek to attract members—also called friends or patrons—who pay a tax-deductible annual fee to the institution in exchange for special privileges, such as free parking, invitations to special receptions or lectures, and the like. This fee is over and above what they pay for admission tickets and can constitute an important

source of revenue for the institution. While the volunteer work of board members, special guilds, and committees is very important to the success of membership drives, a salaried executive may be required to coordinate such activities and to provide the follow-up services that are promised to the members.

Nonprofit radio and television stations also invite membership, usually by means of periodic on-air appeals combined with newspaper and direct-mail advertising, and, here again, a salaried membership director or coordinator is usually required. The position usually falls within the marketing department, although it may be supervised by the special events director or by the development director.

Director of Audience Development

In many performing arts organizations the director of audience development is head of the marketing area and is, in fact, a marketing specialist. Otherwise, he or she reports to the director of marketing and is responsible for increasing the sale of subscription, series, group, special events, and individual tickets. The audience development director works closely with volunteer committees and attempts to increase patrons' involvement with the organization and to attract new patrons. The audience development director must be an ougoing, articulate, and personable individual who can mix comfortably with VIPs and socially prominent members of the community, many of whom provide the core of volunteer work that attracts and maintains the nucleus of a loyal audience. A college education is helpful, though not necessary. This is often a good entry-level position for a mature, energetic, and intelligent person who is also an enthusiast of the particular arts organization.

Systems Specialist

As more sophisticated computers and business machines are acquired by arts and media organizations, it becomes necessary to hire in-house specialists who can design programming as well as advise the organization about the purchase, rental, and maintenance of such equipment. This often proves more cost-effective than hiring consultants or merely taking the advice of computer sales people who, of course, often put their own interests above that of the organization. A systems specialist may have various job titles and may serve a number of departments. In large organizations a number of specialists may be employed to manage specific operations such as a computerized ticket system, computerized stage lighting and sound systems, or computerized office systems. The position does not require specialized knowledge of an organization's artistic product or creative operations, unless the job is involved in the production area; but special training in computer sciences is necessary in both cases.

Director of Public Relations or Director of Press Relations

A director of public relations, sometimes called a promotion director, is the head of a department, usually with authority to hire and fire. He or she may report to the marketing director or directly to the executive director or president. This executive is responsible for placing information about the organization with the media and for helping to create and protect the public image of the organization. The most common means used to accomplish this include the following:

1. Press releases
2. Speeches and public pronouncements from various participants in the organization
3. Press interviews and press conferences
4. Placement of feature stories and articles
5. Critics' reviews
6. Free listings and announcements in the media
7. Program and playbill notes, articles, biographies
8. Press kits and special information packets
9. Special appearances, events, and other "happenings"
10. Letters, announcements, invitations

Perhaps the most important requirement for a career in publicity and public relations is the ability to communicate well, especially in writing. Few public relations people can succeed without the ability to write succinctly, creatively, and correctly. Typical challenges facing the public relations professional may include how to reduce volumes of information about a composer or production into a one-page release; how to create excitement about a replacement performer whom nobody has ever heard about; how to soft-pedal the personal problems of the executive director; and how to explain why, after just receiving a $5-million endowment from a wealthy patron, the organization still needs another $5 million. An in-depth knowledge of the art form is not always required, although it is certainly desirable. Also desirable is the ability to work quickly and accurately under tremendous deadline pressures. A large number of professional contacts in the press, media, advertising, and publishing fields is also a big plus, as is a college education that combines journalism, advertising, and the arts.

The director of public relations, or of press and media relations, is the liaison between his or her company and the print and media outlets that communicate to the public. Responsibilities common to this position involve—

1. Keeping up-to-date lists of newspaper, magazine, radio, and television editors, reviewers, and feature writers and using them to greatest benefit

2. Maintaining a list of deadlines that show when copy, ad placements, listing placements, and mailings are due—and meeting due dates
3. Arranging press conferences, interviews, and photo sessions and supervising them
4. Inviting press members to performances and exhibitions and maintaining good relations with them
5. Acting as host for visitors, artists, press, VIPs, board members, volunteers, and others
6. Supervising the distribution of posters, leaflets and give-aways

Although a college education is required for most high-paying jobs in this category, it is certainly possible to begin with a small organization and then, perhaps, acquire additional training as you continue to gain experience. Because personal contacts play such an important role in successful press relations, it is easier to climb the job ladder in the same city or area than to move around geographically.

Press Agent

The title of press agent is generally used by self-employed individuals who work for artists and organizations on a specific project as consultants or as independent contractors—as opposed to working on salary for nonprofit organizations. (See Chapter 9.)

Director of Public Information

The title of public information officer or director of public information is usually associated with an arts council, service organization, foundation, museum, or corporate broadcasting company—in other words, organizations that do not usually promote or sell tickets to events. A public information officer usually holds the highest public relations position within such an organization. He or she is responsible for the public's perception of the organization and serves as the chief spokesperson for it. This requires full knowledge of its operations and personnel, together with an ability to communicate its goals and policies to the public. Typical duties for this job include—

1. Writing press releases
2. Preparing position-papers, reports, speeches, and articles
3. Supervising the production and printing of annual reports, pamphlets, and brochures
4. Acting as a liaison to other arts, media, foundation, service, and government groups
5. Lobbying on behalf of the organization

This is obviously a highly visible position. One must be diplomatic, persuasive, and accurate, and be able to think on one's feet. For these reasons a person who has worked in a government post that requires interaction with the public, or for a large corporation or lobbying group, can often easily transfer his or her skills to the arts and media industry. Experience in customer relations, counseling, and even box-office management would be immediately transferable to public information positions with small organizations.

Director of Community Relations

Large performing companies and visual arts organizations often sponsor tours and other outreach programs. For example, the Charlotte Opera has a touring program that presents over two hundred performances annually to schools, libraries, and community centers throughout North Carolina. These performances provide extra work for company members, as well as income and state-wide exposure for the organization, which, in fact, is dependent upon smaller surrounding communities for its survival. In cases like this, the director of community relations plays a critical role in forming a partnership with civic groups, school boards, social and service clubs, unions, churches, and chambers of commerce. The responsibilities of the position include—

1. Addressing civic groups and clubs as a representative of the organization
2. Providing promotional material and publicity to the sponsoring groups
3. Enlisting the support of local groups for the purpose of fundraising and audience development

Likely candidates for this position come from the ranks of the local community. It is necessary to know the customs, interrelationships between organizations, and the leaders of the various interest groups, as well as to fit comfortably into the community. This may be an entry-level position for someone with prior experience as a volunteer or for someone familiar with local school boards and civic groups.

Director of Advertising

Most arts and media organizations use the services of outside advertising or graphic design agencies. Some meet their advertising needs exclusively in this way, others employ in-house specialists and only occasionally hire independent agencies. Advertising must reflect the policies and decisions of the marketing, promotion, and sales departments; the executive in charge of advertising reports to the head of those areas. Whether advertising is part of the job of a marketing, promotion, or sales executive, or is the responsibility of a

full-time position, the functions are the same:

1. Purchasing advertising space in the print media
2. Buying advertising time on radio and television
3. Supervising the production of display ads
4. Creating, designing, and/or supervising all advertising copy
5. Negotiating with or supervising all copywriters, graphic designers, and printers
6. Controlling the advertising budget and deciding how this budget will be spent

A natural path to the position of advertising director would be from the commercial advertising world. An account executive who also understands and has a sensitivity to an art form could draw on his or her experience to meet the advertising needs of a theatre, dance, or cable television company. Other skills and experience in the illustration, graphics, and printing fields are also transferable to organizations in the arts and media industry.

Courses and seminars on marketing often include information on advertising, as would a graduate program with a concentration in marketing and promotion. Such an education may not be necessary to get a career started in the advertising area, but would become so if you wished to work into higher positions.

Continuity Manager

The continuity manager in a television or radio station works with the sales department and the advertising agency, or directly with the advertiser. The continuity manager is assigned to write copy for the station—introducing programs, for example—and also rewrites agency or client copy. The continuity person also edits copy before it is aired to insure that it conforms to station and FCC standards. This is a good position from which to move up in the advertising and marketing field.

Director of Sales or Sales Manager

In large film studios and film companies a sales director may be a vice-president who reports directly to the president or production chief. Sales responsibilities are divided between domestic and foreign markets and, perhaps, between movie theatre exhibitors and the major television networks, cable system operators, and/or video-cassette retailers. The word *sales* is somewhat misleading here because, except for the cassette market, virtually all major films are leased rather than sold. In any case, once a deal has been made, the business department collects and processes the payments, and the legal department devises and monitors all sales or leasing contracts and agreements.

Commercial broadcasting networks and companies earn their money by selling advertising time around their programming. The director of sales is the person responsible for selling that time and, on the network level, heads a staff of regional and local sales managers who work with advertising agencies and local businesses to sell commercial time. The director works closely with the network's research departments—which is a marketing function—and with station management to determine the advertising rates that will be charged, and to develop sales strategies. This executive must combine excellent managerial, planning, and selling skills and usually has at least a few years experience as a salesperson. Director or vice-president of sales is a high-paying, high-leverage, and very mobile position within the broadcasting field.

In the cable television business the director of sales, or sales manager, supervises the door-to-door sales people who are attempting to attract subscribers to the cable television system.

In the live arts, sales directors are the box-office, admission, or ticket-service managers described below.

Ticket Service Manager

The ticket service manager is a key position with many opera companies, symphony orchestras, and other organizations that rely on subscription sales to gain their audiences. This manager supervises the processing of subscription orders: assigning seat locations, handling all subscription requests and complaints, and providing statistics to the marketing department regarding the sales progress during subscription campaigns. The ticket service manager either supervises the box-office staff or works closely with it and, in some cases, with outside ticket agencies, such as Ticketron. Because this executive may be the only management representative with whom a subscriber or ticket-buyer speaks, it is important that he or she conveys a positive image of the organization—return or repeat business is crucial to future sales. Conversely, reporting to the marketing director about customer reaction to publicity and advertising is an important function. The ticket service manager also works with the development department to assure that important donors and key corporate sponsors are given special attention and, when possible, to identify potential new donors. Other duties of the job include making recommendations about pricing tickets, supervising group sales, maintaining subscriber and ticket customer lists for mailing purposes, keeping records of all ticket income, and overseeing a staff and the necessary paper work.

Group Sales Manager

A fundamental principle of economics holds that it is cheaper to sell a hundred units of a product once rather than to sell one hundred units individually. Hence the importance of group sales. While series or

subscription sales aim to sell each customer a number of different events, group sales aims to sell one event or performance to a large group of people, often offering a discount as enticement. When the volume of group sales is high, a director or manager is hired to process such sales and, more important, to increase them. This requires direct contact with numerous ticket and travel agents, theatre-party organizers, educational institutions, social and professional organizations, and former group buyers. Group sales is supervised by the marketing department, or by the ticket service manager in large organizations.

Subscription Sales Manager

When the volume of subscription sales is high and is not handled by a ticket service manager or by the box-office staff, a subscription sales manager is hired to process the considerable paper work involved and, perhaps more important, to keep the subscribers happy. Thus, this is really a public relations job, though it also requires an eye for exacting detail.

Merchandise Marketing Manager

When special merchandise is sold that is tailored to an organization or to its primary product—plays, operas, films, or the corporate logo, for example—a merchandise manager is hired within the marketing department to supervise the design, manufacture, and sale of such items. Museums, galleries, and performing arts companies often reproduce and sell their posters. And countless other items are designed around a particular company or production: T-shirts, ash trays, buttons, tote bags, umbrellas, post cards, souvenir booklets. These, combined with other merchandise that reflect or relate to the image of the organization, are often sold in lobby gift shops and through mail-order catalogues, providing much-needed sources of earned income. Obviously, jobs in this area require a background in business, marketing, and sales, with no special arts knowledge.

When film studios and networks generate special merchandise to capitalize on their most popular performers, shows, or characters, the manufacturing rights are sold to specific designers or companies, and while the studio or network is not involved in distribution and sales, they may be entitled to a percentage of any profit that is made. Numerous lawsuits, incidentally, have centered around the question of who has the legal right to sell certain subsidiary rights to whom.

Concessions Manager

Arts organizations that operate in large facilities may have the space and the inclination to house beverage stands or bars, restaurants, gift shops, parking

facilties, coat-checking services, and a variety of vending machines. When these are leased to independent concessionaires, the organization is placed in the role of a landlord, and the rental agreements are handled by the business or financial department. These agreements may call for flat rental fees or a percentage of concession sales, or both. In other cases, the organization operates the concessions itself, assuming all the business and personnel obligations. A concessions manager may be hired to oversee the management and operation of each enterprise. This job is obviously far removed from the artistic concerns of the organization, yet customers will hold the organization accountable for whatever happens to them while they are on the premises. Good public relations, then, is an important element in concession management.

When concessions involve merchandise generated by the organization, they are supervised by the marketing department. Otherwise they come under the control of the building operations department and may be supervised by a house manager. Running a concession may not seem like a very promising beginning for a career in arts management, yet we hasten to mention the fact that the Shubert brothers started out by selling orange drinks in the lobby of a theatre in Syracuse, New York!

Sales People

As we have seen throughout this chapter, sales people are in demand in almost all branches of the arts and media industry. Indeed, salesmanship is at the core of virtually all of American industry. While sales jobs may first be offered on a commission basis, with no salary guarantees, successful sales people can quickly move up to important executive positions. Virtually all arts and media organizations that have something to sell always have the need for a good new salesperson. This is why sales is such an easily accessible entry-level area, and why you should consider starting in sales if you are thinking about building a career with an arts and media organization. It is a proven method for getting to know the territory and for moving up, perhaps all the way to the top.

Looking across the industry, entry-level sales positions can be summarized as follows:

The performing arts: box-office treasurers and staff people who process subscription and group-ticket orders; also sales clerks for special merchandise and concessions

The visual arts: museum admissions clerks, gift shop and merchandise sales people, and gallery sales companies

Broadcasting: Sales representatives who sell air time to advertisers and also those who sell programming to affiliate and independent broadcasting companies

Cablecasting: Sales people who interest customers in buying the basic cable service and then in buying additional pay services; also sales representatives who sell time to advertisers

Film: Studio and film company sales people who lease films to both domestic and foreign film exhibitors, to television and cablevision companies, and to other organizations; also sales representatives for film distribution and video-cassette companies

☆ 8 ☆

Jobs in Fundraising, Fund Giving, and in Service Organizations

Jobs related to the business of fundraising and philanthropy are found exclusively within the not-for-profit sector. While commercial enterprises often seek outside money to fuel their projects, such money is loaned or invested by those who usually expect to share in profits earned from their enterprise. Raising investments is the job of a financier or chief finance officer, who, for example, may also be the producer, the gallery owner, or the company president. On the other hand, money given to nonprofit organizations is donated, and a donor's only return may be a tax deduction and the pleasure of assisting a cause, project, or institution that is dear to his or her heart. Arts service and support organizations, including unions and professional associations, are often active in both the nonprofit and commercial sectors.

What Is Fundraising?

The word *development* has become a euphemism for *fundraising* and is now the most frequently used term when describing activities and job titles in this area. A development director whose main responsibility is fundraising should not be confused with an audience development director, whose main responsibility is to increase ticket sales, or earned income, and who works within the marketing and promotion area. In the film and television fields the word *development* is most commonly applied to the creative process of developing screen properties, or scripts, from novels, plays, or original scenarios.

The days when a symphony orchestra or a dance company was supported by a single philanthropist or when a new production at the Metropolitan Opera was underwritten by a single check from a Mrs. Rockefeller or a Mrs. Belmont are over. One does occasionally hear of a multi-million-dollar gift to finance a new museum wing or to construct a new concert hall, but, for the most part,

144

the task of funding the arts in the not-for-profit sector is much more difficult and complex than it used to be. Even if the artistic director or general manager is qualified to serve as a fund raiser—and most do devote some time to this chore—he or she seldom has the time to accomplish all that's required. Hence, the position of director of development or, in large institutions, a department of development headed by a vice-president and supported by a sizable number of employees and volunteers.

Director of Development or Development Officer

All development officers must have well-honed verbal and writing skills, as well as the personality to successfully interact—the buzz word is *interface*—with corporate and foundation leaders, government funding officers, and philanthropists. Warm, outgoing, effervescent people tend to function well in this field, provided that they are also clear-headed and doggedly persistent in the pursuit of their goal, which is money. In short, the job requires a sophisticated and charming beggar! This is not an easy role for most people to play, and even those who do it well tend to weary of the job after their initial years of success.

Recent cuts in government funding for the arts, and the resulting increase in competition for foundation and corporate support, have shifted the need away from development officers who are merely good proposal writers and increased the demand for a new breed. Development officers today must have the ability to research, identify, and secure funding from a wide and often unusual array of sources. Nine of out ten requests are likely to elicit negative responses. And the one positive response is likely to require five meetings, twenty phone calls, and a small mountain of research data, correspondence, and grant proposal drafts. Again, the operative word for this professional is *persistence.*

Development officers can and often do transfer their skills to the arts and media industry from other fields, such as education or health-care. But a fund raiser in the arts must learn the specific sources that fund the arts and must cultivate potential donors, board members, and others who are especially supportive of a given institution or project. Such contacts, together with a knowledge of the community, comprise the most valuable assets in a fund raiser's portfolio. Because they deal mainly with prominent and cultured people, most development officers have at least one college degree and a broad knowledge of the arts.

Chart 23
Executive Organization:
Development Area for a Large Arts Institution

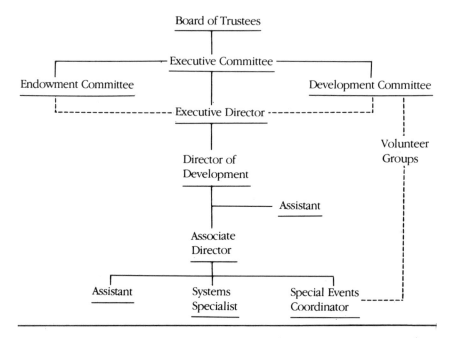

The basic function of development is to raise the unearned income necessary to make up the difference between revenues and operating expenses. The director reports to the executive director and works closely with members of the board of trustees, whose members should be ready and willing to provide contacts and lend meaningful support. If board members are not supportive, the development person's job is difficult, if not impossible. In large institutions the development director supervises a support staff and has access to word processors and computers that assist in conducting research, gathering and storing information, and soliciting funds. (See Chart 23.) While small sums from individuals are often solicited by mail, larger contributions almost always require personal contacts. A development director must have the ability and presence to make personal appeals to foundation and corporate contributors, arts council executives, and potential individual donors. Often accompanied by a board member or someone from the artistic staff, the fund raiser must present a strong, well-documented, and informed case on behalf of his or her organization. In summary, the director will be responsible for—

1. Identifying and contacting potential donors through research and board contacts

2. Supervising the preparation of written proposals and grant applications
3. Designing direct-mail, telephone, and other fundraising campaigns
4. Preparing reports on how funds were allocated for the funding agencies
5. Personally soliciting funds through visits to prospective donors and thanking those who actually donate
6. Conceiving and supervising special events, galas, sweepstakes, and other approaches to raising funds

As discussed in Chapter 3 and documented in the Career Kit, there are many opportunities to learn the mechanics of fundraising for the arts through seminars and workshops. These should be attended periodically by professionals working in the field, as well as by neophytes, so that they may keep abreast of the ever-changing tax laws, government agencies, and economic trends that influence the field of philanthropy.

Associate or Assistant Director of Development

A development associate or assistant complements the efforts of the director of development by executing the extensive research and paper work required in this area. Typical duties are—

1. Researching the funding histories and requirements of corporations, foundations, and other funding sources
2. Maintaining files on the histories of individuals, including board members, who are donors: their professions, memberships, dates and amounts of their contributions, services volunteered, and other pertinent information
3. Keeping mailing lists up to date
4. Keeping a calendar of deadlines for grant applications and status reports
5. Acknowledging in writing all contributions received, however small
6. Preparing text and statistics for proposals
7. Assisting with special events

The associate must be an excellent writer and very organized. A missed deadline can mean losing a grant, and not thanking an individual for a contribution can mean losing that contributor for the future. Many development offices now depend heavily on data processing so that typing, word processing, and computer skills are usually required. This is a good entry-level area, except where advanced experience is required. It may also be a good step up for someone with experience as a copy editor, researcher, or secretary who is seeking to develop a higher-paying specialization.

Special Events Coordinator

Most boards of trustees for nonprofit arts and media organizations have a number of auxiliary committees made up of volunteers who raise money for the organization: Friends of the Theatre, the Opera Guild, the Women's Club, Friends of Channel Thirteen, and so forth. These groups organize events such as dinner parties, receptions, and tours, and also assist in running galas, benefits, and telethons. They not only raise money by selling tickets, souvenirs, and other items, they also provide valuable community-relations services and build grass-roots credibility for the organization.

The special events coordinator is a salaried staff person—a kind of in-house Pearl Mesta or Elsa Maxwell—who usually reports to the development director and who coordinates and acts as host of special events. The special events coordinator must be able to organize, recruit, and supervise volunteers. Many such coordinators are women in the upper social strata of the community who possess the social grace and position necessary to direct volunteers who have interests and backgrounds similar to their own. It is not unusual for women who are reentering the job market after some years absence to be considered for this position.

Arts Councils

The National Endowment for the Arts (NEA) and the National Endowment for the Humanities (NEH) are the two federal agencies that are most frequently mentioned in connection with federal subsidy for nonprofit projects in the arts and media industry. Additional federal funding is provided by the Corporation for Public Broadcasting (CPB) and by various cabinet-level agencies. NEA and NEH also provide funding for the state arts councils, of which there are fifty-six—American Samoa, Guam, the Northern Marianas, Puerto Rico, the Virgin Islands, and the District of Columbia each have what are considered state arts agencies, which are members of the National Assembly of State Arts Associations. In addition there are over fifteen hundred local and community arts councils that are funded by state arts agencies, local governments, and private and corporate contributions.

Most arts council policies are determined by an independent council, panel, or advisory board. These bodies, composed of appointed citizens who serve on a volunteer basis, have no legal authority but function in much the same way as a board of trustees for nonprofit organizations. The major function of an arts council is to—

1. Provide financial support to arts and media organizations and to individual artists through the awarding of grants or "contracts"
2. Provide technical assistance
3. Present arts programs, workshops, and performances in public facilities and schools

4. Disseminate information about the arts and the media

Some councils operate facilities and produce programs; others "buy" services for the public through direct contracts or grants.

The following is an organizational model of an arts council:

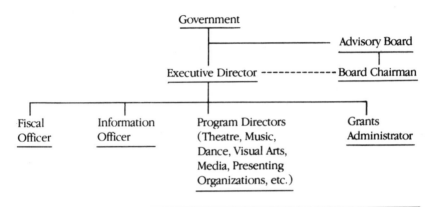

Chart 24
Executive Organization:
A State Arts Council

Because chairpersons for arts councils are appointed by elected officials, a number of very unlikely and seemingly unsuitable appointees have been named at federal as well as state and local levels. Celebrities from the arts world, the socially prominent, political campaign staff managers, and wealthy contributors to political coffers have been appointed to such posts, without having had any prior experience in arts administration. Some have proven themselves to be highly effective leaders, others have not. The career professionals who work for arts councils, however, are usually proven administrators, who possess college degrees and long experience in the field.

United Arts Funds

United arts funds are service organizations that raise money for the arts through federated or joint appeals. Funds are raised from the community—including business, the general public, government, and/or foundation sources—and are distributed to arts and media groups that are members of the fund. The function of a united arts fund or council is to—

1. Determine the goals of a campaign
2. Solicit the funds on behalf of its constituents

3. Determine the distribution of the funds, thereby guiding the arts policy of the city
4. Provide arts and media groups technical assistance, as well as informational and nonfinancial services
5. Engage in programming activities

The board of a united arts fund is composed of prominent business leaders and philanthropists, as well as board members and managers from major arts institutions in the area. The staff, which works under the supervision of an executive director, is divided into four categories: administration, fundraising, programs and services, and facility management and technical assistance. Volunteers are also utilized in all areas.

Private Foundations

A foundation is an incorporated nonprofit organization, the main function of which is to distribute funds, or grants, to eligible individuals and organizations. It is similar to an arts council, except that its assets are not derived from tax-levied money, but from private estates or corporate earnings. The policy of a foundation is determined by a board of trustees—foundations are nonprofit organizations, even though associated with the private sector and with commercial corporations—and the board is empowered to grant funds according to the stated guidelines of the foundation's by-laws. Most small foundations are administered individually by a lawyer, estate executive, or part-time director. Large foundations have a president, chairperson, or director, who is supported by a professional staff.

Jobs within foundations are among the most sought after in the nonprofit arts and media field, and for good reason. Foundations have financial solvency and do not have to raise operating funds; they are usually concerned with broad issues that have long-range ramifications; they usually pay the professional staff very well. There are, however, a few realities that the arts administrator should consider when seeking a position with a foundation:

1. Foundations are not only concerned with the arts; most philanthropic grants in America are made to medicine, education, and the sciences—few foundation giving officers, therefore, are concerned with the arts exclusively.
2. Foundations seldom advertise for staff positions, but rely upon recommendations, word-of-mouth contacts, and in-house promotions.
3. Foundations receive many solicitations from groups seeking funds, and they are often unresponsive both to grant-seekers and job-seekers.

Large foundations with departmentalized staffs, such as the Ford and Rockefeller foundations, are set up much as arts councils are. An executive

director or president reports to the trustees; and program directors evaluate proposals and prepare reports with the assistance of an administrative staff.

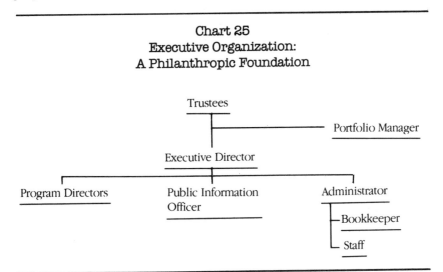

Chart 25
Executive Organization:
A Philanthropic Foundation

Corporate Giving Officers

At the present time federal tax law allows corporations to reduce their pre-tax earnings by up to 10 percent by making contributions to eligible nonprofit organizations. However, less than 10 percent of all corporations take advantage of this opportunity. Yet, if a true "flat tax" should become law, as has been proposed periodically, the loss of the tax deduction would drastically alter the field of fundraising.

Beyond the financial benefits, corporations are increasingly using their contributions for public relations purposes. By sponsoring national tours of ballet companies or art exhibitions, for example, Philip Morris Incorporated has been able to associate its name with culture and the arts, which, in turn, adds to its national visibility. The oil companies have found that public television is an effective medium for reaching up-scale viewers, so they underwrite numerous cultural and scientific programs. In fact, PBS is sometimes referred to as the "Petroleum Broadcasting System"!

Corporate-giving positions are on the most-popular list among administrators working in the development area. Yet, such jobs seem out of reach or difficult to obtain because—

1. A corporation's giving-policy is usually based on the return on investment that may come from enhancing public image and strengthening a community where there is a plant or office—or by directly benefiting employees of the company.

2. Corporations like to promote from within and, therefore, will recruit business-types for most junior positions.
3. Giving-policies are an extension of the overall corporate policy—and frequently an expression of the personal interests of the corporate board president or chairperson—and those best suited to interpret those policies, it is felt, are veterans of the firm.

Not all corporations involved in philanthropy maintain a special giving office. Often this function is performed by the public-relations or community-affairs department. Whatever department or individual executive title is used, a corporate giving officer is charged with—

1. Interpreting corporate policy as it relates to the arts, social services, health, and education
2. Representing the corporation in the community
3. Supplying information and making recommendations on grant applicants to the corporate-giving advisory board.

The position also includes other public-information and public-relations functions.

It is interesting that while jobs in a corporate-giving office are often offered first to executives within the firm, many avoid moving into this area for fear of stalling their business careers. This fact provides at least a small hope to outside applicants.

Professional Associations

A professional association either represents people working for a particular type of arts organization, such as the American Association of Museums, or people working in a particular job category, such as the National Society of Fundraising Executives. An association is organized as a nonprofit corporation, with a board of trustees that is appointed or elected. These organizations are supported by fees or annual dues from members—who may be individuals or organizations—and in many cases by grants and contributions. The functions of a professional association are—

1. To act as a clearinghouse for information, statistical data, and materials about the profession
2. To lobby for members within industry, government, and before the public
3. To provide technical, managerial, and educational assistance, and special programs
4. To set up and run national and regional conferences that bring together members of the profession

An association's staff members usually have prior experience in the field and a

deep interest in it. Most associations depend greatly upon the participation of their volunteer boards and members, who are called upon to serve on panels at conferences, to accept unsalaried consultancies, and the like. The typical organizational chart for the staff of a national membership association is shown below. (See Chart 26.)

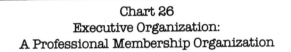

**Chart 26
Executive Organization:
A Professional Membership Organization**

Unions and Guilds

Performers, creative artists, directors, many types of managers, and most craft technicians working in the commercial or nonprofit sectors of the arts and media industry belong to trade unions that are chartered by the AFL-CIO, or to professional membership organizations, commonly called guilds. Unions and guilds are nonprofit organizations that draw members from the trade or profession they represent: Actors' Equity Association, the Screen Actors Guild, the Dramatists Guild, the International Association of Theatrical Stagehands and Employees, the Association of Theatrical Press Agents and Managers, to name a few. The chartered unions undoubtedly have more clout with top management than do the unchartered guilds, as illustrated by the 1982 antitrust suit that was initiated against the Dramatists Guild by the League of American Theatres and Producers, which protested that playwrights should not be protected by minimum-payment and royalty standards but should negotiate individually with each producer for each production. Such action against card-carrying members of the performers', stagehands', or camerapersons' unions, of course, would threaten industry-wide walkouts.

Unions and guilds are formed to represent their members to management regarding such matters as contracts, salaries, working conditions, benefits, and pensions. They are financed by membership fees, annual dues, and, in some cases, by a percentage of their members' earnings from union- or guild-related jobs.

The management of a union or guild is similar to that of arts-service and technical-assistance organizations. There is a board, nominated and elected by the membership, that hires the chief operating officer, who holds the title of executive secretary or executive director. This individual, along with a staff, is responsible for—

1. Executing the policies of the union
2. Representing the union and its membership to the industry and to management
3. Assuring legal and proper compliance with the basic minimum contracts of its members
4. Protecting the finances of the union or guild
5. Disseminating information to union or guild members
6. Providing information to the press and the public
7. Overseeing union pension funds, benefit programs, and the like

The chief executive officer is usually a member of the union or someone closely connected to it, such as a former legal counsel or working member of the profession. The other staff members do not necessarily come from the rank and file. It is common for staff members to be specialists in particular aspects of management or to be generalists in the field. The chief executive officer must be an accomplished advocate for the membership and must also be sensitive to the internal policies of the organization in order to represent and satisfy the many different factions that inevitably exist within the organization. Leadership and administrative abilities are also an obvious requirement.

There is no typical organizational structure for a union or guild office. Depending upon the size of the membership and the complexity of the organization—some have a national office with regional affiliates called "locals"—the duties outlined above are handled by one or more staff persons.

During rehearsal and production periods for filmed, taped, or live projects, a union member may take on certain administrative duties by serving as a deputy and representing fellow members to management. These positions are in some ways managerial, although they are not part of management per se. In a symphony orchestra the position is called personnel manager; other positions of this type are shop steward or deputy. Experience in such positions would, of course, be a good primer for jobs either in the union office or with management.

Technical Assistance Group

Technical assistance groups are established to provide management assistance, advice, and services to nonprofit arts organizations. They are formed according to the type of arts group they represent—Museums Collaborative, for example—and by areas of expertise, such as Volunteer Lawyers for the Arts, the Arts and Business Council, or Business Volunteers for the Arts. Technical assistance groups are usually nonprofit organizations subsidized by contributions and grant monies and perhaps by small fees charged to their clients. Their boards are composed of leaders from the profession as well as experts from the commercial business world who wish to contribute their time and expertise. Some corporations "loan" certain executives to technical assistance groups or to specific arts organizations for limited periods of time, during which the corporation continues to pay the executive's salary.

Consulting services and advice are provided by specially trained program directors who have worked in the field and by outside consultants hired to supplement the regular staff. Some of the better-known organizations in this category are the National Federation of Local Cable Programmers, Theatre Communications Group, and the Foundation for the Extension and Development of the American Professional Theatre.

☆ 9 ☆

Jobs in Production and Operations Management

Ⅰf there is one area of the arts and media industry in which job titles vary greatly in relation to job functions, it is the area of production and operations management. Titles are not consistent even within the same type of arts organization. For example, the operations person for a symphony orchestra may be called the orchestra manager when there is also a general manager; or a general manager when there is an executive director. In dance the position may be called director of operations, company manager, or production manager. It is possible to find a production manager who is actually a go-fer, and another who runs the whole operation. An office manager may be a mere receptionist; a research director may be doing the job of a curator. In film and television, floor manager and traffic manager are operations positions with responsibilities that vary greatly. So when you are interviewing for a job in this area, listen very closely to the job requirements and, if possible, check them out with current or former employees of the organization.

What Is Production and Operations Management?

Operations is a catchall term for any job involved with the day-to-day functioning of a facility, or with the production aspects of a business. An operations manager, although responsible to senior management, is not directly involved in policy decisions or planning on the corporate or board level; the job is restricted to internal management duties. It is meant to complement senior management by freeing top executives from the bulk of internal management chores. The operations manager is concerned with directing the flow of communications between departments, supervising staff and administrative functions, and maintaining the good morale of the staff. Operations in the arts and media industry could be divided into three categories or departments with the following overall functions:

1. *Production Management:* controls production costs; coordinates schedules of technical, creative, and management personnel before

and during productions; conducts contract reviews and contract administration; supervises special events and touring productions

2. *Building Management*: oversees maintenance, security, house management, space allocation, rentals, box office, concessions, insurance, medical and safety problems, repairs, and renovations

3. *Office Management*: supervises employee relations, including benefits, compensation and salary reviews, grievances, and contract compliance; orders supplies and equipment and maintains an inventory; organizes internal communications and office systems

Each of these areas may have a manager who is supervised by a department head or by the general manager or executive director. More so than other positions, production management jobs relate most directly to the artistic product itself and may therefore fall under the supervision of the artistic director or one of the creative artists, such as the conductor or the scenic designer. For example, the personnel manager works with the conductor to organize rehearsals; the stage manager works under the director of a production to help supervise the actors; and the technical director works under a scenic designer to help supervise carpenters and other craft employees. In small organizations, operations jobs usually combine management responsibilities with craft functions, so that the technical director may also serve as the stage electrician or carpenter, for instance.

Production Manager

(See above. Also see Production Manager for film and television below.)

Facilities or Building Manager

(See above.)

Office Manager

(See above.)

Company Manager

A company manager for a Broadway production or for a first-class national tour is a member of the Association of Theatrical Press Agents and Managers (ATPAM). For most other performing arts, film, and television productions the job title is usually production manager or production assistant. This person is accountable to the general manager or executive producer and is responsible for solving routine personnel problems related to the cast, the musicians,

stagehands, and the technicians; for providing payroll information; and for distributing checks to those people paid by the producer. He or she also serves in lieu of a tour manager when a theatrical production is on the road, securing housing for the company, making travel arrangements, and the like.

House Manager

The house manager is also a member of ATPAM in Broadway and other large unionized performing arts facilities. He or she is employed by the landlord to oversee the smooth operation of the facility, to verify box-office statements, and to supervise the security personnel, ushers and ticket-takers, and the maintenance staff. The house manager is to the landlord what the company manager is to the producer. In nonunionized facilities, the house manager reports to the general manager and may not have any responsibilities related to the box office other than accountability for the ticket stubs. In large museums, galleries, and media facilities this job may come under the title of buildings and grounds supervisor and include tremendous security responsibilities.

Stage Manager

In all theatres that employ Actors' Equity Association (AEA) members, the stage manager must also belong to AEA. Opera, dance, and musical theatre companies that work under American Guild of Musical Artists (AGMA) contracts must sign their stage managers to AGMA contracts. The title of stage manager is sometimes used in film and television credits to indicate people who do little more than relay cues to actors and camera operators. AEA membership for stage managers is somewhat illogical since they fulfill an operational function that is managerial as opposed to creative or purely technical. Even the job title defines it as managerial.

Large commerical productions and institutional performing arts companies employ production stage managers who supervise rehearsal scheduling, monitor compliance with union rules, and supervise stage managers and assistant stage managers, who are in charge of the stage, the performers, and the crew only during performances. This job entails coordinating various activities with the company and house managers and requires a person who can think quickly and pay exacting attention to detail. Because stage managers work closely with artistic and stage directors, many often become directors themselves; others move into the management area.

Technical Director

In the performing arts a technical director is a person who supervises all the

craft elements and staff workers who are involved in assembling the physical production: carpenters, electricians, audio and visual engineers, and technical crew members. In film and television this function may be handled by a chief engineer or a production supervisor. The job requires a thorough knowledge of all the craft and technical aspects of production together with organizational and leadership ability. This is a good stepping-stone toward a stage manager position or a higher production management position.

Tour Manager

Large modern dance and large ballet companies, opera companies, symphony orchestras, rock groups, dance bands, and even cabaret stars employ tour managers—when this job is not filled by a company manager—as do small regional companies that maintain busy touring schedules. A tour manager travels with the company and often precedes it into the next performance city. He or she is a representative of both management and performers and usually deals with presenters. The presenters are under contract to the producing or packaging organization to provide specific stage, dressing room, auditorium, and technical facilities, and the tour manager sees that such commitments are upheld or that alternate plans are made so that performances may take place. The tour manager must have a thorough knowledge of both union contracts and booking contracts; he or she must prepare and distribute the payroll, arrange transportation and living accommodations, oversee local publicity and promotion efforts, and generally serve as a loving parent to keep spirits and, therefore, performances at a high level. Some of these duties may be handled by the home producing office or by the presenting organization, or by a personal manager when a major star is involved. But usually there must also be an advance manager or coordinator of some kind who checks to make certain that what has been contracted and requested is actually going to be provided.

Music Administrator

Music administrators are employed by large symphony orchestras and by some opera companies. This is an operations position that requires someone with a professional understanding of music. The music administrator reports to management but has a dotted-line relationship with the artistic or music director. He or she is responsible for—

1. Setting rehearsal schedules for the company and the soloists

2. Arranging "covers," or substitutes, for the important performers

3. Arranging accommodations, travel, hospitality, and amenities for visiting artists

4. Preparing lists of substitute programs, performers, and pieces so that the music director can make informed decisions

5. Working with the general manager to negotiate artists' contracts and to control the budget

6. Keeping a record of past programs and making suggestions for future programming

The music administrator must know approximately how long it will take the orchestra to rehearse a Bruckner symphony or a Mozart concerto, as well as which singers have sung which parts and sung them well, which pianist can play a Beethoven concerto on two days notice, and the like. In some organizations the music administrator supervises a librarian and library staff and works closely with the personnel manager of the orchestra.

Personnel Manager

In the performing arts the personnel manager is unique to symphony orchestras and is usually filled from the ranks of the musicians; in some cases the job is a stepping-stone to a general-management position. The personnel manager supervises the musicians—not telling them how to play or interpret the music, but telling them when to appear for rehearsals, when a break is due, and so forth. He or she represents the players both to management and to the conductor on all matters concerning contracts, conduct, discipline, and work performance. The personnel manager also assists in setting up auditions and in hiring extra players and substitutes. As with stage managers, personnel managers often belong to a performers' union.

Contractor

Small music organizations, especially those without a full-time orchestra, usually use a contractor to assume the functions otherwise performed by a personnel manager. A contractor may also supply union musicians to orchestral groups, Broadway shows, road shows, cabarets, nightclubs, recording studios, and other enterprises that require union musicians. Depending upon his or her abilities, the contractor supervises musicians' careers, negotiates contracts, and satisfies management demands. A skillful contractor can exert tremendous control over the musical activity in a particular area, deciding who plays where, when, how often, and for how much. Some are also working musicians themselves.

Librarian

In a small orchestra the music librarian is one of the musicians, while in a

large orchestra the librarian is a full-time administrator whose responsibilities include renting and purchasing music parts and scores, controlling the costs for such expenditures, organizing and maintaining the music library, and supervising assistant librarians.

Film studios and television networks with a large collection of films or teletapes may also employ people to keep track of and supervise such inventories. Museums employ archivists, conservators, and collection managers to fulfill a similar function, as described below.

Curator

The title of curator in a visual arts organization may be given to any person who is in charge of overseeing a collection. In small museums and galleries the chief curator is also the executive director or general manager. Where large collections are involved, the curatorial staff is departmentalized, and each curator may supervise assistants and specialists who work exclusively in a particular wing of a museum, or in a particular area or on a particular aspect of a collection.

Conservator

A conservator for a museum is a curator who is responsible for the care, preservation, and repair of objects in the collection.

Exhibition Designer or Director

Exhibitions for commercial galleries are usually designed by the gallery director or manager, in consultation, when possible, with the artist. Museum exhibitions may be conceived and mounted by an exhibition director or by a member of the curatorial staff. Major exhibitions usually require that art works be loaned from a variety of far-flung sources. This necessitates negotiations for the loans, travel and insurance arrangements, security, and other factors that may require many months if not years to consummate. In such cases the exhibition designer works closely with the senior management of the museum and its legal counsel, and may also have to negotiate with foreign governments, religious institutions, tribal chieftans, crowned heads, corporate presidents, individual art collectors, and a broad assortment of other personages.

Registrar

Registrar is the title given in large museums to a staff person who organizes, documents, and otherwise keeps track of art objects in the museum's collection.

Collections Manager

A collections manager works with the conservator in a museum to maintain a catalogue of the collection and to oversee the moving and storing of items in the museum's collection.

Director of Acquisition, Research, and/or Publications

Large museums often hire a research director to oversee in-house and field research that is sponsored by the museum, special educational research programs, and visiting researchers who use the collection. Museums may also employ a director of acquisition, who works under the museum director and is responsible for buying or otherwise acquiring new items. Independent consultants, agents, and art dealers may also be retained to search out, recommend, and acquire objects either on a permanent or loan basis. If the museum publishes catalogues, exhibition programs, magazines, research papers, art books, and other materials, there may also be a position for a full-time publications director.

Research and acquisition, as discussed in Chapter 5, are also important to film, television, and cablevision companies, although mainly in the contexts of market research and product or property development.

Gallery Manager

When an art gallery is not managed by the owner, a gallery manager or director is hired to supervise the day-to-day operations. This includes hiring and supervising the staff, tending to all business and sales matters, and coordinating the art displays and exhibitions. It also entails press and public-relations work, together with the management of exhibit openings and special events.

Productions Manager (Film and Television)

Although this chapter opens with a general definition of production management, the job of production manager deserves special attention because of its importance in the film and television branches of the industry. The production manager reports directly to the executive producer for a project or to whatever senior executive is responsible for seeing that the project meets artistic and budgetary goals. This often gives the production manager even more power than the film director, because if this manager reports that the project is running over budget—which could result from any number of factors for which the director is supposedly responsible—it could

and sometimes does result in the director being fired. Perhaps appropriately, production managers are members of the Directors Guild of America (DAG). Specifically, they are responsible for allocating and controlling budgeted funds; scheduling rehearsals, locations, and shootings; hiring union employees; arranging for necessary transportation; and securing permits and rentals for location or studio production purposes. Obviously, this job offers ideal training for becoming a film or television producer.

Line Producer

A line producer is the person who coordinates the day-to-day activities of a film production, including all the creative and business personnel. Not to be confused with the executive producer, who sets the film in motion either with the idea and concept or with the packaging elements, the line producer works closely with the director in determining the elements for the production.

Unit Manager

The unit manager works under the production manager in overseeing all business aspects of the film's production relating to the hiring of crew, scheduling the shooting, and coordinating the various departments so they function as one unit. While this job may be filled by the production manager on small film projects, large projects that are shot at different locations concurrently may require unit managers or a number of assistant unit managers.

Production Auditor

The production auditor assists the production and unit managers in preparing the production budget, disbursing funds, accounting for expenses incurred, and forecasting the estimated final cost of production on a daily basis. These figures are the basis on which both major and minor decisions are made regarding the project at hand and the personnel involved with it. A background in business and accounting would obviously be an asset in this position, but curiosity and the willingness to persist in validating the propriety of costs are the hallmarks of a successful auditor.

Production Office Coordinator

The job of production office coordinator is comparable to any office manager's position. In the film and television areas it involves overseeing the administrative details and personnel management of a production company or

unit; acting as the representative of the producers on certain matters; and in the absence of a large staff, fulfilling numerous clerical and bookkeeping functions.

Program Director

This important job requires a person who can coordinate the entire programming schedule for a broadcasting or cablecasting station. This may include the scheduling of syndicated programs, as well as those produced by the network and by individual stations. It also involves developing original concepts, buying the rights to existing properties, hiring employees, negotiating for studio or location sites, and scheduling production time as well as air-time. The job of program director is at the middle of the executive ladder and is a good spot from which to move up.

Traffic Manager

The traffic manager for radio, television, and cablecasting stations schedules all air-time, both programming and advertising; schedules announcers; and coordinates the work of the program directors and the advertising sales people. In small companies this job is usually combined with another, such as announcer or news editor. It requires precise thinking together with a knowledge of the station's market and audience profile.

Studio or Station Operations Assistant

Small film, cablecasting, or broadcasting companies have a need for an all-around person who can handle numerous details in various aspects of the business—everything from inventing sound effects to scouting locations and doing the payroll. This producer's assistant, or guy or gal Friday, is likely to be the first staff person whom the producer hires. While it is an excellent first job in the media branch of the industry, it does require some specialized training or background, together with organizational ability and a willingness to perform both menial and higher-level tasks. The job title may be anything from intern to assistant to the producer, depending upon the size and budget of the company.

Franchise Manager

When a cable television company is in the process of seeking new markets, it assembles a team of employees to win from the authorities of a given community or municipality the franchise agreement that will enable the company to operate a cable system in that area. The team is usually comprised

of an engineer, a market analyst, a financial analyst, and a public relations specialist; it's headed by a franchise manager who must supervise the team, negotiate the agreement with city representatives, and report all dealings to the corporate headquarters. While this job ends when the franchise process is completed, it provides a broad range of experience in managing a cable television company or a television station.

Director of Education or Director of Outreach

Colleges, schools, conservatories, and special programs train future artists, technicians, and managers; in turn, performance and media organizations sponsor activities that are designed to educate the public-at-large. While the management of schools and educational programs is discussed in Chapter 5, it is appropriate here to examine arts and media organizations that engage in educational activities. Many opportunities exist for a person with experience on one side of the coin to flip that knowledge to the other.

Museums and performing arts organizations have realized the potential value of educational programs as marketing devices to build future audiences, particularly among the young, and to create an appreciation and understanding of an art form, which, in theory, creates a larger demand for it. Indeed, outreach efforts are essential for the survival and growth of arts organizations because they rely on a continuing influx of new patronage to supplement current support and to replace lost patrons.

One of the earliest and best-received examples of educational programming was the nationally televised "Young Peoples Concerts" of the sixties, which featured Leonard Bernstein and the New York Philharmonic. These programs featured accessible music with appealing narration designed to entertain the young. Like all educational programming, these special concerts were designed to attract new audiences by presenting works in an entertaining and easily understandable manner. Another purpose is to bring the arts to new audiences. This is most efficiently achieved through the broadcast media. And most such programming is carried by public radio and television stations, which, after all, were originally licensed for the purpose of educating the communities they serve.

Educational programming by arts and media companies is generally designed to fulfill one or more of the following goals:

1. To increase the performing opportunities for a company and also tc provide more exposure and income

2. To increase an audience base and prepare future audiences

3. To enrich and inform an audience

4. To market an organization to new constituencies

5. To enhance the public image of an organization as well as its patrons and/or sponsors

The person responsible for these important functions may be called director of education, director of outreach, or community affairs director. Specific duties of the job may include—

1. Conceiving and developing programs
2. Developing curriculum and course content
3. Hiring, training, and supervising teachers or program directors
4. Developing materials such as study guides, brochures, and press releases
5. Coordinating educational outreach programs with artistic directors and performers
6. Representing the organization to the outside community and to special interest groups

The director of education is a senior-management position that usually requires skills in marketing, fundraising, public relations, and audience development, as well as a knowledge of pedagogy. This executive usually reports directly to the general manager or executive director and works in close partnership with other department heads. Because outreach programs frequently involve extensive touring, the education director may also function as a tour manager—selling performance dates, arranging transportation, working with sponsors on publicity, and organizing guest lectures, demonstrations, and workshops—or he or she may supervise a tour, or a company manager and a technical crew.

A director of education in a museum is usually involved in designing, supervising, and marketing education programs within the museum—these may include special weekend or evening art classes, group tours, and membership events. The position may involve hiring and training administrative staff, guides, and instructors as well as producing brochures and special materials. Obviously the museum's education director must work closely with the membership director, the public information officer and, especially, with the curators to develop specific programs around the permanent and visiting collections and exhibitions. Such jobs are often filled by people who have teaching backgrounds in the arts as well as managerial expertise.

Director of Public Access

A new position in the field of education for the arts and media industry, as mentioned in Chapter 5, is the coordinator or director of public access for local cable television systems. Public access, sometimes required by local franchise agreements, sets aside a certain amount of air-time or a number of independently controlled channels for the exclusive use of the community in presenting locally produced programming. In other words, the cable

television company has no control over the content of such programming and offers the air-time on a noncompetitive, first-come basis. A director of public access is responsible for—

1. Contacting local groups and providing them with information regarding the opportunities for using public-access air-time
2. Setting up classes in the technical aspects of producing public-access programming
3. Offering technical advice on production, but not on program content
4. Monitoring the programs
5. Setting up and controlling program schedules

Although public-access channels are operated for the benefit of the community, cable television systems use them as marketing tools to increase the number of local viewers and to create goodwill for the system within the community.

Internship Director

Although apprenticeships, or internships, probably date back to the beginning of organized society, they are a fairly recent phenomenon in the field of arts and media management. Happily, however, there are now countless opportunities to work as an intern and thereby begin a career in this industry—both in the nonprofit and commerical sectors. Television networks, film studios, repertory theatre companies, museums, performing arts centers— all have internship programs and the larger ones have full-time internship directors or coordinators. Most such positions carry a salary, but some are filled by volunteers.

An internship director often has a background in teaching as well as a special dedication to the organization with which he or she is working. The job entails recruiting qualified interns, who usually work for little or no salary, placing them within the organization, and monitoring their work to be certain that both the interns and the organization derive the greatest possible benefit from this relationship.

☆ 10 ☆

Becoming Independent

It seems appropriate to begin the last chapter of this book by repeating a theme from the first chapter: The arts and media industry today is replete with opportunity for the introduction and development of new products, companies, and services. While much of this opportunity will be explored by established corporations and institutions, there will certainly be enough left over to challenge the minds and energies of individual entrepreneurs and independent-minded specialists. Chapter 5 describes how the various branches and disciplines within the industry are organized, but it does not claim that present practice is perfect or that it cannot be improved. Indeed, many critics and practitioners feel that improvements, industry-wide, are an urgent necessity. If you agree and if you believe that you have a contribution to make, then you must decide whether to work within an existing organization or to strike out on your own.

Evaluating Your Readiness

Almost everyone dreams of becoming his or her own boss at some time. Most of us would like to set our own working hours, make a lot of money, and be fully in charge of our professional careers. But if you're thinking of going independent, you'd better take a hard look at the realities. First of all, self-employed people—especially when they first establish businesses—must work much more than the standard eight-hour day, five days a week. Are you ready to virtually marry your work and have it move in with you? Second, it costs money to establish a new business, and it takes even more money to support yourself until the business shows a profit—if it ever does. Are you financially ready to make a necessary investment and even to sustain a loss, if that should be the result? Third, there is a lot of well-established, highly successful competition in almost any specialization you may select. Are you ready to compete for potential clients or properties given your present knowledge, experience, reputation, and contacts?

Many people with a lot of money and a little interest in the arts and media industry have become producers, gallery owners, or landlords even though they possess a minimum of experience. This is fine as long as they have the intelligence to hire good general managers or other business agents. Many of

the most successful entrepreneurs have learned their businesses from the bottom up—as have other types of independent managers and business people in the field. It must be said, however, that striking out on your own requires a mixture of—

1. Self-confidence that borders on arrogance
2. Courage that is nearly blind
3. Self-motivation that is endless
4. Ambition that is almost crazed
5. Optimism that is a little naive

People who are their own bosses often say that they never would have gotten into the business if they had known when they started what they know now. And, indeed, if someone presented you with a list of all the pitfalls, liabilities, and trouble that could befall you, chances are—if you're sane—you'd go on collecting a paycheck.

Psychologically, the optimum time to go independent is after you've acquired a good amount of experience and before you've become too secure or comfortable in your life style. Comfort and routine tend to reduce one's ability to take risks. Of course, the situation is different if you're financially independent—for example, retired from your first career and seeking to transfer your knowledge to a second. Or, you may be a practicing attorney, accountant, or other professional who decides to give up a corporate position and take on clients in the arts and media field.

If you feel that you have a reasonable chance for success in your own business and you have the start-up resources at hand, you should probably go ahead when your desire to do so is hot. After all, if you fail you can always go back on someone else's payroll. But if you don't make the attempt, you may pay heavily with a lifetime of regrets.

Forming a Private Corporation

The reasons why a self-employed professional should form a corporation instead of operating as an unincorporated business are discussed in Chapter 6, which also covers the most common types of corporate structures. But it is prudent to reiterate the importance of this formality here.

To become incorporated you will need to hire an attorney—not just any attorney, but one who is familiar with the type of business you are incorporating. The attorney will assist you in drawing up the papers of incorporation, conducting a corporate name search—no two corporations may have the same name—and filing with the appropriate city, state, and federal authorities. This process usually takes from two to six weeks and, except in very complicated cases, should not cost a great deal of money. The time and the money are worth it to protect your personal estate from your business liabilities.

Many people who earn good livings in the arts and media industry are self-employed. It would be impossible to describe all the different ways such professionals work, but the following list shows the most common independent pursuits. Sometimes a professional offers services in more than one activity—such as a landlord who also serves as producer or an attorney who handles general manager responsibilities—or a unique combination of special skills and interests.

Accountant

There are only a handful of large accounting firms that specialize in theatrical and media clients: Lutz and Carr in New York City and Price-Waterhouse in Los Angeles are two examples. This is a competitive field open to CPAs with a knowledge and love for the arts. Aside from providing the usual tax, accounting, bookkeeping, and payroll services, accountants may also serve as business managers, financial consultants, and money managers for individual and corporate clients who are successful enough to need these services. In the media world there are openings for general accountants as well as for production accountants and auditors. For ambitious CPAs with a good work-record such positions can lead all the way to the top of the corporate career ladder, or to the establishment of their own accounting firms.

Advertising Agent

No very large advertising agency can afford to specialize in arts and media accounts exclusively. However, because performing-arts producers, film studios, and television networks usually farm out their advertising campaigns, some agencies retain an executive who concentrates on such clients. There are also about a dozen small advertising agencies that do specialize in arts and media accounts, and most that do are located in New York City and Los Angeles. If you are a person with marketing experience, are acquainted with a number of potential clients, have access to one or more imaginative graphic artists, and wish to go independent, setting up your own advertising agency to service this industry could be a viable way to earn a living; although the field is highly competitive.

Art Dealer
(See under "Art Galleries" in Chapter 5.)

Artist Manager
(See under "Artist Management" in Chapter 5.)

Artists' Representative or Agent

(See under "Talent Agents" in Chapter 5.)

Attorney

A number of law firms and many individual attorneys specialize in one or more aspects of what is generally called entertainment law. The television networks and large film studios, of course, maintain legal departments with attorneys on staff to devise and approve contracts and agreements, oversee corporate legalities, represent the corporations in any litigations brought against them, and to initiate legal actions against others. Many of the busier theatrical producers, unions, guilds, and cable television companies also retain full-time attorneys. Because the arts and media industry depends so heavily upon literary, dramatic, musical, choreographic, and photographic properties, matters pertaining to copyright law are often of central concern, and a number of lawyers concentrate on this complex subject. Some attorneys have grown rich by providing their services to theatre and film producers in exchange for a percentage of the profits. Working closely as legal counsel to a producer from the beginning of a project provides a good way to become involved in entertainment law. Most legal professionals in this field have a genuine love for the arts, and many have made meaningful contributions to the artistic process by nurturing and protecting their artist clients, and by working with arts companies and organizations. It is also true that many top leadership jobs in the industry are held by people who have earned a law degree. This is not coincidence, but is due to the fact that sound legal training is a major asset in dealing with the growing complexities not only in the arts and media industry but in most others as well.

Casting Agent

(See under "Talent Agents" in Chapter 5.)

Consultant

Anyone with specialized knowledge and skills may offer his or her services as an independent consultant—and thousands do! Fundraising, marketing, promotion, and finance are four specializations in high demand, especially by arts and media organizations in the nonprofit sector. If you have been an executive with several well-known arts organizations and have established a wide and well-respected reputation, becoming an independent consultant may be an attractive option. It also helps if you have spoken and continue to speak at arts and media conferences, gotten a book or two published, written articles for trade publications, and otherwise established yourself as an expert.

Don't worry that such exposure will amount to giving away your hard-learned secrets for free. That kind of small-minded thinking has probably defeated more consultants than it has helped. Clients are impressed by credentials earned in the work place and also by a reputation that is known in the open forum.

Consultants have the option of working out of their own homes, although a lot of local travel and air travel are often necessary. It is a good idea to check out the competition before devising a fee schedule. Begin by taking a close look at your personal and business expenses—what is the minimum hourly, daily, and monthly income you must earn to cover these? This is the yardstick that will measure your profit or loss, your success or failure.

Contractor

(See Chapter 9.)

Distributor

Many film, television, and cable television corporations have distribution departments with staffs that lease their properties to a variety of outlets. But there are also numerous independent distributors; these are people who have cultivated business contacts with local, national, and foreign movie exhibitors, television stations, and cable system operators, to which the independent distributors lease the screening rights for films for which they are licensed to do so. Other distributors work in the video-cassette market and sell their products to cassette retailers. Most filmmakers prefer to have their products financed and distributed through a preproduction deal with a major studio. Their second choice is usually a preproduction deal with an independent distributor. But in many cases, a filmmaker must first form a production company and shoot the film, and only then hope to find a distributor who will market it. Distributors must be good sales people with a wide range of contacts in the industry and a keen sense of the media marketplace. It should be mentioned that film distribution is further removed from the artistic process than any other line of work discussed in this book.

Gallery Owner

(See also "Art Galleries" in Chapter 5.)

A gallery owner is most often an art enthusiast and collector who believes sufficiently in his or her own taste and perception of the art market to operate a gallery. Many are financially well off and, at least initially, do not have to depend upon their gallery profits to earn their living—which is wise. Of the thousands of galleries in the United States and Canada, many fold each year,

and many more operate at a loss. Like producing plays or films, operating an art gallery is a highly speculative venture. A person entering this field for the first time should hire an experienced director or manager and also rely upon the services of marketing and promotion consultants with proven track records. If one buys an existing gallery, it may be wise to retain the director or original owner long enough to observe how the business functions.

Most galleries specialize in the works of particular artists or in a particular style or period of art, and develop a clientele of collectors and buyers for the works they exhibit. No gallery can be all things for all people; most owners feel lucky if they attract a few faithful buyers.

General Manager
(See Chapter 5.)

Impresario or Entrepreneur or Financier

Impresario is a rather archaic term that refers to a person with great entrepreneurial ability who produces or presents and promotes artistic ventures, usually on a large or spectacular scale. Florenz Ziegfeld, Sol Hurok, Billy Rose, and Mike Todd were all well-known impresarios—but, unfortunately, they are all dead. The services that they once provided are now supplied by corporate executives or by independent producers, who usually gamble with other people's money rather than with their own. Whatever the source of the capital, however, an impresario or an entrepreneur is responsible for providing it and is therefore the financier.

Landlord

Film studios, Broadway theatre owners, and movie-theatre chains are landlords, as are the trustees for museums, public parks, zoos, libraries, film archives, nonprofit theatre facilities, and performing arts centers. Most such landlords have an artistic as well as financial interest in their real estate, which is fortunate for the industry when the market goes through a slump. But a considerable portion of business in the arts and media industry is conducted in space that is rented from landlords who have no special interest in its well-being, and this can be unfortunate.

The private ownership of an arts facility is a special kind of trusteeship, because such facilities are comparatively rare and often highly valued by the communities they serve. Few people mourn the demolition or conversion of a local restaurant, gas station, or abandoned factory. But when the wrecking ball threatens the local theatre—even a movie theatre—a public outcry is likely. Of course the landlords of such facilities hope to make profits and are entitled to

do so. The trouble is that many are inexperienced or uninterested in the arts and unwilling or incapable of hiring managers or finding tenants who can successfully operate the facility.

People with the capital and ambition to become involved in the commercial theatre sometimes buy a stock theatre, a dinner theatre, or even a few Broadway theatres. This provides instant entry into the industry, and with the right management is a sensible beginning. Capital is all that it takes to become a landlord of a commercial arts facility. The owner may then personally operate the facility or do so in absentia.

Packager

Anyone who chooses performance material and brings performers together with a director is a packager. The difference between a packager and a producer is that the former does not supply the capital for the project—at least not beyond his or her basic office expenses and operating costs. Rather, the packager is paid by the buyer(s), who must absorb all rehearsal and preproduction expenses, royalties, salaries, travel, and other costs. The exception to this is when a production is sold as a unit package, in which case the packager meets all expenses and the buyer writes a single check to cover these, and also to pay the packager's fee or commission. But this payment is made up front, or prior to the first performance of the production, so the packager's financial outlay is again minimized.

The most common types of packaged shows in the performing arts disciplines include bus-and-truck tours of popular plays and musicals that the packager sells to presenting organizations—a few performances to each; and shows that are sold for one- and two-week engagements at winter and summer stock theatres and dinner theatres. Or the packager may put together a Vegas-style nightclub show, an industrial show, a television movie or mini-series, or a commercial. In any case, the packager must have all the qualities of a producer as well as contacts with potential buyers in the appropriate industry markets.

Personal Manager

Highly successful artists may employ a full-time personal manager instead of or in addition to an agent or an artists' management firm. A personal manager usually attends to the artist's finances, investments, travel, appointments, living accommodations, and in some cases legal affairs. Payment may be in the form of a salary or a percentage of the artist's earnings, or a combination of both. It is not unusual for a personal manager also to be the artist's spouse or close friend, although such a dual relationship requires extraordinary qualities in both parties if it is to endure.

Presenter or Booking Agent

An independent presenter or booking agent is a person who engages attractions—be they theatrical productions, concerts, nightclub acts, or films—on behalf of some type of presenting organization. This is usually done in exchange for a percentage of the box-office net or gross, though there may also be the guarantee of a fee or commission to cover the agent's operating costs. Booking agents may be used by absentee landlords of performance facilities, or they may work in conjunction with community groups and arts societies whose purpose is to sponsor visits by performing artists or companies, or to run a lecture series, or to offer a film series. Booking agents must have experience and contacts with packagers, artists' representatives, producers, distributors, and others who are responsible for supplying the appropriate product. Some presenters—not to be confused with presenting organizations with an in-house manager who performs this function—have made significant contributions to the cultural health of the communities they serve. Most work alone or with a single secretary or assistant and have low overhead.

Press Agent or Public Relations Consultant

While the larger arts and media organizations have their own marketing, press, and promotion departments, as discussed in Chapter 7, there are thousands of small companies and one-time projects in the arts and media industry that require independent press agents and/or other promotion specialists. Some utilize large advertising agencies while others turn to one of the hundreds of independent press or public-relations agents. Most such agents specialize in a certain type of arts or media account: Broadway theatres, Off-Broadway theatres, nonprofit performing companies, nightclubs, film companies, or cable television companies. A good press agent or public relations person must have a working relationship with many members of the media, as well as with printers and graphic designers. He or she must have well-honed writing abilities and a knowledge of marketing, as well as imagination, inventiveness, and flair.

A public relations agency may merely write and distribute press releases and feature stories, or it may design and execute a whole marketing campaign, which also includes newspaper and media advertisements, direct-mail promotions, press parties and interviews, and special happenings.

Producer

In the arts and media industry a producer is any person or organization that provides the capital to finance a given project or product. In the not-for-profit sector the producer is really the institution or organization itself, because *it*

provides the financing. In the commercial sector, an individual may personally put up the needed money or, more often, may raise it from private and corporate investors, with whom the producer enters into a partnership and agrees to share any profits. An individual who produces in the commercial theatre is likely to have worked in the industry for a number of years; he or she perhaps belonged to the Association of Theatrical Press Agents and Managers, and has also worked as a general manager. The only essential requirement for being a producer is to have a property—meaning a script or something upon which a script could be based—and to own the option to produce it if it is not in the public domain. But experience in this profession is of prime importance, as is the ability to attract investors and the best artists for the project at hand. Only a small number of shows presented live or electronically ever show a profit, so producing is a highly speculative venture.

A majority of films now produced are the results of the efforts of independent producers, who function much like Broadway producers. Instead of leasing a theatre, however, film producers must sooner or later—preferably before the film is shot—enter into a contract with a distributor who will lease the showing-rights to exhibitors.

All producers must spend a great deal of time hunting for properties or ideas that they wish to produce, and for which they believe there is a sufficient audience to make the project worthwhile. The process entails seeing as many plays, films, and television shows as possible; reading countless original manuscripts, scenarios, and story treatments, even unpublished works in galley form; and keeping in contact with literary agents and publishers. Selecting what to produce is the most vital decision a producer makes, after which comes choosing the necessary artistic talent for the project. This process requires an in-depth familiarity with the professional work of hundreds of artists and other people in the industry, which means that producers must spend a lot of time as entertainment consumers. (See also Chapter 5.)

Theatre Architect or Architectural Consultant

All professional architects, including those who design or redesign performance facilities, must be licensed by the American Institute of Architects. Theatre architecture is a small field and also an interesting and highly specialized one, because a theatre architect must have a general understanding of the needs of artists and audiences in terms of using a facility. The architect usually works closely with a variety of consultants, including specialists in acoustics, stage systems and equipment. The most satisfactory performance facilities are usually built according to the needs of an existing performing arts company. Specifications are developed through consultations involving the architect, management, and the artistic directors. Unfortunately, however, many theatres and performing arts centers are commissioned by

civic organizations, universities, or other groups before a performing company is established. In this event, there may be no notion of how the facility is going to be used. The result can be a building that tries to satisfy a variety of potential users but ends up satisfying none.

Some degree-holding licensed architects have become scenic designers and vice versa; these two fields are complementary and, when the requisite skills are combined, offer a wide range of possible design projects and consulting opportunities.

The Arts and Media Management Career Kit
Graduate Programs in Arts Administration

While the following list is up to date as of publication, college programs in this field are still evolving in terms of their curricula requirements. The tuition rates quoted are for the 1984/85 academic year and provide criteria for comparison, but keep in mind that most tuition costs in recent years have been increasing between 5 percent and 10 percent annually. And, while many programs exercise flexibility in regard to application deadlines, such dates are often inflexible when it comes to financial assistance deadlines. For further guidance in selecting the right program for you, see Chapter 2.

Some of the programs in this listing cover the arts management field as a whole, though most concentrate on the performing arts or have a particular emphasis on arts administration. We have not listed graduate programs in museum management because virtually all of these offer degrees in art history with a concentration or special option in management. Perhaps the best and most comprehensive guide for both graduate and undergraduate programs in museology is *Museum Studies Programs in the United States and Abroad,* published by and available for $3.50 from the Office of Museum Programs, Building of Arts and Industries, Room 2235, Smithsonian Institution, Washington, DC 20560.

Courses and degree programs related to broadcast management, film production, and media studies are too numerous to list here, but Chapter 2 provides the titles of the best references, which you can find in most libraries.

GRADUATE DEGREE PROGRAMS

THE AMERICAN UNIVERSITY
Master of Arts in Arts Management
Department of Performing Arts
Washington, DC 20016

(202) 885-3420

Degree Requirements: 45 credits, which include a thesis and a four-hour comprehensive exam. Program is two and one-half years in length.

Courses Offered: Core requirements are Survey of Arts Management, Creative Theory and Criticism, Public Relations and Promotion in the Performing Arts, Case Studies in Arts Management, Fundraising Management for the Arts, and two nonmanagerial arts-related electives; 12 credits from the following four area—business, public relations, public administration and/or communications modules, plus a four-to-six-month internship (can be waived), and a 6-credit thesis or major paper.

Admission Requirements: 3.0 undergraduate grade-point average based on the last 60 credits completed, transcripts, two letters of reference, and an interview.

Application Deadline: August 1

Tuition: $267 per credit hour

Financial Aid: work-study, assistantships, and Basic Opportunity grants

ANGELO STATE UNIVERSITY
Master of Arts in Theatre Management
Department of Drama and Speech
San Angelo, TX 76902

(915) 924-2031

Degree Requirements: minimum of 30 semester credit-hours, including thesis, practicum experiences in box-office, public-relations and house management, but no internship requirement. Program is three to four semesters in length.

Courses Offered: Audience Development and Theatre Marketing, Developing Financial Resources for the Theatre, Theatre Financial Management, practicum, plus electives

Admission Requirements: baccalaureate degree with a minimum of 24 hours of course work in drama, 3.0 grade-point average or better in last 60 undergraduate hours, GRE scores, resume, and interview

Application Deadline: August 15 for fall; January 2 for spring

Tuition: $81 for first credit plus $16 for each additional credit up to $300 per semester for state residents; $71 for first credit plus $51 for each additional credit up to $1200 per semester for out-of-state students

Financial Aid: graduate assistantships and other forms of financial aid

BROOKLYN COLLEGE OF THE CITY UNIVERSITY OF NEW YORK
Master of Fine Arts in Performing Arts Management
Department of Theatre
Brooklyn, NY 11210

(718) 780-5666

Degree Requirements: 45 credits, including completion of three practicum assignments (totaling 600 hours of field work) and a full-time, four-month professional residency

with a leading performing arts company or organization that results in an evaluation report. Program is two years—four semesters—in length.

Courses Offered: Principles of Performing Arts Administration; Research and Bibliography for Arts Managers; two courses in theatre, music or dance history; Business Management for the Performing Arts, Financial and Managerial Accounting, Managerial Economics for the Performing Arts, Promotion and Marketing for the Performing Arts, Technology and the Performing Arts, Theatre Design and Planning, Studies in Repertory Theatre, the Performing Arts and the Law, Fundraising for the Performing Arts, Broadcast Management, Stage Management, Advanced Seminar in Performing Arts Management, Practicum I, II, III, Professional Residency, and thesis report

Admission Requirements: 3.0 undergraduate grade-point average, performing arts background, statement of goals, two letters of reference, transcripts, and an interview when possible

Application Deadline: June 1 for fall semester, December 1 for spring semester

Tuition: $81 per credit with a $937.50 maximum per semester for 7 or more credits for state residents; $116 per credit with a $1,337.50 maximum for 7 or more credits per semester for out-of-state students

Financial Aid: teaching fellowships, Performing Arts Center internships on campus, work-study, salaried off-campus internships, loans, and tuition waivers

COLUMBIA COLLEGE
Master of Arts in Arts, Entertainment, and Media Management
600 South Michigan Avenue
Chicago, IL 60605

(312) 663-1600

Degree Requirements: 45 credit-hours, including internship and thesis. Program is four semesters in length.

Courses Offered: Accounting Principles; Marketing Principles; Applied Marketing; Organizational Techniques for Arts Managers; Media Management/Studio Practicum; Decision-Making—Record Industry; Production Management for the Performing Arts; Museum and Curatorial Practices; Arts, Media, and the Law; Financial Management; Decision-Making—Electronic Media; Presenting, Promotion, and Management; Music Business—Special Aspects; Fundraising and Grant Proposals; Computer Uses for Arts Managers; Policy Making for Arts Managers; Visual and Performing Arts Management

Application Deadline: August 15 for fall, January 1 for spring

Tuition: $158 per credit

Financial Aid: information available upon request

COLUMBIA UNIVERSITY
Master of Fine Arts in Arts Administration
School of the Arts
615 Dodge Hall
New York, NY 10027

(212) 280-4331

Degree Requirements: 60 credits, including core curriculum of 42 credits, internship, and thesis. Program is normally two years in length.

Courses Offered: arts administration courses include Principles and Practice, the Arts in Context, Law and the Arts (each 6 points); Arts and the Media, Support Structures of the Arts, internship and master's project (each 3 points); business courses include Managerial Accounting, Financial Planning and Control, Organizational Behavior, Business Policy, Marketing Strategy, and Collective Bargaining (each 3 points)

Admission Requirements: bachelor's degree, a strong foundation in at least one arts discipline, at least three years of relevant practical experience after graduation, three letters of recommendation, essay, and personal interview

Application Deadline: March 15

Tuition: approximately $330 per credit

Financial Aid: modest financial aid available on a case-by-case basis, in addition to state and federal loan programs

DREXEL UNIVERSITY
Master of Science Program in Arts Administration
Department of Performing Arts
Philadelphia, PA 19104

(215) 859-2452

Degree Requirements: 45 quarter-credits—36 in course work and 9 in internship; thesis required of internship. Program is one year in length.

Courses Offered: the American Political System, Social History of the Arts, Accounting for Nonprofit Organizations, Technical Writing for the Arts, Technology and the Marketing of the Arts, Organization Theory and Behavior, Arts Administration Seminar, Management Techniques in the Arts, Law and the Arts, internship and thesis; recommended electives—Production Procedures in the Arts, Production Laboratory in the Performing Arts, Psychology of Arts Personnel Administration, Management Information Systems, Microcomputer Applications in Arts Administration

Admission Requirements: baccalaureate degree, strong and demonstrated affinity to the field, 3.0 grade-point average for last two years of undergraduate work, and letters of recommendation

Application Deadline: August 6 for fall term; November 10 for winter term; February 7 for spring term; May 3 for summer term

Tuition: information available upon request

Financial Aid: assistantships, part-time positions with the Department of Performing Arts, partial tuition waivers; full-time students may also elect to participate in graduate co-op program, taking a six-month period of full-time employment mid-way in the program for salaried income and possible future placement.

FLORIDA STATE UNIVERSITY
Master of Fine Arts in Theatre Management
School of Theatre
Tallahassee, FL 32306

(904) 644-5548

Degree Requirements: minimum of 60 semester-hours, though more are usually necessary; no thesis, may include internship. Program is two years in length.

Courses Offered: various courses offered in the schools of Business, Public Administration, Visual Arts, and Communication

Admission Requirements: undergraduate degree, statement of goals, letters of recommendation, GRE scores, and resume

Tuition: approximately $38 per hour in-state students, $62 per hour out-of-state students

Financial Aid: information available upon request

GOLDEN GATE UNIVERSITY
Master of Arts and Master of Business Administration in Arts Administration
Graduate School of Management
536 Mission Street
San Francisco, CA 94105

(415) 442-7000, ext. 7463

M.A. Degree Requirements: 48 credits including a thesis. The M.A. may be completed in two years. The school operates on a trimester system.

M.B.A Degree Requirements: 57 credits including thesis. The program is three years in length and consists of general business courses plus advanced courses in arts administration.

Courses Offered: General Business Program—Mathematics for Managers, Financial Accounting for Managers, Managerial Accounting, Economics for Managers, Finance for Managers, Marketing for Managers, Organizational Behavior and Management Principles, Computer Technology for Managers, Statistical Analysis for Managers; Advanced Program—Elements of Arts Administration, Marketing and Public Relations for. Arts Administration, Fundraising for Arts Administration, Legal Aspects of Arts Administration, Computer Use in Arts Administration, and thesis. Internships are only

assigned at the discretion of the program director and are undertaken after completion of all required course work.

Admission Requirements: bachelor's degree with grade-point average of 2.50 or higher, transcripts, two years of arts-related experience, and an interview

Application Deadline: Students may enroll at the start of the fall, spring, or summer semesters.

Tuition: $155 per unit

Financial Aid: installment plans, grants, emergency loans, work-study, and the National Direct and Guaranteed Student loans

INDIANA UNIVERSITY
Master of Arts in Arts Administration
School of Business, Room 458
Bloomington, IN 47405

(812) 335-0282

Degree Requirements: 39 credit-hours, including a four-month to one-year internship. Program is two years in length..

Courses Offered: business courses—12 to 16 hours—include Accounting, Financial Management, Marketing Communications, and Legal Concepts in Business; arts administration courses—15 to 18 hours—include Concert Management, Museum Management, Musical Theatre Management, Theatre Management, Seminar in Arts Administration (requiring a substantive paper in lieu of a thesis), internship, and related evaluation report.

Admission Requirements: a strong undergraduate background in the arts and/or business administration, prior work experience, GRE scores, letters of recommendation, plus bachelor's degree

Application Deadline: February 15; fall admission only

Tuition: $65.75 per credit hour for in-state students; $180.25 per credit-hour for out-of-state students

Financial Aid: Contact the university's Office of Scholarships and Financial Aid for information.

NEW YORK UNIVERSITY
Master of Arts in Arts Administration
School of Education, Health, Nursing, and Arts Professions
Department of Arts Administration
300 East Building
Washington Square
New York, NY 10003

(212) 598-7791

Degree Requirements: 54 credits, including internship; program for full-time students lasts at least one and one-half years. Course credits vary, from 3 to 4.5 to 6.

Courses Offered: Accounting for Management, Analysis, and Control; Business Economics; Seminar in the Environment of Arts Administration; Principles and Practice of Arts Administration; Development for the Performing Arts; Law and the Arts; Marketing for the Performing Arts; Quantitative Methods for Business Decisions; Behaviorial Science for Administrators; management electives, and two internships

Admission Requirements: two letters of reference, a degree from an accredited undergraduate institution with at least a 2.5 grade-point average, and either a strong background or prior experience in at least one art form

Application Deadline: July 15 for the fall semester and November 25 for the spring semester

Tuition: $222 per credit

Financial Aid: The school does not offer aid. Students should apply early to the N.Y.U. Office of Financial Aid for state and government loans. Internship sponsors are requested to pay small stipends.

SANGAMON STATE UNIVERSITY
Master of Arts in Community Arts Management
Springfield, IL 62708

(217) 786-6535

Degree Requirements: 50 hours of course work and field experience. The program is two years in length.

Courses Offered: Theatre and Concert Management, Museum and Visual Art Center Management, Financial Management for Nonprofit Organizations, Internships I and II, Field Experience I and II, Problem-Solving and Program Evaluation Seminar, Information Management Systems, Analytic Tools for Public Administrators, Philosophy of Arts, and a variety of electives outside the program

Admission Requirements: bachelor's degree, some arts background; admission to the program only after acceptance by the university

Application Deadline: open, though preferably prior to March 21

Tuition: in-state students—$41 per hour part-time and, $492 full-time, maximum; out-of-state students—$123 per hour part-time, and $1,476 full-time, maximum

Financial Aid: Tuition waivers, loans, graduate assistantships, and work-study are available.

SOUTHERN METHODIST UNIVERSITY
Dual Degree Program: Master of Arts and Master
of Business Administration
in Arts Administration

Meadows School of the Arts
Dallas, TX 75275

(214) 692-3425

Dual Degree Requirements: 63 credit-hours for a full-time program lasting twenty-one months, including an internship during the last semester

Courses Offered: Financial Reporting and Managerial Accounting, Management Science and Computers, Economics for Business Decisions, Case Studies in Public Relations, Legal Environment of Business, Financial Management, Introduction to Marketing, Management Science and Computers, Economics for Business Decisions, Operations Management, Individual and Organizational Behavior, Management of the Total Enterprise, Seminars in Arts Administration, electives, 3 hours of internship; no thesis or major paper required

Application Deadline: February 1; admission for the fall term only

Tuition: $256 per credit-hour

Financial Aid: administrative associateships available to some students; these offer tuition remission and may include a stipend.

STATE UNIVERSITY OF NEW YORK AT BINGHAMTON
Master of Business Administration with a Specialization in Arts Administration
Fine Arts Building, Room 233
Binghamton, NY 13901

(607) 798-2630

Degree Requirements: 64 credits, including internship; the program lasts two full years and covers five semesters.

Courses Offered: Financial Accounting, Statistical Analysis, Organizational Behavior, Public Policy for the Arts, Computer Proficiency, Managerial Economics, Managerial Accounting, Management Finance, Management Information Systems, Macroeconomic Analysis, Human Resource Management, Employment Practices in Arts Institutions, Models for Management Decisions, Operations Management, Grant and Proposal Writing, Arts and the Law, Managerial Policy, Environment of the Arts World, electives, and a sixteen-week internship; no thesis requirement

Admission Requirements: bachelor's degree, satisfactory GMAT scores and grade-point average, transcripts, two recommendations, interest or experience in one or more art form, and an interview when possible

Application Deadline: February 15

Tuition: $937.50 per semester in-state students; $1,112 per semester out-of-state students

Financial Aid: assistantships, fellowships, and affirmative action funds available; over half of the students receive some form of financial aid.

UNIVERSITY OF AKRON
Master of Arts Option in Arts Management
College of Fine and Applied Arts
Department of Theatre and Dance
Akron, OH 44325

(216) 375-7890

Degree Requirements: minimum of 36 hours, including thesis; the program is two years in length.

Courses Offered: Introduction to Graduate Studies, Audiences for the Arts, Introduction to Arts Management, the Role of Arts Administrator, Legal Regulations and the Arts, Arts Management Internship, research and thesis, plus electives in the areas of business, marketing, accounting, information systems, and urban studies

Admission Requirements: bachelor's degree, 2.75 minimum grade-point average; applicants must meet the admission requirements of the graduate school.

Application Deadline: April 1 for assistantships

Tuition: $74 per hour for in-state students; $127 per hour for out-of-state students

Financial Aid: graduate assistantships

UNIVERSITY OF CALIFORNIA, LOS ANGELES
Master of Business Administration in Management in the Arts
Graduate School of Management
Los Angeles, CA 90024

(213) 825-2014

Degree Requirements: twenty-four courses of 96 quarter-units, including an internship with two papers approved by a faculty committee; program is two years and the intervening summer—three quarters per academic year; entrance is only in September.

Courses Offered: The curriculum consists of four components: (1) a nucleus course in the first year to develop managerial skills from a personal perspective; (2) a management core of ten out of twelve courses in management subjects; (3) a concentration of eight courses, including an internship, in arts management subjects; and (4) electives either in the School of Management or other departments at the graduate level; the six-month internship is arranged after the first year of course work.

Admission Requirements: bachelor's degree, acceptable undergraduate performance and grade-point average, acceptable GMAT score, recommendations, statement of purpose, past arts experience and/or evidence of commitment to an arts management career, and, if possible, an interview

Application Deadline: March 15 for the following September, though earlier application is desirable

Tuition: $450 per quarter for in-state students; $1,120 per quarter for out-of-state

students; plus a $30 per quarter materials fee. No fees are charged during the intervening summer.

Financial Aid: Grants, work-study, and loans are available.

UNIVERSITY OF CINCINNATI
Master of Arts in Arts Administration
College-Conservatory of Music
Cincinnati, OH 45221

(513) 475-4383

Degree Requirements: 76 credit-hours, including internship. This is a two-year program consisting of seven quarters.

Courses Offered: Introduction to Arts Administration, Management, Collective Bargaining, Ethics in Arts Administration, Economics of the Performing Arts, Computer Programming, Communication in the Arts, Financial Accounting, Management Control Accounting, Funding and Grants, Market Development of the Arts, Production Elements of the Stage, Layout and Design, Legal Aspects of the Arts; Survey of Arts Disciplines, Support Organizations, Professional and Union Groups; two internships, and a research project or paper

Admission Requirements: an undergraduate degree in business or the arts with a minimum 3.0 grade-point average, GRE and GMAT scores, essay, official transcripts, three letters of recommendation, and an interview

Application Deadline: March 1

Tuition: $994 per quarter for in-state students; $1,964 per quarter for out-of-state students

Financial Aid: some assistantships, tuition remissions, and work-study

UNIVERSITY OF IOWA
Master of Fine Arts in Arts Management
Hatcher Auditorium
Iowa City, Iowa 52242

(319) 353-6251

Degree Requirements: minimum of 48 credit-hours, including practicum; maintenance of a 3.0 grade-point average. Each student is assigned three faculty members who set an individualized curriculum—hours may vary up to 60. A non-research thesis is required, with written or oral final exam approved by a faculty committee. The program lasts two full years.

Courses Offered: Introduction to Arts Management; Seminar in Arts Management; Financial Accounting and Marketing Management; Graphic Design and Production; Sociology of Art; Persuasive Writing in the Arts; Macroeconomics; Management of

Organizations; Computer Methods; Society, Law, and Business; practicum, and at least 3 credits in the history of each of the following—art, music, dance, theatre

Admission Requirements: undergraduate degree with at least 3.0 grade-point average, GRE score, letters of recommendation, previous work in at least one art field, and interview when possible

Application Deadline: March 1

Tuition: based on hours taken—$134 to $600 per term for in-state students; $134 to $1400 per term for out-of-state students

Financial Aid: assistantships and loans

UNIVERSITY OF NEW ORLEANS
Master of Arts in Arts Administration
College of Liberal Arts
Lakefront
New Orleans, LA 70148

(504) 286-6804

Degree Requirements: minimum of 36 credit-hours; students must also present credit for 18 hours of foundation courses, which may be taken after admission. Comprehensive exam, internship of at least 300 hours, and an internship report are required. The program is two years in length.

Courses Offered: Use of Computers in Arts Administration, Economics of the Arts, Funding and Promotion of the Arts, Legal and Business Applications for the Arts, internship, plus interdisciplinary courses drawn from various departments

Admission Requirements: bachelor's degree with 2.5 grade-point average minimum; composite score of 1000 on the GRE, or a minimum of 400 on the GMAT; and three letters of recommendation

Application Deadline: one week before registration; April 15 and November 15 for graduate assistantships

Tuition: $492 per term for in-state students; $932 per term for out-of-state students

Financial Aid: assistantships and other types of aid

UNIVERSITY OF UTAH
Master of Fine Arts in Theatre with an Emphasis in Arts Administration
College of Fine Arts
Art and Architecture Center, Room 167
Salt Lake City, UT 84112

(801) 581-8709

Degree Requirements: approximately 81 credit-hours; seven consecutive quarters, including summer; there are six quarters of internships of 20 hours per week and one

quarter of a full-time internship. A degree project is required. The program is for full-time students only.

Courses Offered: Principles of Arts Administration, Introduction to Computers, Marketing for the Arts, Media, Boards of Directors and Auxiliaries, Technical Production for Administrators, Touring, Membership and Season Ticket Campaigns, Financial Management, Audience Development, Development of the Arts Institution, Fundraising and Grantsmanship, Facility Programming and Planning, Law and the Arts, a Graduates' Seminar, quarterly informal arts administration seminars, electives in the College of Business, and a degree project.

Admission Requirements: 3.0 grade-point average or better for bachelor's degree, demonstrated interest in the arts, resume, three letters of recommendation, personal statement of goals. Students are admitted in September only.

Tuition: approximately $322 per quarter for a 12-hour load for in-state students; $936 per quarter for a 12-hour load for out-of-state students

Financial Aid: some available through the University Financial Aid Office; some internships provide payment.

UNIVERSITY OF WISCONSIN—MADISON
Master of Arts in Arts Administration
Center for Arts Administration
Graduate School of Business
1155 Observatory Drive
Madison, WI 53706

(608) 263-4161

Degree Requirements: minimum of 24 credits in addition to a core of business courses, internship, and master's paper; the program is two years in length. Full-time internships are arranged during the summer after the second semester or at the end of all course work.

Courses Offered: foundation courses include Microeconomics, Financial and Administrative Accounting, Budgets and Budgetary Control, Marketing, Organizational Behavior, Statistics and Legal Aspects of Business; arts administration courses include a two-semester seminar in arts administration given in three-to-five-week workshop formats; a colloquium in arts administration research; an administrative process course, and electives

Admission Requirements: undergraduate degree with minimum 3.0 grade-point average, GRE or GMAT scores, three letters of recommendation, and a written statement

Application Deadline: February 1

Tuition: $112 per credit with a maximum of $894.50 for over 8 credits for in-state students; $333 per credit with a maximum of $2,661.50 for over 8 credits for out-of-state students

Financial Aid: limited fellowships and project assistantships, loans, and work-study

VIRGINIA TECH
Master of Fine Arts in Arts Administration or Stage Management
Division of Performing Arts
Blacksburg, VA 24061

(703) 961-4670

Degree Requirements: 81 quarter-hours of credit; an internship of no fewer than three months with a professional arts organization; a production or research thesis. The program is three years in length.

Courses Offered: Style of Theatrical Production, 6 quarter-hours; Directed Readings, 6 quarter-hours; Roundtable, 3 years, no credit; Management Studio, variable, 18 to 54 quarter-hours over three years; internship, 9 quarter-hours; thesis, 2 to 9 quarter-hours

Admission Requirements: undergraduate grade-point average of 2.75 minimum; GRE not required but recommended; submission of portfolio or other materials; three letters of recommendation and an interview

Application Deadline: April 1

Tuition: for programs of 9 hours or more—$692 per quarter for in-state students; $755 per quarter for out-of-state students

Financial Aid: graduate assistantships

YALE UNIVERSITY
Master of Fine Arts in Theatre Administration
Yale School of Drama
222 York Street
New Haven, CT 06520

(203) 436-1587

Degree Requirements: 11 terms of courses in the core curriculum, 4 terms of courses with a concentration in management, finance or marketing; 2 terms of courses in theatre history, dramatic literature, or criticism; and an additional 5 terms of electives; a year-long professional assignment with the Yale Repertory Theatre or an original research project resulting in a thesis. The program is three years in length.

Courses Offered: Theatre Management, Marketing, Accounting, Financial Management, Theatre Organization, Contracts, Administration Seminars. Also offered are Mass Communications and Subscriptions, Advertising, Press Relations and Publicity, Theatre Management Planning and Development, and Theatre Labor Management. Students work each year at rotating assignments at the Yale Repertory Theatre/School of Drama in public relations, administration, box-office management, and as company manager; possible one-term internship with professional theatre organization during the second year of the program is optional.

Admission Requirements: undergraduate degree, four letters of recommendation, résumé, statement of purpose, transcripts, GRE score, and interview; experience is preferred but is not necessary.

Application Deadline: February 1

Tuition and fees: $6,700 per year

Financial Aid: Work-study, educational loans and grants are available based solely on need.

YORK UNIVERSITY
Master of Business Administration Programme in Arts and Media Administration
Faculty of Administrative Studies
4700 Keele Street
Toronto, Ontario M3J 1P3
Canada

(416) 667–2360

Degree Requirements: The programme is three terms per year and requires four terms, usually two academic years, to complete. The first of these may be taken on a part-time basis in the evenings. A four-month summer internship after the first two terms of study plus a major group exercise may be completed in lieu of a thesis.

Courses Offered: Introduction to Arts and Media Management, Management of Artistic Resources, Management in Media Environment, Cultural Policy, Communications Policy, Legal Aspects of Arts and Entertainment, plus electives in various departments

Admission Requirements: minimum of a B average during last two years of undergraduate study, GMAT score, and two letters of recommendation

Tuition: $129 (Canadian) per course

Financial Aid: limited number of graduate research and teaching assistantships, usually awarded to second-year students

GRADUATE CERTIFICATE PROGRAMS

FLORIDA STATE UNIVERSITY
Certificate in Arts Administration
Institute of Science and Public Affairs and School of Visual Arts
123 Education
Tallahassee, FL 32306

(904) 644–5474

Certificate Requirements: Requirements vary with major field of interest; the program may be completed in two semesters.

Courses Offered: Arts Administration in the Public Sector, Management of Arts Organizations, and a variety of electives

Admission Requirements: baccalaureate degree with at least a B average in final two years, GRE score

Application Deadline: one month prior to desired enrollment

Tuition: approximately $38 per credit for in-state students; $62 per credit for out-of-state students

GOLDEN GATE UNIVERSITY
Certificate in Arts Administration
Graduate School of Management
536 Mission Street
San Francisco, CA 94105

(415) 442-7000, ext. 7463

Certificate Requirements: 36 units, including a thesis; school is on a trimester system.

Courses Offered: See M.A. and M.B.A. listing for Golden Gate University under Graduate Degree Programs.

Admission Requirements: Send for special application form.

Application Deadline: prior to each semester's start

Tuition: $155 per unit

Financial Aid: installment plans, grants, emergency loans, work-study, and federal loan programs

Arts and Media Management Internships

Internship positions in the arts and media field combine working with learning and are intended to provide hands-on experience for those interested in pursuing a career. A worthwhile internship will offer the participant a broad overview of the organization's management and allow that person to take part in specific projects under the supervision of the management staff and to observe a variety of meetings and events related to the organization's work.

Because many internships are nonsalaried or provide only a small stipend, the intern should look upon the arrangement as a quid-pro-quo situation: The intern's wages are experience and contacts rather than salary. You are advised to examine the position carefully before accepting. Avoid the danger of becoming a go-fer or file clerk and make certain that the people for whom you will be working have good reputations and management practices.

Many service organizations, management assistance groups, and unions offer internships—sometimes called apprenticeships or fellowships—as seen in the list that follows, and more information may be obtained by contacting them directly. In addition, the majority of nonprofit performing arts companies offer internships in the management areas, as do an increasing number of commercial arts and media corporations. For example, the three major broadcasting networks accept interns, who are really nonsalaried trainees, and often hire them for regular positions. In fact, this is one of the best ways to break into a network job. For a listing of internships in film and television see

the *Guide to College Courses in Film and Television* (Peterson's Guides Inc., Box 2123 Princeton, NJ 08540) and consult *Factfile #2,* "Careers in Film and Television" (National Educational Service of the American Film Institute, John F. Kennedy Center for the Performing Arts, Washington, DC 20566).

Current listings of internships with performing arts companies can be found in *Internships* (Writer's Digest Books, 9933 Alliance Road, Cincinnati, OH 45242), and in *STOPOUT! Working Ways to Learn* (Garrett Park Press, Garret Park, MD 20896). *ArtSearch* and *The National Arts JobBank,* as detailed under the Job Referral section of the Career Kit, also list current internships as they become available.

The list that follows is only a sampling of several dozen interesting and well-established internship programs. There are countless other possibilities for this type of training in the arts and media industry. Certainly, you should not discount making direct personal contact with an organization or individual from whom you wish to learn. Offer your services gratis, or for very little, and you may soon find yourself climbing a sturdy career ladder!

ALLIANCE OF RESIDENT THEATRES/NEW YORK (ART/NY) (Theatre: all
325 Spring Street, Room 315 management areas)
New York, NY 10013

A highly competitive program is offered for ten to twelve interns per school semester; work includes an internship with a New York theatre, guidance and counseling services, supervision of placement, and weekly seminars. ART/NY also acts as a clearinghouse for other New York City theatre internships.

THE AMERICAN MUSIC SCHOLARSHIP ASSOCIATION (Music: public relations
1826 Carew Tower and general administration)
Cincinnati, OH 45202

The internships are offered each year; the length and beginning times for which are flexible. A public relations intern handles local and national press and media; an administrative intern handles office management, membership information, and correspondence. There are no specific criteria for acceptance.

AMERICAN SYMPHONY ORCHESTRA LEAGUE (ASOL) (Symphony orchestra
633 E Street, NW management)
Washington, DC 20004

The Orchestra Management Training Program is a one-year internship administered by ASOL in cooperation with member orchestras. A limited number of fellowships that award approximately $10,000 plus travel expenses are offered each year. Fellows spend two or three months with a metropolitan, regional, and major orchestra and also work in the ASOL office.

ATLANTA URBAN CORPS (All arts fields)
Georgia State University
Box 671
Atlanta, GA 30303

The Arts Administration Internship Project is a twelve-week program that provides practical experience in specific areas of arts administration throughout the state of Georgia and is open to out-of-state residents as well as college students.

CITY OF NEW YORK, DEPARTMENT OF CULTURAL AFFAIRS (All arts fields)
2 Columbus Circle
New York, NY 10019

Open to college students in New York City; interns work for a semester or more with local performing or visual arts organizations, often for work-study wages through the Urban Corps; college credit may also be earned.

CORPORATION FOR PUBLIC BROADCASTING (CPB) (Public television:
1111 16th Street management)
Washington, DC 20036

Women's and Minority Training grants provide on-the-job training with stipends for women and minorities to work with public broadcasting stations. Grants are for one or two years. Stations apply to CPB and pay half the stipend. Qualified applicants should contact CPB.

KAUFMAN-ASTORIA STUDIO (Film: production)
34–31 35th Street
Astoria, NY 11106

The Astoria Internship Program is open to college students with at least three years of film studies. College credit may be earned for internship assignments in various aspects of film production.

KENNEDY CENTER EDUCATION PROGRAM (Arts education and theatre)
Internship Coordinator
Kennedy Center for the Performing Arts
Washington, DC 20566

Three-month internships are offered with the Alliance of Arts Education, the American College Theatre Festival, and with Programs for Children and Youth. Applicants must be college seniors or graduate students in the fields of arts administration, theatre, arts education, or journalism.

LINCOLN CENTER FOR THE PERFORMING ARTS (Performing arts: operations)
Internship Coordinator
140 West 65th Street
New York, NY 10023

While the constituent companies that perform at Lincoln center may offer internships, so does the general operating office for Lincoln Center as a whole. Two interns are hired each year on a highly competitive basis—one three-month position and one six-month position, both of which begin in June and pay approximately $225 per week. Applicants must have completed at least one year of graduate study in business or arts administration.

MEDIA CENTER FOR CHILDREN, INC. (Educational films)
3 West 29th Street
New York, NY 10001

Interns participate in the operation of the Media Center; administrative duties, publication production, and evaluation of films for children comprise most of the work.

MUSEUM'S COLLABORATIVE (Museums: general management,
15 Gramercy Park South marketing, personnel management)
New,York, NY 10003_

The Cultural Institutions Management Program offers three months of training, which consists of a one-week seminar, an eleven-week practicum, and a three-day follow-up seminar. The practicum is usually done at the organization where the participant is an employee. There is a fee for this program and an applicant must be sponsored by an arts institution.

NATIONAL ENDOWMENT FOR THE ARTS (NEA) (Arts councils: operations)
Management Fellowship Program Administrator
Nancy Hanks Center
1100 Pennsyvania Avenue, NW
Washington, DC 20506

The NEA Management Fellowship Program offers in-house internships for arts managers who have demonstrated a strong commitment to their field. Fellows work with the staff and attend seminars, lectures, and panel meetings. Approximately fifteen fellows are selected for each of the thirteen-week fall, spring, and summer fellowship periods. Grants for this highly competitive program include a stipend of $3,300 plus round-trip travel reimbursement.

NATIONAL TRUST FOR HISTORIC PRESERVATION (Museums and architecture)
Youth Programs Assistant

Office of Preservation Studies
1785 Massachusetts Avenue, NW
Washington, DC 20036

A summer internship program for students interested in horticulture, architecture, art history, history, and the humanities.

NEW YORK CITY URBAN CORPS (All arts fields)
32 Worth Street
New York, NY 10013

The Summer Management Intern Program offers internships to graduate arts administration students, among others, who have some field experience. Small stipends are available for students to work with New York City arts groups. The Urban Corps together with the New York City Department of Cultural Affairs (see above) also serve as clearinghouses for the assignment of work-study students to cultural institutions in the area throughout the year.

NEW YORK STATE COUNCIL ON THE ARTS (NYSCA) (Arts councils: operations)
915 Broadway, 7th floor
New York, NY 10010

Like most state and community arts councils, NYSCA offers internship opportunities in a variety of program areas to qualified applicants. No stipend is available, but the learning opportunity is considerable; hours are flexible, as is the internship time period.

NORTH CAROLINA ARTS COUNCIL (Community arts council administration)
North Carolina Department of Cultural Resources
Raleigh, NC 27611

The Summer Internship Program offers one month with a small community arts council and two months at a large one. The program is designed to provide an understanding of community arts projects. Small stipends are awarded.

OPERA AMERICA (Opera: general management)
633 E Street, NW
Washington, DC 20004

The Executive-in-Residence Program provides a one-to-three-month residency for executive directors and other staff from Opera America member companies to work with other arts organizations and corporations to learn new concepts and techniques that may be used in their own companies. Opera America pays transportation and living expenses, and the participant's company pays the salary.

PERFORMING ARTS SERVICES (PAS) (Performing arts: operations,
325 Spring Street touring, business management)
New York, NY 10013

The Management Intern Training Program participants work for PAS, a cluster management company that primarily serves avant-garde performing artists. Interns work directly with the staff and gain experience in all components of arts management, including international booking, touring, promotion, and fiscal management. This is a long-term training program that lasts from one to two years and offers a small salary.

THEATRE COMMUNICATIONS GROUP (TCG) (Performing arts:
355 Lexington Avenue general management)
New York, NY 10017

The National Fellowships in Performing Arts Management are six-to-nine-month programs for professionals who wish to increase their expertise or to explore new career directions. Individuals are placed in on-the-job training situations designed according to their stated needs. Fellows work with top managers in the field and priority is given to those who are aiming toward top management positions themselves. Candidates must be nominated by administrative directors from a professional performing arts or arts service organization. A monthly stipend and relocation costs are provided.

VISUAL STUDIES WORKSHOP (Museums and galleries)
31 Prince Street
Rochester, NY 14607

Internships are offered in gallery- and museum-related operations, including touring exhibitions, media projects, and gallery management.

WALKER ARTS CENTER (Museum and cultural center management)
Vineland Place
Minneapolis, MS 55403

An internship program is open to applicants with a master's degree in art history or commensurate experience with a museum or cultural center. Interns participate in all areas of the Center's operation.

WNET (Public television)
356 West 58th Street
New York, NY 10019

The Thirteen College Intern Program is open to college students who live or attend college within the station's viewing area. Interns gain on-the-job training in all phases of the station's operation. More than one-third of over 600 students who completed

the program have found full-time emloyment at the station after graduation. Students receive college credit for the internship.

YALE UNIVERSITY: AMERICAN ARTS OFFICE (Museums)
2006 Yale Station
New Haven, CT 06520

Internships are offered to those with at least a master's degree who plan to enter the museum profession or who are already employed by a museum.

YOUNG CONCERT ARTISTS, INC. (Music and service organizations)
250 West 57th Street
New York, NY 10019

Internships are open to high school and college students who are interested in classical music administration. Students perform general office duties. There is no salary or stipend, but college credit may be arranged.

Arts and Media Management Seminars, Workshops, and Information Centers

The following is a representative list of established, short-term training opportunities in specialized aspects of the arts and media management field. Contact directly those of greatest interest—the length, content, and location of the activities described below are subject to change.

ALLIANCE OF RESIDENT THEATRES/NEW YORK (ART/NY)
325 Spring Street, Room 315
New York, NY 10013

Focus: Off-Broadway and Off-Off-Broadway theatre in New York City

Membership meetings: regular meetings for members to discuss aspects of theatre management, including union relations, marketing, financing, and development

AMERICAN ASSOCIATION FOR STATE AND LOCAL HISTORY (AASLH)
172 Second Avenue North
Suite 102
Nashville, TN 37201

Focus: historical institution administration

Seminars on Interpretation: two two-week sessions offered annually on all aspects of administration

Seminars for Advanced Professionals: usually five days in length on various topics

Annual Seminar for Historical Administration: a four-week summer seminar conducted by nationally recognized authorities on a full range of topics; includes a field trip

Workshops: two-and-one-half-day workshops held in various cities across the country, focusing on one topic each year

AMERICAN ASSOCIATION OF MUSEUMS (AAM)
1055 Thomas Jefferson Street, NW
Suite 428
Washington, DC 20007

Focus: museum administration

Workshops: Legal Problems of Museum Administration—held annually for three days in different locations throughout the country, conducted by the American Law Institute and the American Bar Association with an emphasis on practical information relating to museum management

Annual Meeting: held for five days each spring, presenting prominent speakers and covering many topics regarding museum administration

Workshops and Seminars: sponsored frequently by regional affiliates of AAM throughout the year

AMERICAN COUNCIL FOR THE ARTS (ACA)
570 Seventh Avenue
New York, NY 10018

Focus: arts councils and united arts funds

Seminars and Workshops: held frequently throughout the year in different locations; topics have included "United Arts Funding," "Business and the Arts," and "The Arts and City Planning."

Annual Conference: Each conference is devoted to a specific topic and presents diverse views by speakers from government, industry, education, and the arts. Conferences are held in a different city each year and last four days.

AMERICAN DANCE FESTIVAL
1860 Broadway
New York, NY 10023

Focus: dance management

Seminar Series: Sessions are planned on dance production for dance managers.

Information: through a technical assistance project, offers career counseling, technical position referrals, and other information on dance production and performances

Newsletter: Technical Assistance Project Newsletter contains information on modern dance production and other topics relating to the field.

AMERICAN DANCE GUILD, INC. (ADG)
570 Seventh Avenue
New York, NY 10018

Focus: dance education

Annual Conference: features workshops and speeches on dance and dance education

AMERICAN FILM INSTITUTE (AFI)
Kennedy Center for the Performing Arts
Washington, DC 20566

Focus: film and television

Seminars: held in major cities around the country in all aspects of film, including producing and management

Publications: The American Film Institute Guide to College Courses in Film and Television and *Factfile #2:* "Careers in Film and Television"

AMERICAN LAW INSTITUTE-AMERICAN BAR ASSOCIATION
4025 Chestnut Street
Philadelphia, PA 19104

Focus: legal problems of museum administration

Seminar: held annually for three days at a different location each year; covers practical information relating to museum management and legal problems

AMERICAN MUSIC CENTER
250 West 54th Street
New York, NY 10019

Focus: contemporary music

Workshops: on topics relating to the management of contemporary music ensembles

Information: on publishing, performances, and management

AMERICAN SYMPHONY ORCHESTRA LEAGUE (ASOL)
633 E Street, NW
Washington, DC 20004

Focus: orchestra and general management

Symphony Orchestra Management Seminars: Concentrated eight-day seminars addressing various topics related to orchestra management are presented by lecturers from orchestras and consultants in the field; seminars are held in various locations each year.

Regional Workshops: Six two-day regional workshops are given each year in cities where there are member orchestras; the workshops concern specific management problems and serve as an introduction to the field of symphony orchestra management.

National Conference: a five-day conference held in a major city in the United States each June; sessions for managers, board members, staff, and conductors; general sessions conducted by leaders in the field

AMERICAN THEATRE ASSOCIATION (ATA)
1010 Wisconsin Avenue, NW
Washington, DC 20007

Focus: topics relevant to its constituents

Constituents: American Community Theatre Association, Army Theatre Arts Association, American Theatre Student League, Children's Theatre Association, National Association of Schools of Theatre, Secondary School Theatre Association, University/Resident Theatre Association, University/College Theatre Association

National Convention: an annual conference that offers a variety of workshops and seminars on the management of the arts

ARTS AND BUSINESS COUNCIL (ABC)
130 East 40th Street
New York, NY 10016

Focus: arts management and volunteerism

Corporate Volunteer Training Program: Corporate executives who have volunteered to work with arts organizations are offered an intensive arts management course that covers all aspects of nonprofit arts management.

Annual Conference: a three-day conference in New York City that includes a day of workshops for participants

National Programs: ABC has begun similar programs in other cities, including Seattle, San Francisco, and Houston. Check with the New York office for details about these and other program locations.

ARTS MANAGEMENT
408 West 57th Street
New York, NY 10019

Focus: careers, arts management

Workshops: Four career workshops are presented each year in cooperation with Opportunity Resources for the Arts (see below) and the annual Performing Arts Management Institute workshop (see below).

Publication: Arts Management, a newsletter

ARTS MANAGEMENT INSTITUTE
Department of Theatre
Virginia Tech
Blacksburg, VA 24601

Focus: performing arts management

Conferences: Two-day conferences are offered a few times each year in Blacksburg, each on a specific topic, such as marketing and board development; Virginia Tech faculty and professionals lead the conferences.

ARTS AND SCIENCE DEVELOPMENT SERVICE
971 Richmond Road
East Meadow, NY 11554

Focus: fundraising, marketing

Seminars: one-day seminars offered at different times in various cities; topics include direct-mail marketing and fundraising

ASSOCIATION OF ARTS ADMINISTRATION EDUCATORS (AAAE)
c/o Performing Arts Management Program
Brooklyn College
Theatre Department
Brooklyn, NY 11210

Focus: arts administration and management, higher education programs

Annual conference: held each winter at a selected site; members and invited professionals speak on topics of interest; open to college arts administration program heads, as well as associate members and individuals

Publication: Arts Administration Training Programs in the United States and Canada, published periodically by the Center for Arts Administration at the University of Wisconsin at Madison and available from the American Council for the Arts (see above)

ASSOCIATION OF COLLEGE, UNIVERSITY, AND
COMMUNITY ARTS ADMINISTRATORS (ACUCAA)
Post Office Box 2137
Madison, WI 53705

Focus: arts administration, especially presenting organizations

Public Events Management Seminar: a one-day seminar presented the day before the annual conference in New York City, covering the basics of presenting for the neophyte

Financial Development Workshop: a one-day seminar held during the annual conference focusing on a different theme each year; includes lectures and role-playing sessions

Marketing the Arts: three-day workshops taught by professors from the University of Wisconsin and professionals from the advertising field; all aspects of marketing and advertising the arts are covered; a number of these workshops are offered each year.

Summer Workshops: Three workshops are held each summer in different parts of the country and focus on performing arts presentations, management techniques, and university-community relations; the workshops are five days long and are usually held in July.

Annual Conference: held each December in New York City; small workshop sessions cover a variety of topics, plus major banquet speaker; display booths staffed by leading artists' representatives; hospitality considerations include tickets to numerous performing arts events

ASSOCIATION OF HISPANIC ARTISTS (AHA)
200 East 87th Street —
New York, NY 10028

Focus: Hispanic arts

Hispanic Arts Conference: an annual two-day conference in New York City, includes workshops and seminars on various topics of arts management

Training Seminars: short seminars presented by professionals on topics such as fundraising, marketing, and audience development

BANFF CENTRE FOR CONTINUING EDUCATION
Post Office Box 1020
Banff, Alberta TOL OCO
Canada

Focus: arts management and museum management

Cultural Resources Management: Approximately six seminars are given each year, most at the Banff Centre in Canada; workshops range from intensive five-day sessions to three-week seminars and are designed for entry-level people, middle managers, or executives with practical experience but little formal education in the field; seminars have specific topics such as: "Marketing Strategy for Arts Managers," "Publicity and Public Relations for the Arts," and "Museum and Art Gallery Management."

BOX OFFICE MANAGEMENT INTERNATIONAL (BOMI)
500 East 77th Street, #1715
New York, NY 10162

Focus: box-office management

Conference: an annual, three-day conference held in a major world city with a specific theme related to box-office management

Publication: a newsletter that contains feature articles, results of BOMI surveys, and career opportunities

CARLTON COMMUNICATIONS CORPORATION
635 Madison Avenue
New York, NY 10022

Focus: media and careers

Seminars: one-day seminars on careers in film, television, cable, video, with speakers working in these fields; presented in New York City, Boston, and Philadelphia

CENTER FOR ARTS INFORMATION
625 Broadway
New York, NY 10012

Focus: arts and media management

Information: an office and library open daily to the public with information on all topics related to performing and visual arts and media management; the office staff is available to answer inquiries in person or by phone.

Publications: list available upon request

CENTRAL OPERA SERVICE (COS)
c/o Metropolitan Opera
Lincoln Center Plaza
65th Street and Broadway
New York, NY 10023

Focus: opera

Information: statistical data on the opera field in North America

Publication: COS bulletin with articles on aspects of opera management, published monthly

Conference: annual conference held in a different city each fall with a specific theme; session led by professionals from the field

CHAMBER MUSIC AMERICA, INC.
215 Park Avenue South
New York, NY 10003

Focus: chamber music

Annual Conference: held in different cities; presents workshops on topics related to chamber music presentation and management

CONTRACT SERVICES ADMINISTRATION TRUST FUND
8480 Beverly Boulevard
Hollywood, CA 90048

Focus: film and television

Training Programs: open to qualified applicants; focus on various topics—except acting—in film, television, and related fields

COUNCIL FOR THE ADVANCEMENT AND SUPPORT OF EDUCATION (CASE)
11 Dupont Circle, NW
Washington, DC 20036

Focus: fundraising, public relations, volunteerism

Conferences, Workshops, and Institutes: about sixty each year, one to three days in length, on a broad range of topics including fundraising, management, volunteerism, and public relations

DANCE U.S.A.
633 E Street, NW
Washington, DC 20004

Focus: large professional modern dance and ballet companies

Conference and Meetings: An annual conference and quarterly business meetings are held for member managers and artistic directors; the focus is on various production and management topics of interest.

Publication: a quarterly newsletter

DONORS FORUM OF CHICAGO
208 South Lasalle Street, Suite 840
Chicago, IL 60604

Focus: grants development

Workshops and Seminars: The Forum is an association of independent and corporate foundations that provides services to its members; workshop schedules vary.

EMPIRE STATE COLLEGE: URBAN STUDY CENTER
80 Centre Street
New York, NY 10013

Focus: theatre

Working Semester: a semester-long apprenticeship with a New York theatre—includes workshops, seminars, lectures, and master classes with professionals; the program is arranged through the college, which is part of the State University of New York (SUNY) system; graduate credit may be awarded, depending on courses taken and school attended; in-state tuition is $450, out-of-state is $750.

FOCUS MEDIA INC.
12345 Ventura Boulevard
North Hollywood, CA 91604

Focus: film and television careers and careers for women

Seminars: "The Cast You Don't See on Screen" is a one-day career planning seminar on types of jobs in the industry and the workings of a studio; "Who Hires in Hollywood" is a one-day seminar on the specifics of job-hunting, covering all aspects of hiring in the industry—casting directors, studio personnel directors, non-union producers, and other professionals are represented on the seminar panels; "Women Moving Up in Movies and Television" is a half-day program that encourages networking; it is presented at a breakfast with successful women in the industry.

THE FOUNDATION CENTER
75 Fifth Avenue, 8th floor
New York, NY 10003

Focus: fundraising

Orientation Session: Weekly orientation sessions are offered by the four major offices and many of the regional collection offices on the use of the library and on techniques for researching foundations; sessions are one and one-half hours long—some half-day seminars have been conducted periodically; the Center maintains field offices in Washington, DC, San Francisco, and Cleveland.

FOUNDATION FOR THE EXTENSION AND DEVELOPMENT OF THE AMERICAN PROFESSIONAL THEATRE (FEDAPT)
165 West 46th Street, Suite 310
New York, NY 10036

Focus: theatre, dance, performing arts management, careers

National Conference and Seminar on Theatre and Dance Management: an intensive, three-day, comprehensive conference on a specific topic or topics in arts management, with professionals from the field and managers of companies as speakers; for working professionals, board members, and others interested in the field; held in New York City

Theatre Middle-Management Program: Sponsored in conjunction with the O'Neill Memorial Theatre Center and Theatre Communications Group, FEDAPT offers four intensive one-week sessions for middle-management staff from participating theatres.

Management Workshops for Small Budget Theatres: a series of ten workshops given for representatives of small theatres in the greater New York area; the sessions address the particular problems of small nonprofit theatres, and each theatre represented also receives three days of technical assistance from FEDAPT

Special Workshops: FEDAPT conducts one-time workshops and conferences in various cities; these relate to management topics for both theatre and dance companies.

THE FUND RAISING SCHOOL
Post Office Box 3237
San Rafael, CA 94912

Focus: fundraising

Courses: taught in various locations across the country and designed to teach the principles and techniques of fundraising; courses are given for beginners, experienced practitioners, and volunteers and trustees; continuing education credits are offered.

GEORGIA CENTER FOR CONTINUING EDUCATION
University of Georgia
Athens, GA 30602

Focus: arts administration

Arts Administration Institute: a ten-day program covering principles of management, including fundraising, marketing, career development, community communications; designed for those with arts administration experience, particularly at the local level

THE GRANTSMANSHIP CENTER
1031 South Grand Avenue
Los Angeles, CA 90015

Focus: grantsmanship and planning

Mini-courses, Seminars, and Workshops: for training in writing grants and in management, planning, and resource development; courses are in response to the critical needs of nonprofit and public agencies.

INTERNATIONAL SOCIETY OF PERFORMING ARTS ADMINISTRATORS (ISPAA)
c/o University of Texas
PO Box 7518
Austin, TX 78712

Focus: performing arts and presenting organizations

Scholarships and Internships: a program in which members, who are also graduates of arts administration programs, are selected by committee to serve management residencies with various performing arts companies and agencies around the country

Annual Conference: usually held in New York City in December—at or near the time of the ACUCAA conference; includes workshops and speeches given by prominent members of the profession

MEREDITH COLLEGE
CULTURAL RESOURCES MANAGEMENT PROGRAM
Raleigh, NC 27611

Focus: performing and visual arts management, career development for women

Part-time Program: provides training for the management of organized cultural activities; the program is intended for women with some college training who have an interest in cultural resources; it may be completed over a five-year period and all courses are given on the Raleigh campus.

MUSEUM OF BROADCASTING
1 East 53rd Street
New York, NY 10022

Focus: broadcasting

Open Channels: an annual lecture series held from March to January, open to the public, covering a wide variety of topics, ranging from broadcast management to technological and craft subjects

MUSEUM'S COLLABORATIVE
15 Gramercy Park South
New York, NY 10003

Focus: museums and management

Cultural Institutions Management Program: offered in conjunction with the faculty of the Columbia University Graduate School of Business; a one-week intensive course is followed by an eleven-week practicum within an institution and a three-day follow-up seminar.

MUSEUM MANAGEMENT INSTITUTE
Western Association of Art Museums
Mills College, Box 9989
Oakland, CA 94613

Focus: museum management

Annual Seminar: a four-week seminar of courses for executive and middle-level museum professionals; the first seminar was held at the University of California at Berkeley with tuition at $1,000 plus living expenses.

NATIONAL ACADEMY OF RECORDING ARTS AND SCIENCES
(Chapters in Los Angeles, Chicago, New York City, Atlanta, and Nashville)

Focus: music recording

Annual Conference: workshops that cover the business areas of the music industry

NATIONAL ASSEMBLY OF COMMUNITY ARTS AGENCIES (NACAA)
1620 I Street, NW
Washington, DC 20006

Focus: community arts councils

Information: on local arts councils, conferences; seminars are offered on local and regional levels.

Annual Conference: in different parts of the country each year; workshops and speakers on topics relating to arts councils

NATIONAL ASSEMBLY OF STATE ARTS AGENCIES (NASAA)
1010 Vermont Avenue, NW, Suite 316
Washington, DC 20005

Focus: State arts councils

Information: on state arts councils and federal and/or state partnership programs

Annual Conference: held in different parts of the country each year and presenting workshops and speakers on topics relating to arts councils

NATIONAL ASSOCIATION FOR CAMPUS ACTIVITIES (NACA)
Box 11489
Columbia, SC 29211

Focus: presenting and booking

Annual Convention: offers over one hundred different lectures and events, many of which are related to management

Regional Conferences: NACA cosponsors a number of conferences each year in various cities, most of which have management themes.

NATIONAL ASSOCIATION OF BROADCASTERS (NAB)
1771 N Street, NW
Washington, DC 20036

Focus: television and radio—management and careers

Annual Conference: presents workshops and speakers on aspects of broadcast management

Information: on career development; pamphlets include *Careers in Television* and *Careers in Radio*

NATIONAL ASSOCIATION OF EDUCATIONAL BROADCASTERS (NAEB)
1346 Connecticut Avenue, NW
Washington, DC 20036

Focus: public broadcasting

Public Telecommunications Institute Program: workshops in broadcast management, personnel, production, and engineering

Publication: Current: For People in Public Telecommunications; published twice monthly

NATIONAL ASSOCIATION OF REGIONAL BALLET (NARB)
1860 Broadway
New York, NY 10023

Focus: ballet

Annual Conference: each June in a different city; includes workshops given in response to requests from member companies

NATIONAL GUILD OF COMMUNITY SCHOOLS OF THE ARTS (NGSCA)
665 North Umberland Road
Teaneck, NJ 07666

Focus: community arts education

Annual Conference: held in November; presents speakers and workshops on aspects of community arts education, including fundraising, personnel relations, and career development

Chapter Workshops: Regional chapters offer one-day workshops on specific topics, such as board relations and management.

NATIONAL TRUST FOR HISTORIC PRESERVATION
1785 Massachusetts Avenue, NW
Washington, DC 20036

Focus: museums and historical associations

Publications: Guide to Degree Programs in Historic Preservation (Third Edition, 1980);
Preservation News, and an annual supplement *Higher Education: Academic Programs
in History Preservation*

NEW SCHOOL FOR SOCIAL RESEARCH
66 West 12th Street
New York, NY 10011

Focus: media, careers, music, theatre

Workshops: from one-day to eight-week sessions on topics ranging from careers in
cable to media spot-buying; non-credit courses are open to the general public; check
the bulletin for course offerings and tuition rates.

NEW YORK UNIVERSITY
GRADUATE SCHOOL OF PUBLIC ADMINISTRATION
Program in Arts Policy, Planning, and Administration
4 Washington Square North
New York, NY 10013

Focus: arts management, fundraising

Summer Semester: courses on various topics, including financial management and
fundraising; different areas are covered each summer.

OHIO STATE UNIVERSITY
OFFICE OF CONTINUING EDUCATION
210 Sullivan Hall
1813 North High Street
Columbus, OH 43210

Focus: careers

Seminars: for students and community members; includes topics on career guidance
and development

OPERA AMERICA
633 E Street, NW
Washington, DC 20004

Focus: opera and musical theatre management

Opera Management Program: Two-day and three-day seminars are offered throughout the country on topics related to opera management, including financial management, development, and marketing; sessions are for both staff and trustees and are led by opera managers, university faculty, and representatives from industry.

Annual Conference: includes open sessions and workshops on relevant subjects related to a theme of the conference; held in December or January.

OPPORTUNITY RESOURCES FOR THE ARTS, INC. (OR)
1501 Broadway
New York, NY 10036

Focus: nonprofit arts management, careers

Workshops: "Careers in Arts Administration," a one-day session presented jointly with Arts Management. Speakers from the field give an overview of the profession, including a section on marketing your own career; held in New York City four times annually

Seminars: One-day seminars are presented through the auspices of other service organizations or local arts groups throughout the country.

Publications: Writing a Resume, a booklet with advice on resume writing that includes sample resumes.

PERFORMING ARTS MANAGEMENT INSTITUTE (PAMI)
408 West 57th Street
New York, NY 10019

Focus: arts management

Institute: A three-day program offered annually in New York City each November and in Los Angeles each May, covering subjects such as audience development, budgeting and finance, fundraising, and general management; features prominent speakers from the profession; small group seminars and workshops are also included.

PUBLIC INTEREST PUBLIC RELATIONS, INC.
225 West 34th Street, Suite 1500
New York, NY 10001

Focus: public relations

Promoting Ideas and Issues: panel sessions, workshops, and counseling sessions on topics such as public relations, press relations, special events, and advertising; the two-day workshops are given in New York City.

PUBLIC MANAGEMENT INSTITUTE (PMI)
358 Brannan Street
San Francisco, CA 94107

Focus: fundraising and finance

Training Seminars: given on a regular schedule throughout the country on topics such as fundraising, grantsmanship, nonprofit management, and nonprofit finance; seminars are held in cooperation with colleges and universities and are presented by faculty and PMI staff; in addition PMI offers publications and courses on cassettes, as well as in-house training programs, and research and consulting services.

SANGAMON STATE UNIVERSITY
COMMUNITY ARTS MANAGEMENT PROGRAM
Shepherd Road
Springfield, IL 62708

Focus: arts administration

Sangamon Institute in Arts Administration: a two-week course covering long-range planning, financial management, evaluation techniques, information retrieval, fundraising, career planning, legal aspects of arts management, and other topics; small-group workshop format; offered on campus each summer

SMITHSONIAN INSTITUTE WORKSHOPS
Office of Museum Programs
Arts and Industries Building, Room 2235
Smithsonian Institution
Washington, DC 20560

Focus: museum administration

Workshops: about thirty workshops are offered annually for individuals employed by museums; some are specifically for curators, but most cover areas of museum administration, such as public information, budgeting, and accounting; the workshops last from two to five days and are given at the Smithsonian in Washington.

SOUTHERN ARTS FEDERATION (SAF)
1401 Peachtree Street, NE
Atlanta, GA 30303

Focus: general management, presenting, and museums

Sponsor Development Workshops: five-day sessions, held in different Southeast cities, covering various aspects of presenting the arts in the community; designed for the new arts administrator

Museum Management Program: offered in conjunction with the Smithsonian Institution's Office of Museum Programs; three-day seminars given by the Smithsonian staff

Job-Alike Conferences: This program brings together individuals holding similar jobs in the member arts agencies from the ten-state region; program directors are brought together to discuss common problems

THEATRE COMMUNICATIONS GROUP (TCG)
355 Lexington Avenue
New York, NY 10017

Focus: theatre management

Theatre Middle-Management Program: see FEDAPT, above

Seminars and Workshops: offered periodically in different locations, covering specific topics of concern to theatre managers

Information: TCG collects and makes available data on the theatre in the United States, especially professional resident theatre companies that are nonprofit

Publications: Theatre Profiles, published biennially, is a survey of noncommercial theatres; *TCG Survey,* available to member theatres, has information on salaries, budgets, and related topics; *Theatre Directory* lists theatres, board presidents, managers, and other information; *ArtSearch* (see TCG under the Job Referral section of the Career Kit)

UNITED STATES INSTITUTE FOR THEATRE TECHNOLOGY (USITT)
330 West 42nd Street
New York, NY 10036

Focus: theatre—management and technical aspects

Workshops and Seminars: While USITT deals primarily with aspects of technical theatre production, some management seminars are offered to member organizations and individuals.

VOLUNTEER LAWYERS FOR THE ARTS
1560 Broadway
New York, NY 10036

Focus: legal aspects of nonprofit arts administration

Biweekly Seminars: held throughout the year in New York City to provide information mainly for small or beginning performing arts companies regarding matters such as obtaining not-for-profit status or forming a board, as well as a broad range of legal matters

Special Conferences: held periodically on specific themes

Workshops: for lawyers who wish to volunteer their services to assist nonprofit arts organizations

VOLUNTEER: THE NATIONAL CENTER FOR CITIZENS INVOLVEMENT
1111 North 19th Street
Arlington, VA 20009

Focus: volunteerism

Annual Conference: national conference on volunteerism with seminars

Information: regional information-sharing and skills-building workshops for volunteer leaders and administrators in the arts and humanities

WESTERN STATES ARTS FOUNDATION
142 East Palace Avenue
Sante Fe, NM 87501

Focus: arts councils

Information: on seminars, workshops, and conferences presented by and for the constituent state arts organization

Publication: The National Arts JobBank (see the Job Referral section of the Career Kit)

WOMANSPACE-CAREER OPTIONS
Program for Women
Columbia University
211 Lewison Hall
New York, NY 10027

Focus: careers for women

Workshops: on various career paths involving the arts; also presents panels, career counseling, referral services for women who wish to enter, reenter, or move up in the labor force

YORK UNIVERSITY SEMINARS FOR ARTS ADMINISTRATORS
Faculty of Administrative Studies
4700 Keele Street
Downsview, Ontario M3J2R6
Canada

Focus: performing arts and museums—fundraising and financial management

Seminars: Three-day or four-day seminars are given throughout the year on the York campus; seminar leaders are faculty and arts professionals.

Job Referral Services, Membership Associations, and Periodicals with Job Listings

The following chart lists publications and referral services that announce job openings and/or assist with job placement. In addition, you may want to check with your local and state arts councils, which often receive requests from the arts organizations in their area. Also check with the national associations that represent the councils: the National Assembly for State Arts Agencies (1620 T Street, NW, Washington, DC 20006) and the National Assembly for Local Arts Agencies (1785 Massachusetts Avenue, NW, Washington, DC 20036).

It is important to receive information as soon as possible after a job has become available. The chart, therefore, lists the "turnaround time," or the time it takes for the periodical or referral service to get the new job information to you. This is determined by such things as publication deadlines, the frequency of the publication, and the mailing time—based on the type and class of material mailed. The average number of jobs listed was determined by a sampling of recent publications or by direct contact with the organization. The cost listed is often the cost of membership, which entitles one to a subscription and use of any available job services unless otherwise noted. Note that in some instances the costs listed may be the student, or lowest, rates.

Some of the publications listed below are much more than job listings. *ACA Update,* for example, lists a calendar of upcoming conferences and workshops. *AVISO* features articles of interest to the museum professional. *Symphony News,* although short on the number of classified listings, has a section called "Musical Chairs" that includes news of who has left what position and who has taken which new job. This type of information can tell you a great deal about the field: which areas of the country seem to be fertile and growing, what the qualifications are for particular jobs, and which companies or organizations have a high rate of personnel turnover.

Two local publications have been listed—*Short Subjects* and *Community Arts News*—because they consistently list available jobs. There are numerous other local publications around the nation that you may wish to consult. Publishers and organizations often change their addresses and their rates and formats, so that no list such as the following can be completely up to date. To verify such information, consult the periodical section in a library or check with the Center for Arts Information (625 Broadway, New York, NY 10012: (212) 677-7548).

Organization Name and Address	Fields Covered	Publication and/or Service	Turnaround Time	Average Number of Jobs Listed	Cost	Comments
Advertising Age 200 East 42nd St., Suite 930 New York, NY 10017	Advertising and marketing positions industry-wide	Advertising Age	12 days	25	$50 for 52 weeks	
Alliance of Resident Theatres/New York (ART/NY) 325 Spring St. New York, NY 10013	Theatre administration and production, mostly in New York City	Theatre Times ART/NY, formerly the Off-Off-Broadway Alliance, serves small theatres in New York City.	8 weeks	10	$15 for 8 issues annually	
Alliance of Ohio Community Arts Agencies (AOCAA) c/o Fine Arts Council of Trumbull County PO Box 48 Warren, OH 44482	All nonprofit arts disciplines in Ohio, with a concentration on community arts council positions	Community Arts News	10 weeks	4	Free	One of the most consistent newsletters on the state level
Alpha Cine Lab. 1001 Lenora St. Seattle, WA 98121	Film and audiovisual industry	The Alpha View Finder	15 weeks		Free	
Association for Education, Communications & Technology 1126 16th St., NW Washington, DC 20036	Educational television and the communications media	ECT Newsletter and referral service	6 weeks	8-10	$25 for members; $75 for nonmembers	The service is a jobs clearinghouse; positions are listed in the Newsletter.

Organization	Field	Publication	Frequency	Number	Cost	Comments
American Association of Museums 1055 Thomas Jefferson St. NW Washington, DC 20007	Museums, mostly fine arts. and mostly higher-level positions	AVISO	6 weeks	40	$24 for membership	The best single source for administrative openings in museums, giving full job descriptions and information on recruiting
American Association for State and Local History 172 Second Ave. North Suite 102 Nashville, TN 37201	Specialty museums and historical societies	History News	6 weeks	12	$20 membership	Thorough job descriptions; best source for these special fields
American Council for the Arts (ACA) 570 Seventh Ave. New York, NY 10018	Performing arts and some museums, arts councils, and united arts funds	ACA Update	4 weeks	10	Free to ACA members	Opportunity Resources lists its top positions in Update each month.
		Job Line	1 day	10		Job Line provides a recorded message of current job openings and those received after publication deadline.

Organization Name and Address	Fields Covered	Publication and/or Service	Turnaround Time	Average Number of Jobs Listed	Cost	Comments
American Dance Guild 570 Seventh Ave. New York, NY 10018	Mostly dance teaching positions, some college or school administrative positions	Job Express Registry, part of ADG's referral services	8 weeks		Free to members and nonmembers	To register, mail a resume and particulars to American Dance Guild.
American Film Institute (AFI) JFK Center for the Performing Arts Washington, DC 20566	Film and television	AFI Education Newsletter	12 weeks		$10 and up for membership	
American Historical Association & Review 400 A Street, SE Washington, DC 20003	College, university and historical museum administration and other positions	Employment Information Bulletin	3 weeks		$12.50 per year for nonmembers	New positions are sent to subscribers between issues.
American Symphony Orchestra League (ASOL) 633 E St., NW Washington, DC 20004	Orchestra and some other performing arts management positions	Symphony News	5 weeks	12 5	$15 and up for membership	The best single source for symphony orchestra positions Classified ads

Organization	Service	Response Time	Number	Cost	Notes
American Theatre Association (ATA) 1010 Wisconsin Ave. NW Washington, DC 20007	ATA Placement Service Bulletin Referral service	6 weeks	70	$15 annual subscription Members only—additional $30	Most listings are administrative jobs. Registrant credentials are sent to institutions that list openings.
Arts Reporting Service PO Box 40937 Washington, DC 20016	Arts Reporting Service	2 weeks	4	$48 per year	Most listings can also be found in other publications.
Association of College, University, and Community Arts Administrators (ACUCAA) PO Box 2137 Madison, WI 53705	ACUCAA Bulletin Employment referral service	5 weeks 3 weeks	5 10	$30 students; $130 others	Usually higher-level positions that are duplicated by ACA listings Many middle-management and entry-level positions in performing arts; a package of 8–10 job descriptions is mailed to subscribers every 2 weeks.

Organization Name and Address	Fields Covered	Publication and/or Service	Turnaround Time	Average Number of Jobs Listed	Cost	Comments
Association of Independent Video and Film Makers/ Foundation for Independent Video & Film (AIVF) 625 Broadway New York, NY 10012	Film and video	The Independent	5 weeks	4	$15 students; $25 others, includes all services	The Notices section sometimes lists employment opportunities.
		Bulletin		1		Releases sent to members, sometimes listing jobs
		AIVF Independent Directory	Annual			Lists members' credits and experience made available to employers
Association of Science-Technology Centers (ASTC) 1016 Sixteenth St., NW Washington, DC 20036	Science museum administrative positions	ASTC Newsletter	Bimonthly	8	$18 per year	Detailed job descriptions; unfortunate turnaround time
Box Office Management International (BOMI) 500 East 77th St. #1715 New York, NY 10162	Career opportunities throughout the world, mainly box office and business; all performing arts	Newsletter	4 weeks		$95 membership per year	Issues job bulletins
		BOMI/SEARCH— referral service	2 weeks			

Broadcasting Magazine 1735 DeSales St., NW Washington, DC 20036	Radio, television, and related arts positions	*Broadcasting Magazine*	10 days		$45 per year for 52 issues	Brief job descriptions but timely; many management positions
Broadcasting Magazine 630 Third Ave. New York, NY 10022	All media	*Broadcasting Magazine*	10 days		$60 days for 52 issues	Numerous listings in all facets of media
Broadcast Management & Engineering 295 Madison Ave. New York, NY 10017	Radio and television and cable management—many station manager jobs; engineering and production	*Broadcast Management & Engineering*	30 days	25	$24 for 12 issues per year	
Central Opera Service (COS) Metropolitan Opera Lincoln Center Plaza New York, NY 10023	Opera management and artistic positions	COS Referral Service	2–4 weeks	160 per year	$25 membership; additional services $25 and up	Opera administrators register with COS and receive job notices; about 220 are registered at any given time.

Organization Name and Address	Fields Covered	Publication and/or Service	Turnaround Time	Average Number of Jobs Listed	Cost	Comments
College Art Association 149 Madison Ave. New York, NY 10016	College teaching, studio, and administrative visual arts positions; some fine arts museum openings	Referral service	3 months	200	$20 for nonmembers	Job openings mailed 5 times per year; placement orientation and interview sessions at annual conference in February.
Councils on Foundations, Inc. 75 Fifth Ave., 8th floor New York, NY 10003	Fundraising, arts, and social services	Foundation News	4 months	5	$20 per year	Has a classified section listing jobs not often found in other publications
Daily Variety 1400 North Cahuenga Blvd. Hollywood, CA 90028	Film and the media	Daily Variety	2 days		$60 per year, weekdays	
The Grantsmanship Center 1031 South Grand Ave. Los Angeles, CA 90015	Fundraising, grant writing, development in all nonprofit organizations, including those in the arts field	Grantsmanship Center News	3 months	8	$28 per year	Not too many arts-related positions; but notices that don't appear elsewhere

Greater Philadelphia Cultural Alliance 1719 Locust St. Philadelphia, PA 19103	All arts disciplines on all levels of experience	*Short Subjects*	5 weeks	10	$8 per year	Listings almost exclusively for positions in the Philadelphia area
International Association of Auditorium Managers 500 North Michigan Ave. Suite 1400 Chicago, IL 60611	Operations and general management positions in arts centers and auditoria	*Auditorium News*	8 weeks	10		Jobs in arts, civic, and convention centers; sent to members and affiliates
International Society of Performing Arts Administrators (ISPAA) c/o University of Texas PO Box 7518 Austin, TX 78712	Executive and general management positions in performing arts centers	*Performing Arts Forum*	8 weeks	4	$15 per year	Short job descriptions that usually appear in other listings
Knowledge Industry Publications 701 Westchester Ave. White Plains, NY 10604	Engineering, editorial, sales, and consultant jobs in the media	*Video User*	1 month	5	$24 for 12 monthly issues	
Media and Methods 1511 Walnut St. Philadelphia, PA 19102	Instructional media	*Media and Methods*	6 weeks		$11 for 9 issues	

Organization Name and Address	Fields Covered	Publication and/or Service	Turnaround Time	Average Number of Jobs Listed	Cost	Comments
National Art Education Association 1916 Association Dr. Reston, VA 22091	Visual arts administrative positions in colleges and museum education programs	NAEA News	10 weeks	10	$12 for students; $35 for others	Very specialized, with an emphasis on teaching and other education positions
National Association of Broadcasters 1771 N St., NW Washington, DC 20036	Television, radio, and cable	NAB Employment Clearinghouse				An advisory service that assists women and minorities and also provides career counseling
National Association of Educational Broadcasters 1346 Connecticut Ave., NW Washington, DC 20036	Educational radio and television media	Educational Broadcasting PACT Center			For Conference registrants: $400 fee	Conducted at the annual NAEB conference; provides job listing files to applicants, plus information about people looking for employment

National Dance Association/American Alliance for Health, Physical Education, and Recreation 1201 16th St., NW Washington, DC 10036	Some dance and recreation administrative positions	Referral service			$12.50 and up for membership	At the annual conference there is an employment service and referral program.
National Guild of Community Schools of the Arts, Inc. 665 North Umberland Rd. Teaneck, NJ 07666	Music, dance, and visual arts education administration	*Guildnotes* Employment referral service	5 weeks 6 weeks	4 6	$25 membership	Job descriptions in the newsletter Job descriptions sent to members
New York Times 29 West 43rd St. New York, NY 10036	All sectors of the arts and media industry; all positions	*New York Times*, Sunday edition—*Careers in Education* and *Employment* sections	5 days	300	$1.25 per issue; $1.50 outside New York City	A majority are entry-level positions; development and academically related positions appear in *Education* section.

Organization Name and Address	Fields Covered	Publication and/or Service	Turnaround Time	Average Number of Jobs Listed	Cost	Comments
Opera America 633 E St. Washington, DC 20004	All nonprofit arts, middle- and upper-management levels	Intercompany announcements	5 weeks	3		Not sent to individuals, may be available through Opera America or your local opera company
Opportunity Resources for the Arts, Inc. 1501 Broadway New York, NY 10036	All nonprofit arts, middle- and upper-management positions	Placement services	1 day	40 per year	$20 registration fee	Individuals send a resume and covering letter stating area of interest, geographic preference, and salary goal; 3–5 years experience often required
Southeastern Theatre Conference 1209 West Market St. University of North Carolina Greensboro, NC 27412	University and community theatre positions in the Southeast, Puerto Rico, and the Virgin Islands	Jobs Contact Service			$15 for service, plus a membership fee of up to $20	Year-round referral service to member organizations that list openings; formal placement and/or referral at annual conference

Taft Corporation 5125 MacArthur Blvd., NW Washington, DC 20016	Mostly development jobs	*The Nonprofit Executive*	5 weeks	25–40	$78 per year, 12 issues	
Theatre Communications Group 355 Lexington Ave. New York, NY 10017	Performing and visual arts management positions	*ArtSearch*	3 weeks	40	$25 per year	Also lists career development opportunities such as internships; one of the most widely read especially on each coast
Variety 154 West 46th St. New York, NY 10036	All arts and media fields	*Variety*	1 week	5	$65 for 52 issues per year	No classified ads; but display ads for upper-level management positions
Western States Arts Foundation 141 East Palace Ave. Santa Fe, NM 87501	Performing and visual arts management positions	*The National Arts JobBank*	3 weeks	50	$27 per year; $15 for 6 months	The western counterpart to *ArtSearch* but *JobBank* also lists East Coast openings; comprehensive job descriptions and an indication of whether jobs are listed for first time or repeated

Arts and Media Unions, Guilds, and Societies

The list that follows is comprised of the major unions, guilds, and professional societies related to the arts and media industry. Many provide special career publications, conduct seminars and workshops, and also offer internships or apprenticeships, although one must often be a member to benefit from such services. That is certainly the case for anyone who wishes to take advantage of whatever job referral services a union might offer. Nonetheless, it may be worthwhile to write or phone those groups with a vested interest in employment areas that are also of interest to you.

Because employment organizations frequently change their address and phone number, the latter have been omitted as they would be outdated by the time this book got to press. It is a simple matter to check with a phone directory or with telephone information.

Acronym	Full Name of Organization	National Office Location
ACE	American Cinema Editors	Los Angeles
AEA	Actors' Equity Association	New York City
AFM	American Federation of Musicians	New York City
AFTRA	American Federation of Television and Radio Artists	New York City
AGAC	American Guild of Authors and Composers	Hollywood, CA
AGMA	American Guild of Musical Artists	New York City
AGVA	American Guild of Variety Artists	New York City
ASC	American Society of Cinematographers	Hollywood, CA
ASCAP	American Society of Composers, Authors and Publishers	New York City
APATE	Asociacion Puertorriquena de Artistas y Technicos del Espectaculo	Santurce, PR
ATA	Association of Talent Agents	Los Angeles
BDG	Broadway Drama Guild	New York City
BMI	Broadcast Music, Inc.	New York City
DG	The Dramatists Guild	New York City
DGA	Directors Guild of America	Hollywood, CA
HAU	Hebrew Actors Union	New York City
IATSE	International Alliance of Theatrical Employees and Moving Picture Machine Operators of the United States and Canada	New York City
IAU	Italian Actors Union	New York City
LTE	Legitimate Theatre Employees Union	New York City
NATAS	National Academy of Television Arts and Sciences	New York City

NABET	National Association of Broadcast Employees and Technicians	Chicago
NATR	National Association of Talent Representatives	New York City
PG	The Publishers Guild	New York City
PGA	Producers Guild of America	Beverly Hills, CA
SAG	Screen Actors Guild	Los Angeles
SEG	Screen Extras Guild	Los Angeles
SPG	Screen Publicists Guild	New York City
SMPTE	Society of Motion Picture and Television Engineers	Scarsdale, NY
SSDC	Society of Stage Directors and Choreographers Inc.	New York City
TPU	Theatrical Protective Union	New York City
TWA	Theatrical Wardrobe Attendants Union	New York City
USA	United Scenic Artists	New York City
WGA	Writers Guild of America, East	New York City
WGA	Writers Guild of America, West	Los Angeles

About the Authors

Stephen Langley, author of *Theatre Management in America,* a textbook on the subject used internationally, and of *Producers On Producing,* heads the graduate program in Performing Arts Management at Brooklyn College of the City University of New York, where he is a professor in the Department of Theatre. As Managing Director of the Falmouth Playhouse on Cape Cod for nearly two decades, General Manager of the Brooklyn College Center for the Performing Arts for ten years, and as manager, consultant, and advisor for a variety of other arts projects, he has hired and placed literally hundreds of aspiring arts administrators. After earning degrees from Emerson College in Boston, the Central School of Speech and Drama in London, and the University of Illinois, Dr. Langley published his book on theatre management, which is one of the most important on the comparatively new field of arts management, and one of the first to define the profession. He currently serves as President of the Association of Arts Administration Educators.

James Abruzzo, Vice-President and head of the arts/entertainment search division of Tarnow International—an executive search firm with offices in Springfield, New Jersey; and London, England—has managed over one hundred searches for senior-level management positions with the leading ballet, theatre, and opera companies, symphonies, arts centers, museums, colleges, cable television companies, and broadcasting corporations. Before joining Tarnow, he was the Senior Search Consultant for Opportunity Resources for the Arts, Inc. Mr. Abruzzo holds a masters degree in music composition and an M.F.A. in arts administration from Brooklyn College. He is an Adjunct Associate Professor in the arts administration program of the Columbia University Graduate School: he is also a member of the music management faculty at Baruch College. He has served for three years as Vice-Chairman of the Special Arts Panel for the New York State Council on the Arts and is a trustee of the National Guild of Community Schools of the Arts and of the Staten Island Museum. He lives in Maplewood, New Jersey, with his wife and two children.